# Wildlife Photographer
## of the Year

Portfolio 11

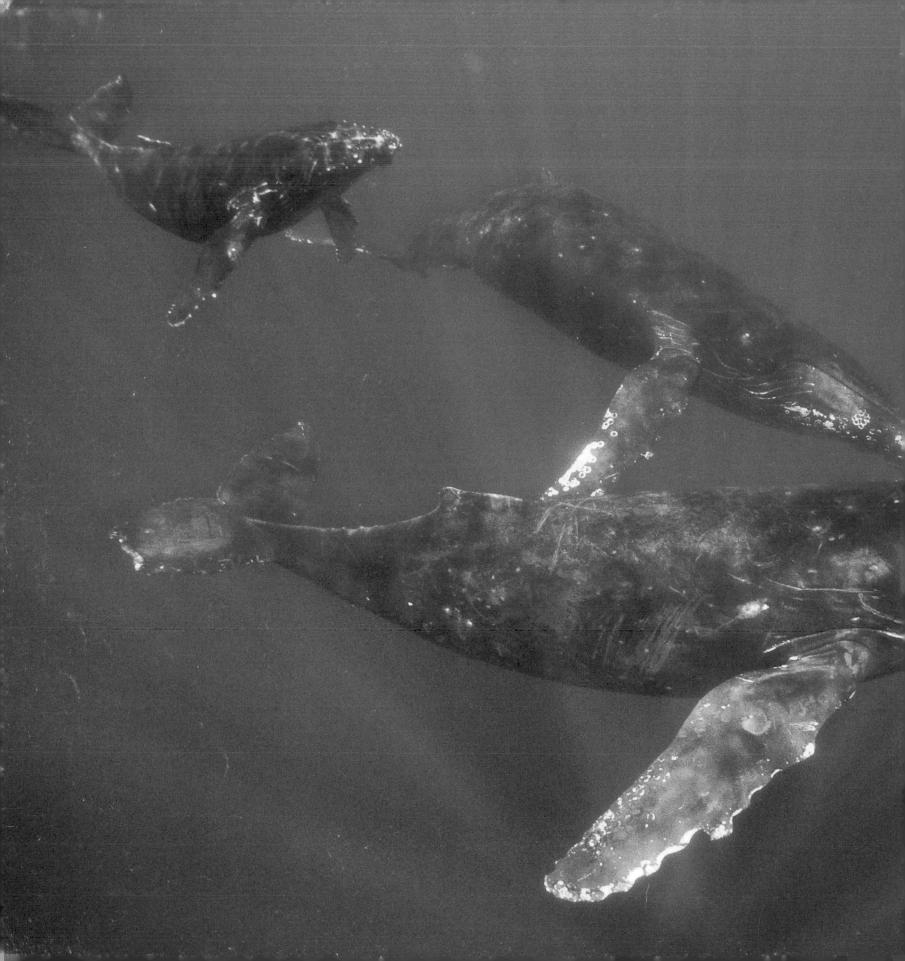

# Wildlife
# Photographer
## of the Year

Portfolio 11

Published by BBC Worldwide Limited,
Woodlands, 80 Wood Lane, London W12 0TT

First published 2001 Reprinted 2001, 2002

Compilation and text © BBC Worldwide 2001
Photographs © the individual photographers 2001

**Editor** Anna Levin

**Designer** Alex Evans

**Jacket designer** Pene Parker

**Caption writers** Rachel Ashton, Tamsin Constable

**Competition officer** Gemma Webster

ISBN 0 563 53448 6

Printed and bound in Great Britain by Butler & Tanner Limited, Frome

Jacket printed by Lawrence-Allen Limited, Weston-super-Mare

Colour separations by Pace Digital Limited, Southampton

# Contents

# Foreword
## by Chris Packham

Let me tell you how it feels.

An agony of impatience, which eventually climbs to a state of realisation – then you know it is actually going to happen, and, when it does, a seizure of breath pre-empts a surge of raw excitement that explodes in your head. Despite this euphoria, your hands do not tremble and there is no faintness; the result of such concentration and focus is a predatory calm, as if life itself depended on the proper outcome of the most critical action – and that action is no more than the squeezing of a button. Then, for a fraction of a second, the sound and flicker of the shutter tattoo the image into your memory and simultaneously onto a small rectangle of celluloid. What follows next is a love-like feeling – a silly urge to scream out loud. But this is not a cup-winning, crowd-pleasing moment – alone and in hiding, even the slightest movement may be dangerous. By now it's over really, and a furtive restlessness rises while the ability to concentrate diminishes. You must leave, go somewhere else to do something else. You do, and in time a degree of normality returns. Much later, when the result arrives it is always, always an anti-climax. That is what it feels like to take a great photograph.

Such are the highs and lows of wildlife photography, but the foundation depends on less emotional and frivolous energies. A good photographer needs a real creative force – the ability to visualise images, sometimes from afar, sometimes in the instant before a picture is made. Planning, however precise, cannot guarantee success, nor the perfect configuration of events. In nature, the photographer is a separate entity, distant or hidden and rarely interacting directly with the subject, and so to transform the reality into not only a photograph but also a picture, requires a high level of skill. To raise that picture to the level of a prize-winner probably needs another ingredient – passion. Antoine de Saint-Exupery, author of *The Little Prince*, wrote that "it is only with the heart that one can see rightly; what is essential is invisible to the eye". When you look at these pictures you will see that hearts as well as shutters have been stirred and that some transcend technique and the physical disciplines of practice. They glow with passion.

This volume, the celebratory issue of *BBC Wildlife* Magazine and the competition itself showcase a rich spectrum of such jewels. The BG Wildlife Photographer of the Year Competition has indeed become a benchmark, and the annual results set ever-increasing standards for the world's wildlife photographers to aspire to.

After its launch at The Natural History Museum in London, the touring exhibition of these images is admired by millions of people across the countries to which it travels. It is a pictorial ambassador for life on Earth, and something which, in their twelfth year as sponsors, BG must be justifiably proud.

When you consider this collection, the end product of 19,000 entries from more than 60 countries, you will note that artistic perfection, technical expertise and plain and simple beauty are not the only qualities portrayed here. The photographs also highlight cruelty, define conservation concerns and capture decaying fragments of our paradise lost. These works evoke very different reactions. Instead of awe and wonder, they generate a sense of loss and shame.

And the everyday, the abstract and the amusing are not forgotten either. These are among the world's finest wildlife photographs, and we can only marvel at their moments. From mega to macro to micro, from snow to sand, from day to night and from sky to sea, this fabulous gallery presents moments which we, the enthusiasts, judges and jurors, see as reaching closer to perfection. For us, the curve of the shark, the aura of the bison and the pattern of the forest are magical works of art, but as you consider these pictures, spare a thought for the poor photographers.

Some will revel in the recognition or the opportunities that such success offers, others may even allow a little smugness to stir their rivals' sensitivities. But overall, I'm sure that the benefit of hindsight - knowing what went before or came after that moment - will generate an ache in their creative souls. Perfection is impossible to attain, and yet the urge to attain it will make photographers rise for another dawn and so ensure that, next year, a new batch of great pictures will grace another album, evoking amazement in us all and making us wish it was us who had squeezed that button.

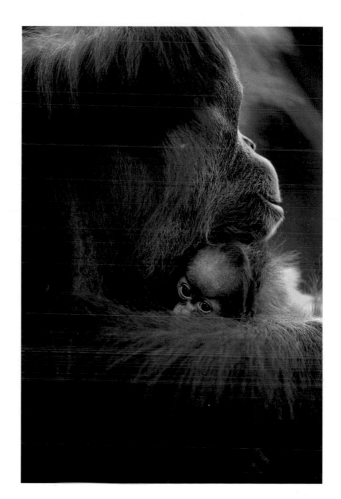

Orang-utan and baby, photographed by the BG Wildlife Photographer of the Year 2000, Manoj Shah.

## BG Group

We are proud to continue our long association with this prestigious international photographic competition, and I am constantly delighted with the exceptional quality of the winning photographs.

As an organisation that works closely with the Earth's natural resources, we are committed to minimising the impact of our activities on the environment.

The images displayed are a monument to the beauty, diversity and fragility of the natural world, and serve as a reminder of the importance of preserving this precious heritage for future generations. I hope that you too will enjoy revisiting these stunning photographs time and again.

**Frank Chapman**
*Chief Executive, BG Group*
**www.BG-Group.com**

**BG Group**

## The Natural History Museum

Home to the nation's unparalleled collections of natural history specimens and one of London's most beautiful landmarks, The Natural History Museum is highly regarded for its pioneering approach to exhibitions, welcoming, each year, nearly two million visitors of all ages and levels of interest. It has also gained unequalled respect for the excellence of its vital scientific research into important global issues such as conservation, pollution and biodiversity.

The Museum is a leading expert voice on the natural world, with access at the heart of its philosophy. The Darwin Centre opening in 2002 will change the way people view the Museum, revealing for the first time the incredible range and diversity of the Museum's collections and the cutting-edge scientific research that it supports.

**For further information**
Call The Natural History Museum on
+44 (0)20 7942 5000
Visit the Museum's website at **www.nhm.ac.uk**
E-mail **marketing@nhm.ac.uk**, or write to us at
Marketing Department,
The Natural History Museum,
Cromwell Road, London SW7 5BD

THE
NATURAL
HISTORY
MUSEUM

## *BBC Wildlife* Magazine

*BBC Wildlife* is Britain's leading monthly magazine on natural history and the environment. It contains the best and most informative writing of any consumer magazine in its field, along with world-class wildlife photography. The latest discoveries, insights, views and news on wildlife, conservation and environmental issues in the UK and worldwide accompany regular photographic profiles and portfolios. The magazine's aim is to inspire readers with the sheer wonder of nature and to present them with a view of the natural world that has relevance to their lives.

**Further information**
*BBC Wildlife* Magazine, Broadcasting House,
Whiteladies Road, Bristol BS8 2LR
**wildlife.magazine@bbc.co.uk.**

**Subscriptions**
+44 (0)1795 414748; fax: +44 (0)1795 414725
**wildlife@galleon.co.uk**
*Quote WLPF01 for the latest subscription offer*

**BBC wildlife**
MAGAZINE

# The BG Wildlife Photographer of the Year Award
# Tobias Bernhard

This is the photographer whose picture has been voted 'best of the year', as being the most striking and memorable of all the competition's entries. In addition to a big cash prize, he receives the coveted title BG Wildlife Photographer of the Year.

Tobias has been fascinated by the underwater world since childhood and became a diver at an early age. He studied graphic design and, after travelling the world for three years, worked for a design studio in his home city of Munich, Germany. His interest in the visual arts, combined with his passion for diving, led him naturally to underwater photography. In 1991, Tobias emigrated to New Zealand, where he continued to explore his interest in the underwater world, working for a few years as a diving instructor. He has spent most of the past eight years on board his boat, a specially equipped ex-fishing vessel, roaming the South Pacific in search of wildlife encounters.

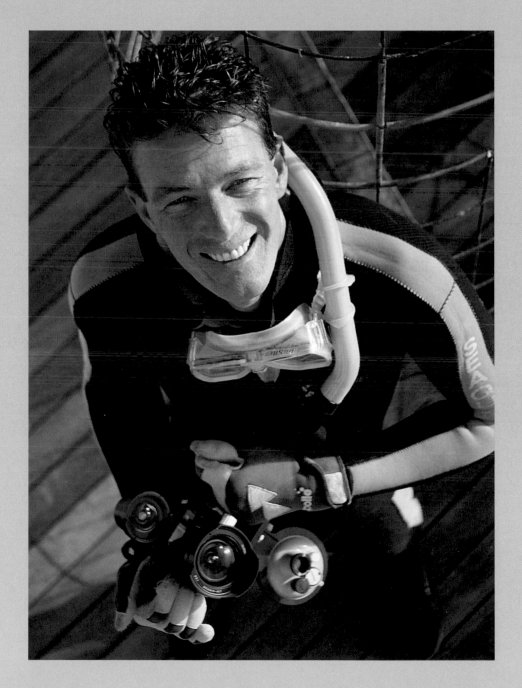

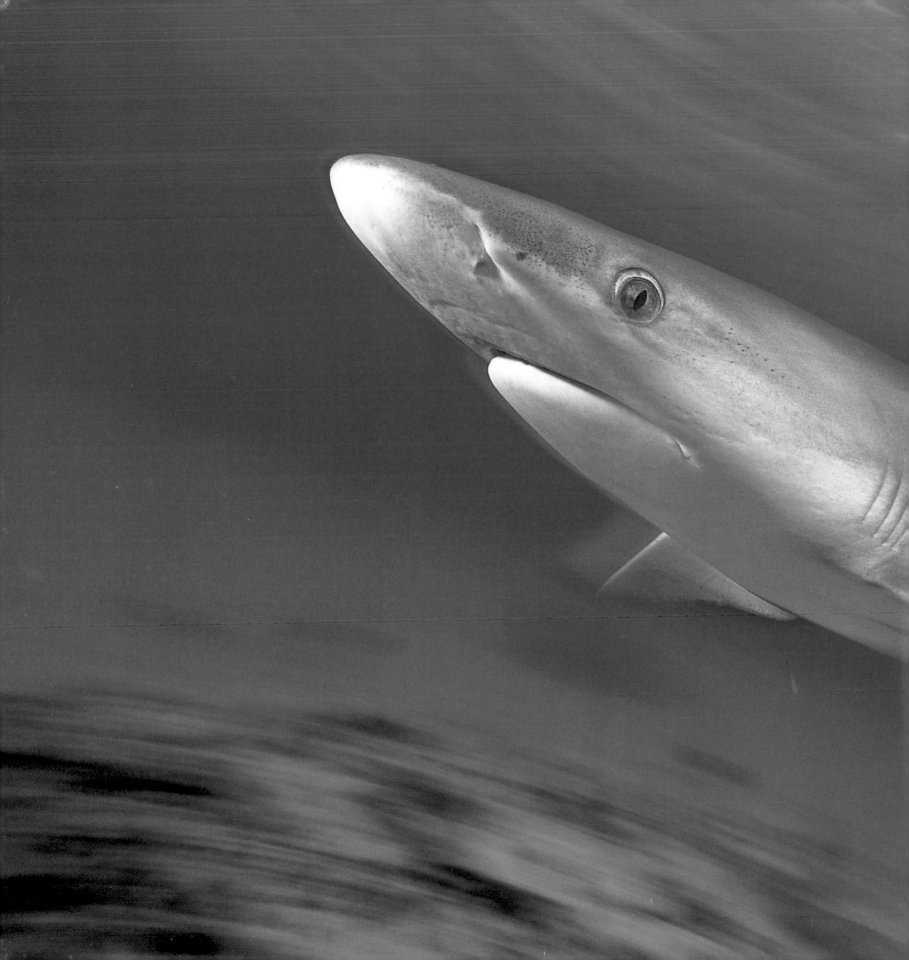

BG WILDLIFE
PHOTOGRAPHER OF
THE YEAR 2001

**Tobias Bernhard**
*Germany*

### GREY REEF SHARK

We found grey reef sharks in this lagoon on the Beveridge Reef in the South Pacific and used bait to habituate them to meeting us at a particular coral head. Over the next fortnight, they ventured closer each day, in groups of up to eight. Most were adult females, with a distinct 'pecking order'. Though these sharks can be dangerous, we never once felt threatened. This dominant female was the biggest (about two metres long), and sometimes, out of apparent curiosity, she would swim straight towards us, then, at the last moment, gybe sharply to change direction. Once I was familiar with this habit, I could preset focus, exposure and flash and concentrate on panning the shark as she cruised in. On this occasion, she was barely 30cm from me.

**Nikon F90X with 18mm lens;
1/15 sec at f16; Fujichrome Velvia;
two strobes.**

# The Gerald Durrell Award for
# Endangered Wildlife

This award highlights species that are critically endangered, endangered, vulnerable or at risk (as officially listed in the IUCN Red List of Threatened Species). It commemorates the late Gerald Durrell's work with endangered species and his long-standing involvement with the BG Wildlife Photographer of the Year Competition.

Xi Zhinong is a natural-history photographer, film-maker and dedicated conservationist. While learning ornithology under the guidance of a teacher from Yunnan University in China, he worked as an assistant cameraman on wildlife films, and went on to become a renowned environmental film-maker, raising awareness of the plight of local wildlife, including black-necked cranes and Tibetan antelopes. After three years filming the Yunnan snub-nosed monkey in the Baima Snow Mountains of Yunnan, he founded the Green Plateau Institute, a non-governmental organisation dedicated to preserving the monkey and its habitat. Xi Zhinong continues to focus on the wildlife of China, and his work is published in leading environmental magazines. He was recently presented with the Earth Award, the highest award given in China to conservationists.

**WINNER**

### Xi Zhinong
*China*

**YUNNAN SNUB-NOSED MONKEYS**

The Yunnan snub-nosed monkey is one of the most endangered mammal species in the world and lives at the highest elevation of all primates – between 3,000m and 4,700m. I had been tracking a group of some 200 individuals in the Yunling Mountains in China, and I finally set up my tripod at a commanding height with a few branches covering me. As the light streamed onto these two juveniles, the 'click' of my camera shutter attracted their attention, and they stared in my direction.

**Canon EOS 1N with 400mm lens plus Canon 2X extender; 1/500 sec at f5.6; Fujichrome Provia III 100 rated at 400.**

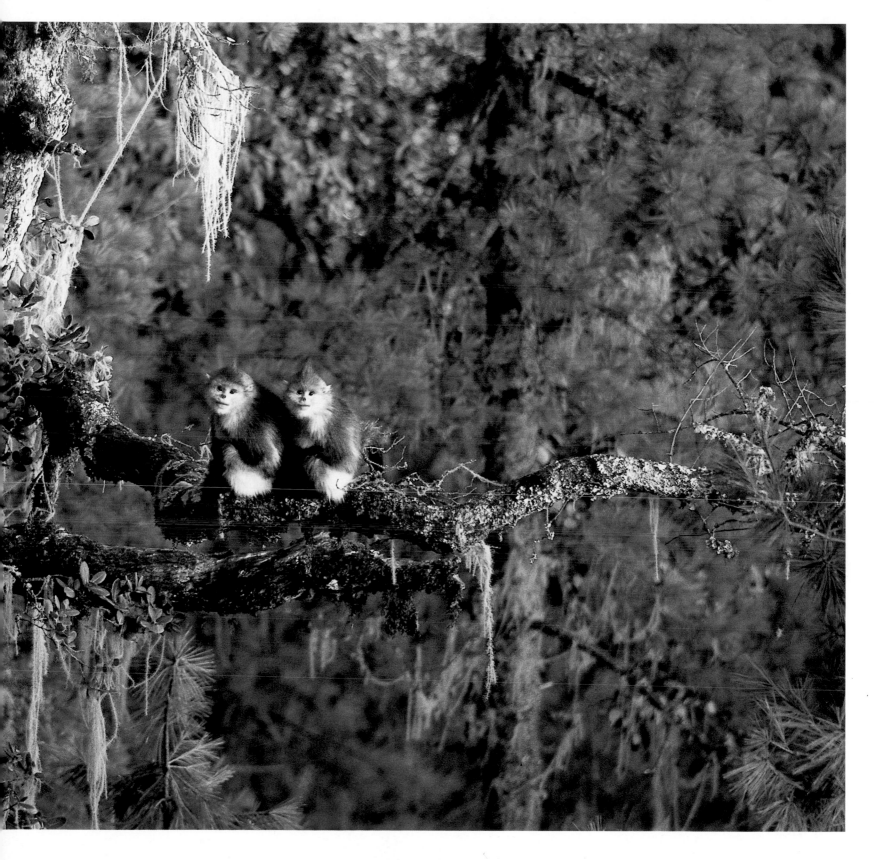

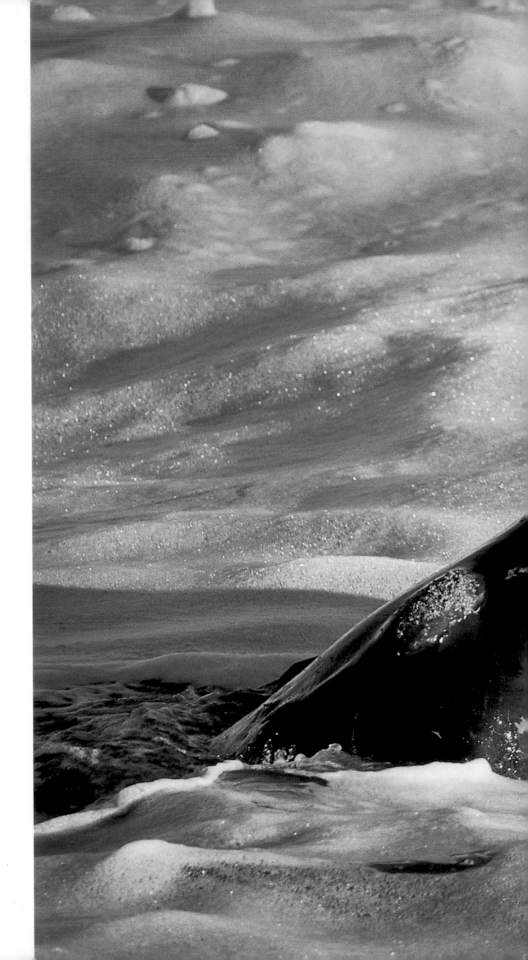

**RUNNER-UP**

**Brigitte Marcon and Jean-Jacques Alcalay**
*France*

**SOUTHERN RIGHT WHALE**
In winter, southern right whales come close to sheltered bays along the South African coast to calve. This whale was moving slowly through the spume near the sea-cliffs of Hermanus, South Africa, with its massive mouth open. Rivers of water gushed out through the baleen plates and from the corners of its mouth. We could clearly hear the loud puffs as it exhaled through its blowhole. It wasn't until after the film was developed that we noticed the grebe bobbing on the waves.

**Canon EOS 1 with 300mm lens plus x2 extender; Elite Chrome Extra Colour; tripod.**

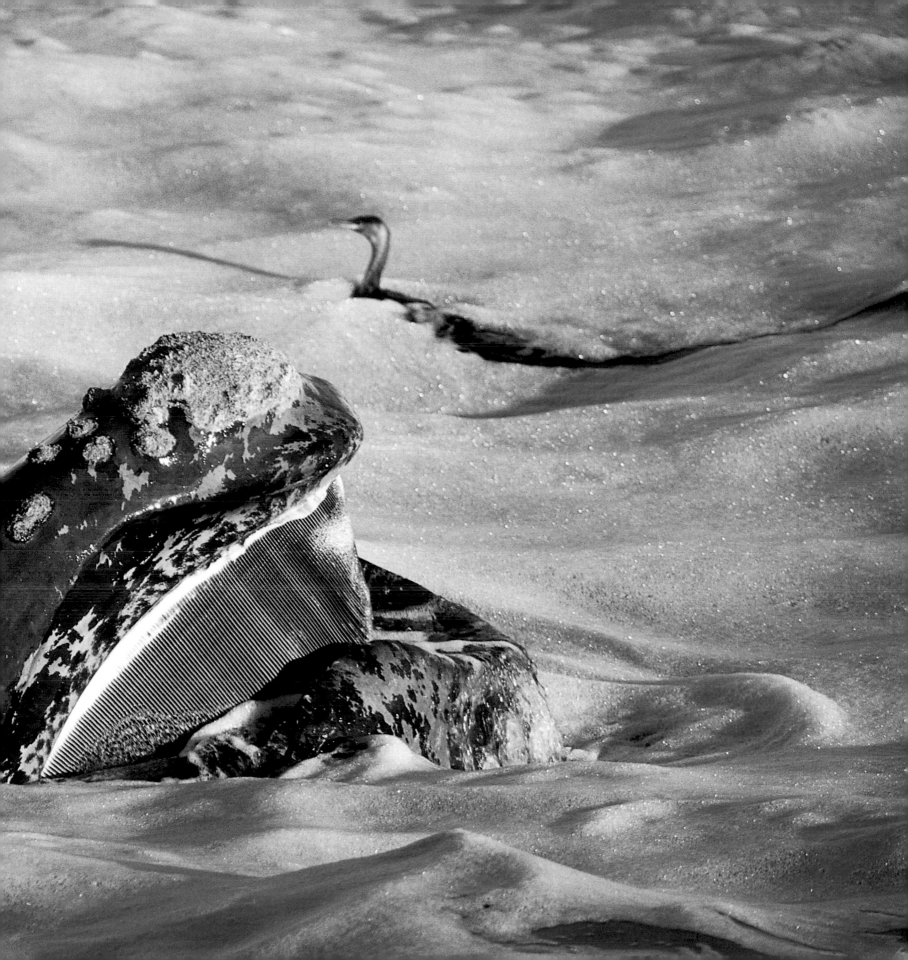

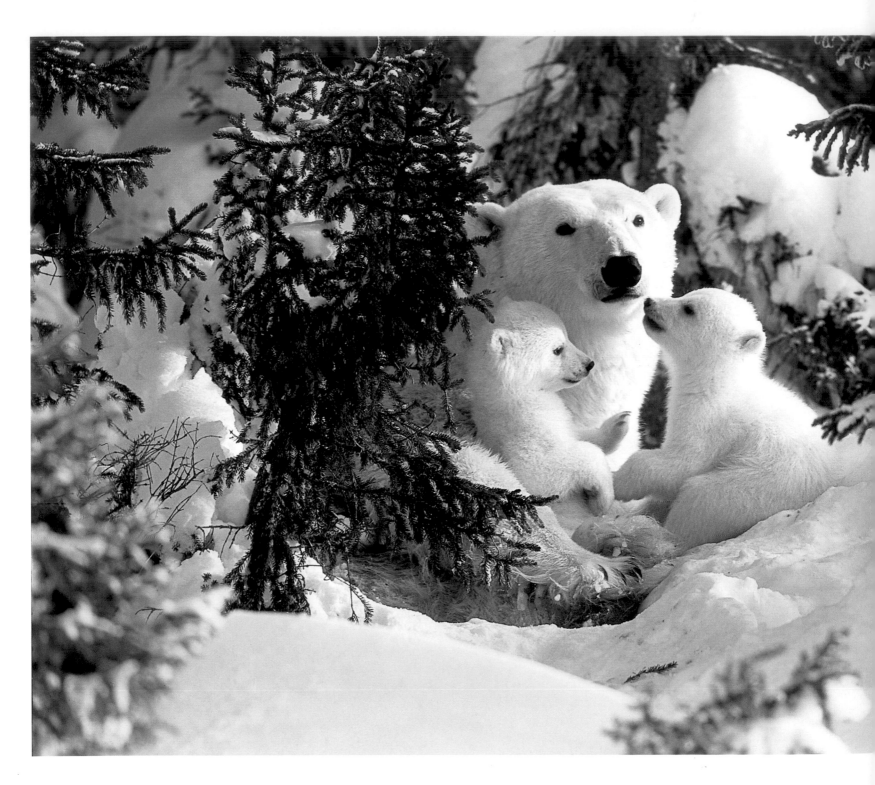

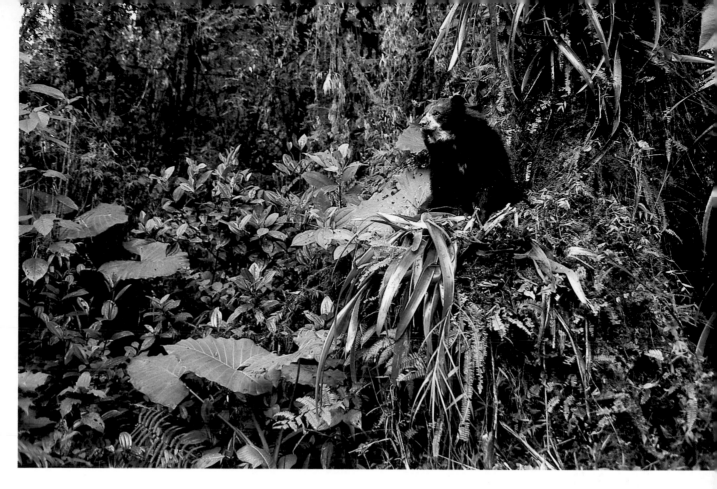

**David Pike**
*UK*

### POLAR BEAR FAMILY AFTER HIBERNATION

It was early March on the tundra in northern Manitoba, Canada, and these polar bears had just emerged from their winter den. The female hadn't seen daylight for perhaps four months. She still seemed dazed and spent the next few hours dozing among the conifers. Her twin cubs were born in the snow-den in early December, and so this was their first glimpse of the outside world. They played, tumbling over one another, exploring the vegetation, or scrambling over their mother's sleepy body. If one of the cubs wandered away, the female would huff gently to get its attention.

Nikon F5 with AF-S Nikkor 600mm lens; 1/250 sec at f/8; Fujichrome Velvia; tripod.

**Edward Parker**
*UK*

### SPECTACLED BEAR

This female spectacled bear was one of several being cared for at La Planada reserve in the foothills of the Colombian Andes. In the wild, she would have spent much of her time expertly climbing trees to forage for bromeliads and other succulent epiphytes, and at the Reserve they have created conditions to allow her to continue this natural behaviour. Today, there are an estimated 18,000 spectacled bears living in the dense, high-altitude cloud-forests that cover the steep slopes of the Andes. But their forest habitat is being destroyed as large areas are cut for firewood and charcoal, or cleared for agriculture.

Canon EOS 1N with 28-70mm lens; 1/60 sec at f2.8; Fujichrome Provia II at 100.

## HUMPBACK WHALES

Each winter in Hawaii, humpback whales come to mate, give birth and raise their offspring. This group of a mother, male escort and calf were easily recognisable because part of the mother's tail fluke had been bitten off repeatedly, hanging around my boat and having a good look at me. Then the mother and escort returned from a deep dive and collected the playful baby.

**Nikon N90s with 18mm lens; 1/200 sec at f5.6; Kodak E100VS; Nexus Master Housing.**

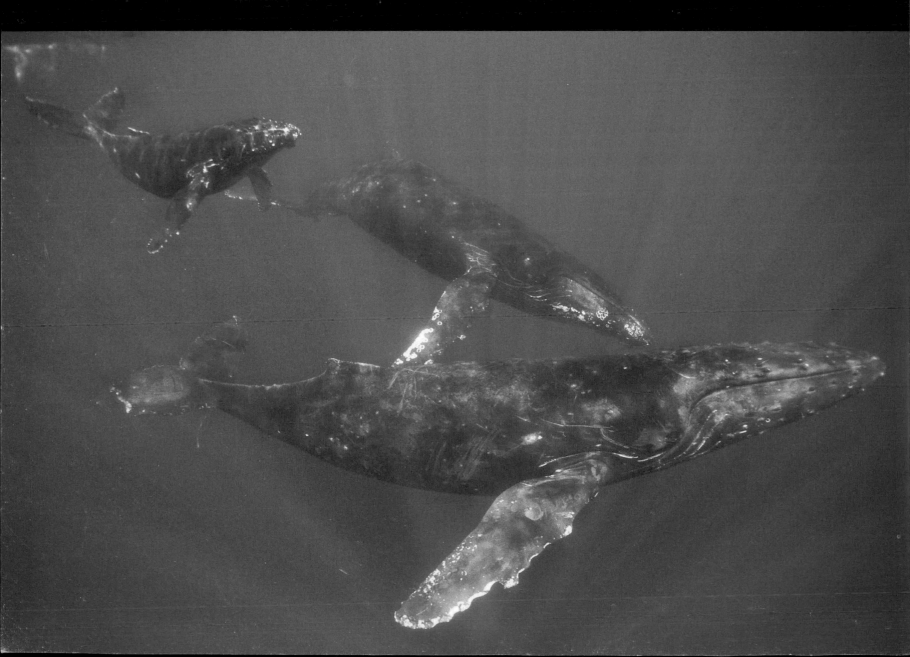

**Phillip Colla**
*USA*
HIGHLY COMMENDED

## BLUE WHALE MOTHER AND CALF

Blue whales are the largest animals ever to have lived: it's almost impossible to grasp just how big they are. An adult can grow to more than 30m, bigger in bulk than a herd of 30 African elephants, and a new-born calf is more than 7.5m long. Blue whales were hunted to near-extinction – more than 350,000 were killed before whaling was banned in the 1960s – and the current population is estimated at only 6,000. These two were among 30-40 blue whales migrating northwards in summer along the west coast of North America to feed in the rich, cold waters of northern California and Oregon.

**Nikon F5 with Nikon 300mm lens; 1/1500 sec at f/4; Kodak E200 with polarizer.**

# Animal Behaviour

## Mammals

These images are selected on their interest value as well as aesthetic appeal, showing familiar behaviour as well as little-seen interactions.

**WINNER**

**Tim Fitzharris**
*USA*

**NORTHERN ELEPHANT SEAL BULLS FIGHTING**
At Point Piedras Blancas, California, I watched and photographed an elephant seal colony for a couple of hours one morning. Suddenly, a fight erupted between two mighty males about 100m away from me in the big surf. I quickly moved closer and began shooting. The lighting and breaking waves were perfect. The bulls were incredibly violent with each other, though neither were seriously hurt after the 10-minute match.

**Canon EOS 3 with 500mm lens plus Canon Teleconverter 1.4X; 1/500 sec at f8; Fujichrome Provia RDPIII.**

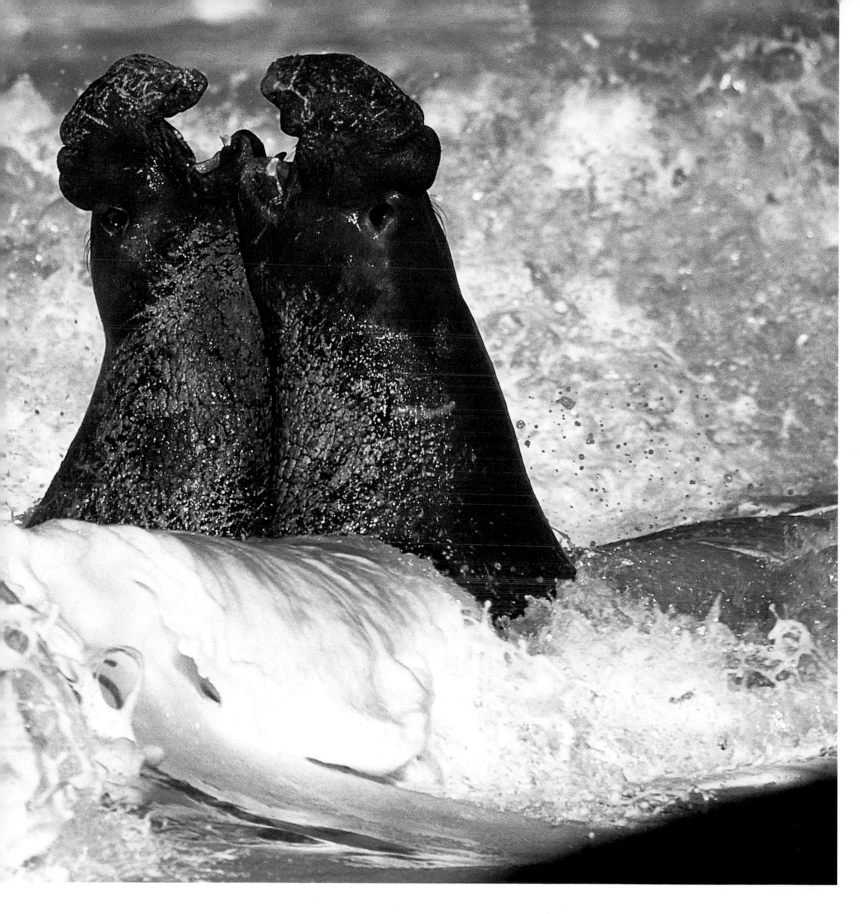

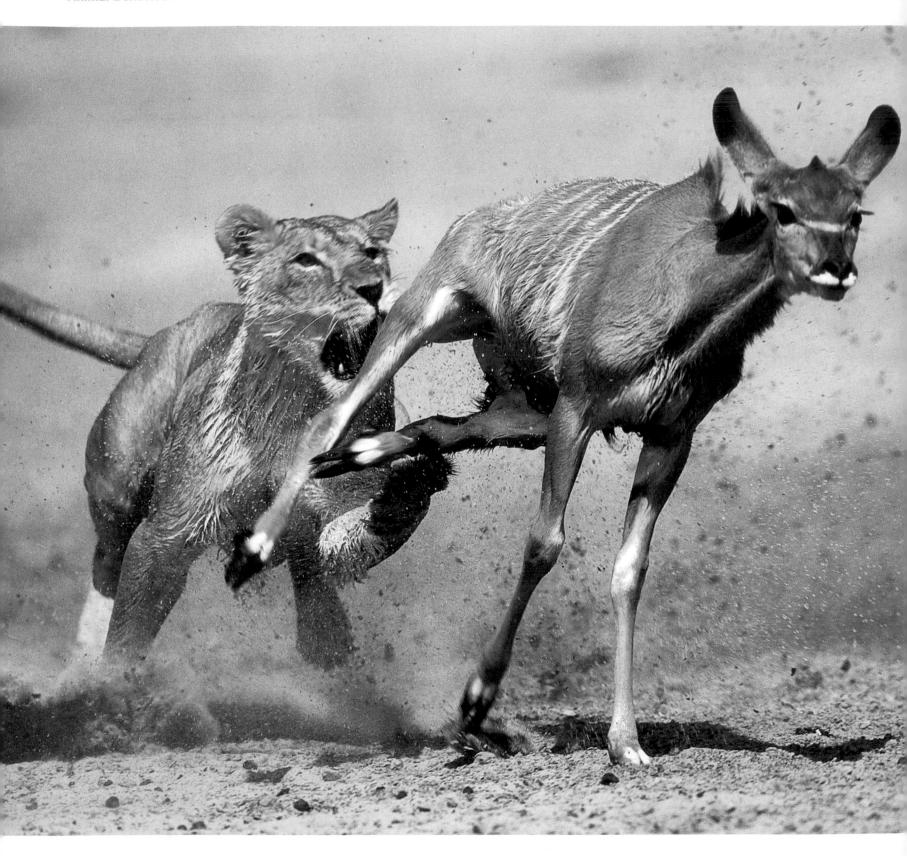

**RUNNER-UP**

**Martin Harvey**
*South Africa*

**LIONESS PULLING
DOWN A KUDU**
In August, there is precious little water in the Etosha National Park, Namibia. Animals are forced to congregate at the few remaining waterholes. This lioness would crouch behind rocks near the edge of the water and wait patiently. When plenty of zebra, gemsbok and eland had gathered to drink, she would burst out of her hiding place. After several failed attempts, the lioness finally managed to capture this sub-adult female greater kudu.

Canon EOS 1n with Canon 600mm lens; 1/500 sec; Fujichrome Velvia; beanbag.

**Joe McDonald**
*USA*
HIGHLY COMMENDED

**LION KILLING A BUFFALO**
January is a lean time for lions in the Masai Mara Game Reserve, Kenya, because the great herds of wildebeest and zebra have left the area in search of new grass. This old, male buffalo had separated from its herd and wandered to within 45 metres of seven male lions. The lions wasted no time moving in and took only 15 minutes to kill him. The climax of the drama was when one of the older lions held onto the huge animal's muzzle before pulling it down.

Canon EOS 3 with 100-400mm IS lens; 1/500 sec at f5.6; Ektachrome 100 VS.

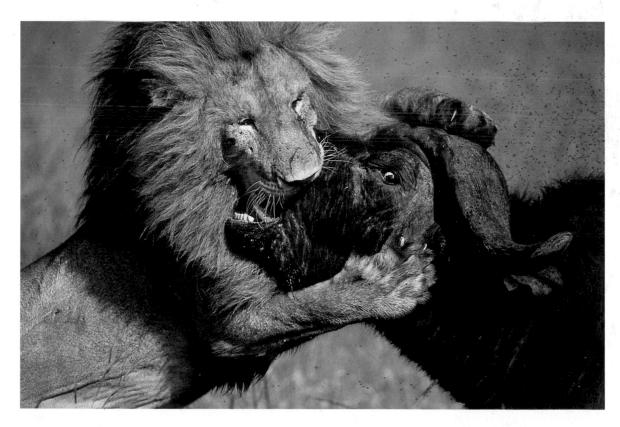

23

**Stephen Belcher**
*New Zealand*
HIGHLY COMMENDED

### HYENA WITH A KUDU FOETUS

At a waterhole in Etosha National Park, Namibia, I saw a female kudu in obvious distress lying beside the water. A pack of spotted hyenas moved rapidly towards her, and the largest female homed in and killed the antelope, keeping the rest of the pack at bay. For the next 45 minutes, she dragged the carcass through the waterhole to the opposite bank where she began tearing the body apart. When she ripped open the uterus, I was surprised to see her drag out a foetus, which she took away to savour alone. Only then did she let the pack eat the rest of the carcass.

Canon EOS 1N with 600mm lens plus 1.4x extender; 1/500 sec at f5.6; Fujichrome Provia 100 rated at 200; tripod inside vehicle.

**Florian Möllers**
*Germany*
HIGHLY COMMENDED

### BROWN BEAR AND FOX

In the Bavarian Forest National Park, Germany, there is an enclosure large enough for bears to live as naturally as possible. I watched a brown bear and her three cubs flush out a fox. The mother seemed surprised, probably because she wasn't used to live prey (deer meat is left out for the bears). She chased the fox to a lake and pushed it in. The fox fought back, but after 20 minutes, the bear killed it, breaking its spine with her powerful paw. Even though this occurred in an enclosure, it was one of the most dramatic scenes I have seen.

Canon EOS 3 with 500mm lens; 1/30 sec; Fujichrome Sensia 100; tripod; fill-in flash.

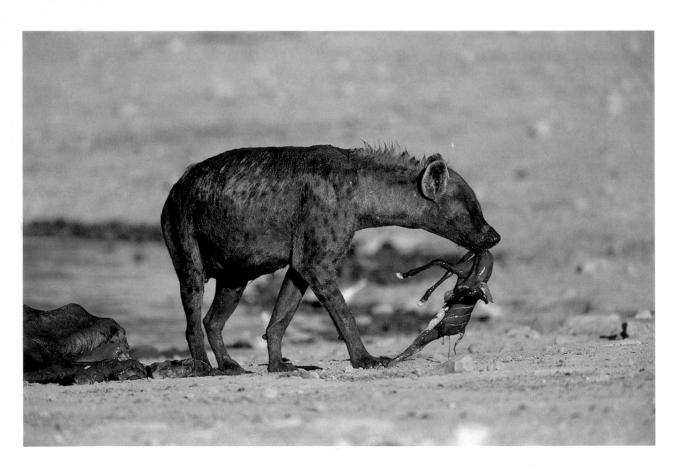

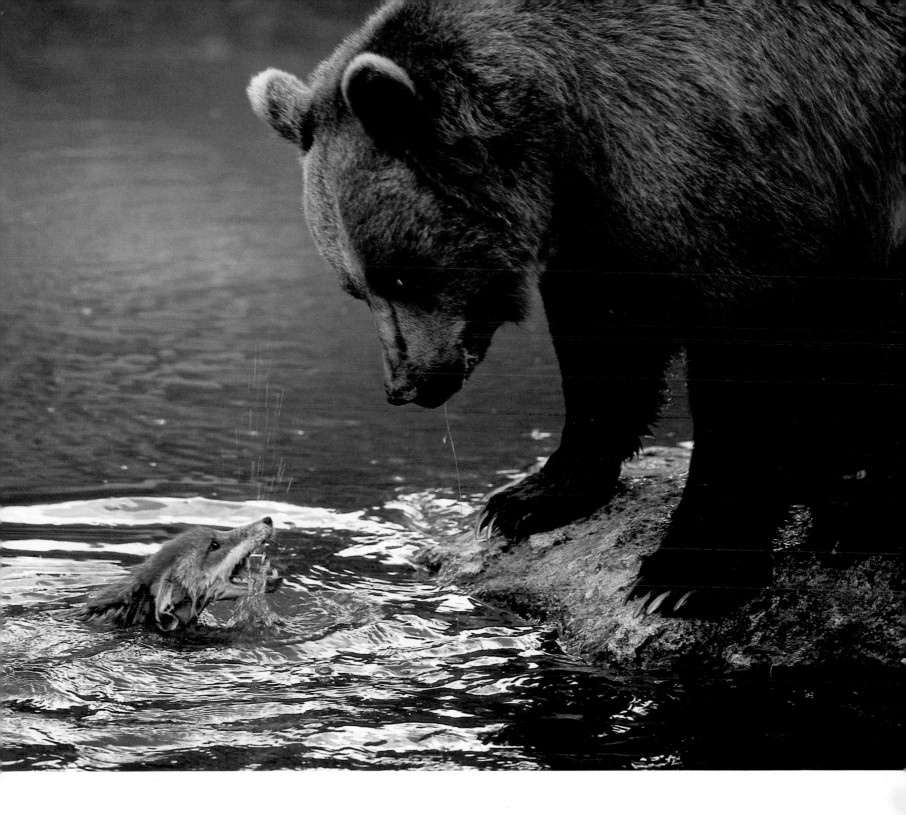

**Thomas Dressler**
*Germany*
HIGHLY COMMENDED

**YELLOW BABOON
YOUNGSTERS PLAYING**
Yellow baboons don't usually
let their babies wander too
far. So I was surprised to see
these two very young
baboons playing alone one
morning by the Luangwa
River in Zambia's South
Luangwa National Park. The
rest of the troop of 25 or so
yellow baboons were some
10m away, grooming and
foraging on the riverbank.
They were all extremely
relaxed. The two youngsters
seemed to be thoroughly
enjoying their new-found
liberty. They played quietly,
but the youngest would
squeak in protest if things
got too rough.
**Canon EOS 5 with 300mm lens
plus Canon EF 2x converter; f8;
Fujichrome Velvia; built-in car
tripod.**

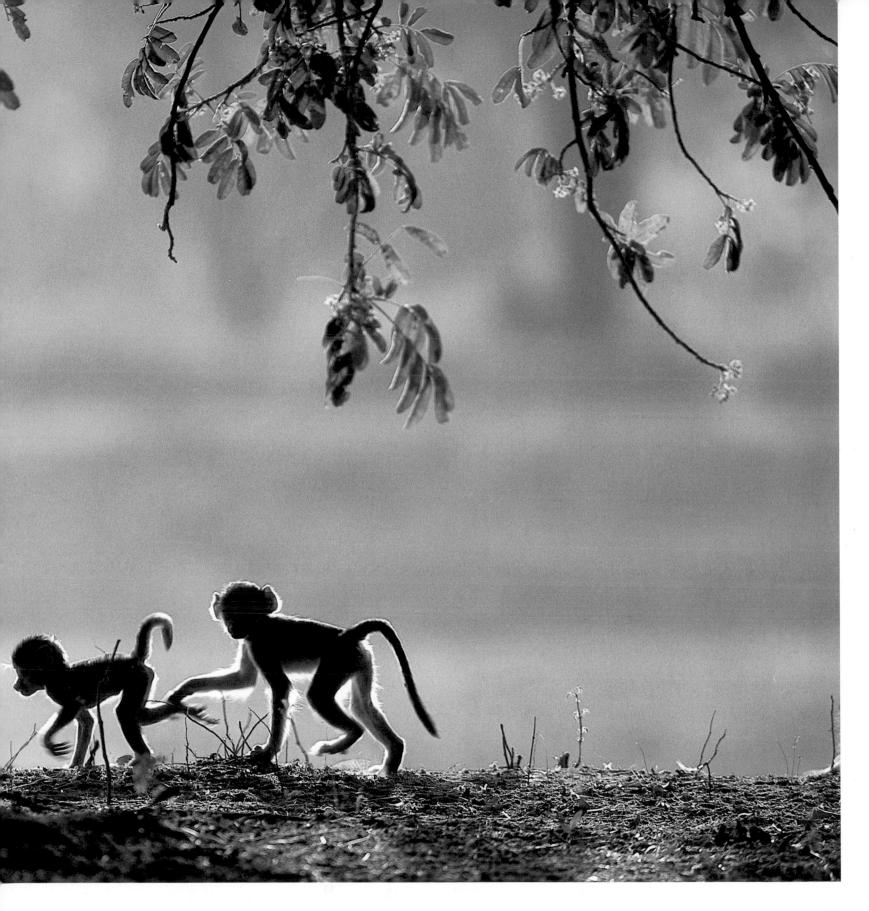

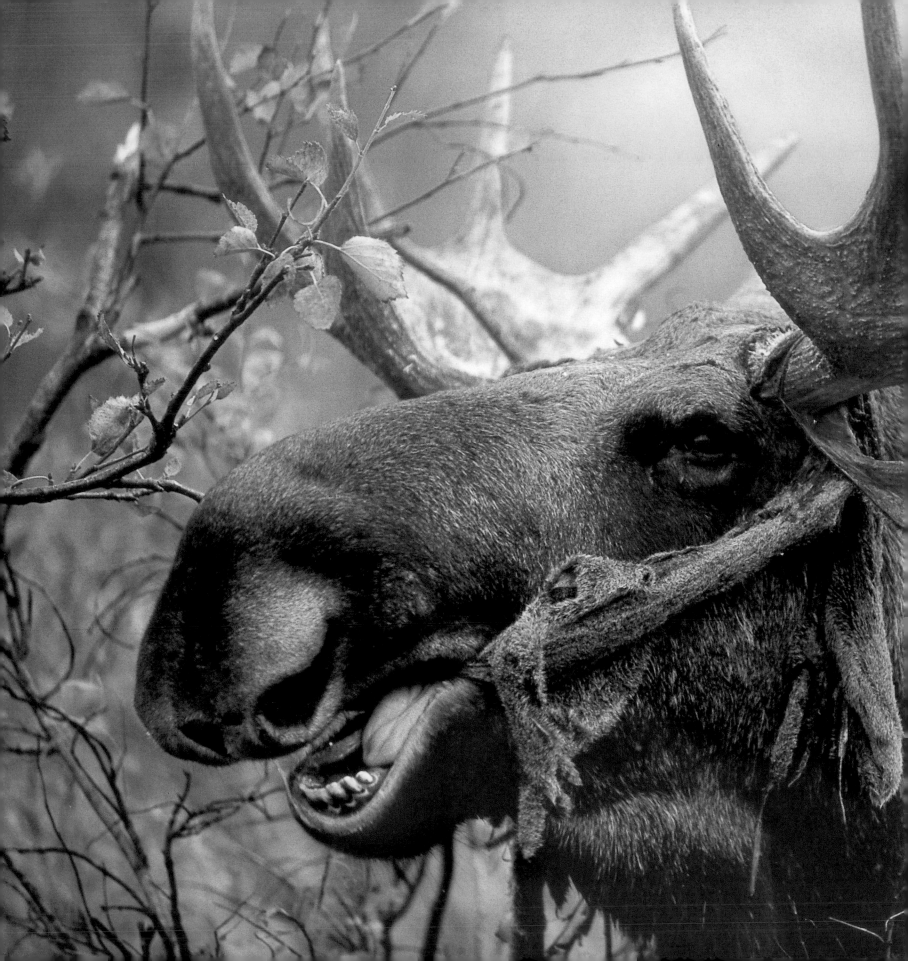

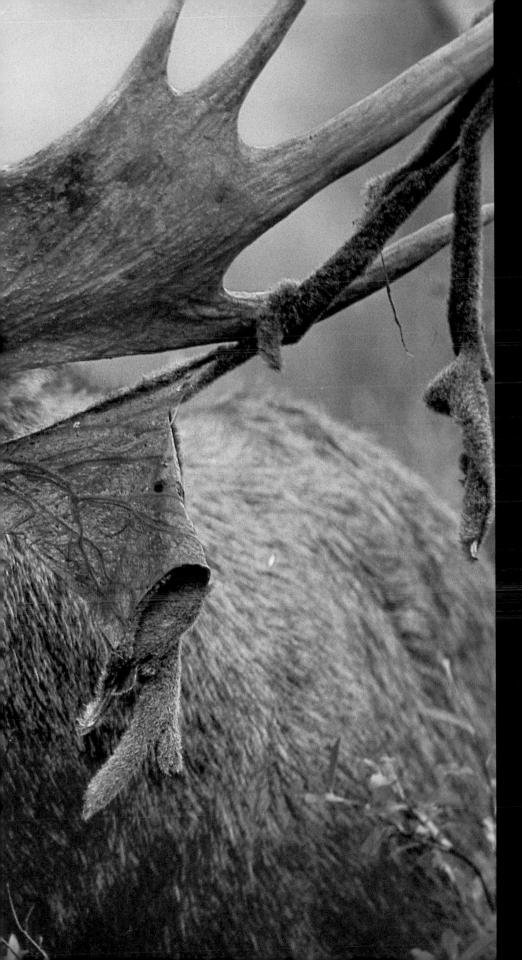

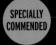

SPECIALLY
COMMENDED

### Staffan Widstrand
*Sweden*

### EUROPEAN MOOSE
### EATING ITS VELVET

The moose in the Sarek
National Park in Swedish
Lapland are used to people.
Moose-hunting has been
banned here for years, and
hundreds of nature-lovers
trek through the park each
year. This bull in the Rapa
Valley allowed me to get as
close to him as I wanted.
When I first saw him, his
antlers were still covered in
velvet. But a couple of hours
later, he began beating the
trees and bushes around him
with his antlers, tearing off
the protective, furry skin to
reveal a beautiful, brand-new
set of antlers, ready for this
year's rut. Some velvet was
dangling in his eyes, and so
the moose then chewed it off.

**Nikon F5 with AFS-Nikkor 600mm
lens; 1/250 sec at f8; Fujichrome
Astia; 100 rated at 200; tripod.**

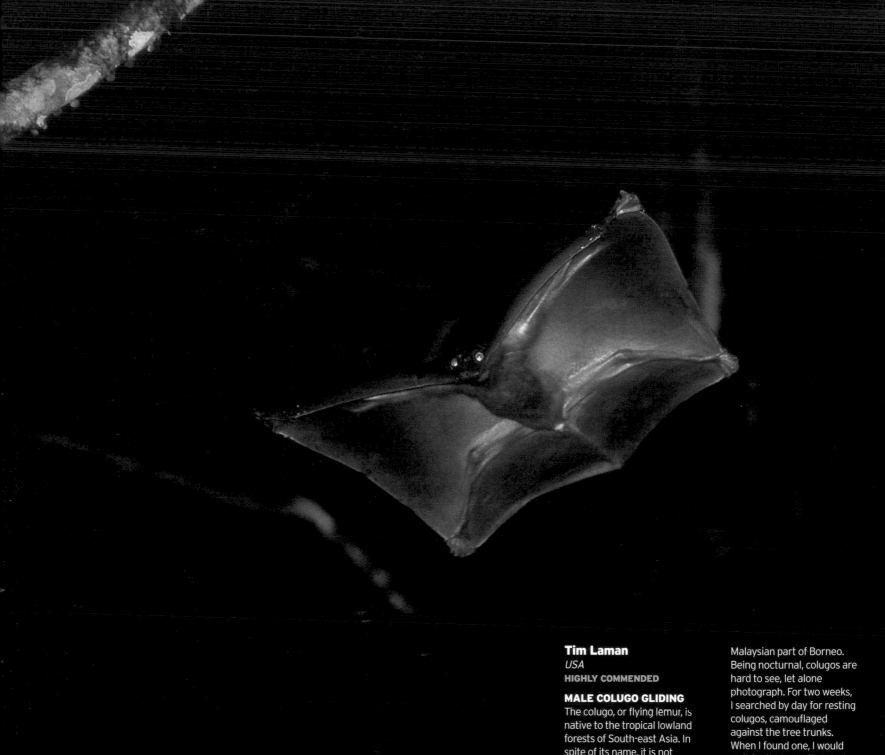

### Tim Laman
*USA*
**HIGHLY COMMENDED**

**MALE COLUGO GLIDING**
The colugo, or flying lemur, is native to the tropical lowland forests of South-east Asia. In spite of its name, it is not related to true lemurs, which are primates, but belongs to an order of its own, Dermoptera. It is the only known mammal glider with all forelimb and hindlimb digits enclosed within the membrane. I took this photograph in Sarawak, the Malaysian part of Borneo. Being nocturnal, colugos are hard to see, let alone photograph. For two weeks, I searched by day for resting colugos, camouflaged against the tree trunks. When I found one, I would wait for it to set off at dusk, gliding from tree to tree in search of fruit and leaves to eat. I followed as best I could, camera in hand.

**Canon EOS 1nRS with 70-200mm lens plus 1.4x extender; flash exposure at 1/250 sec; Fujichrome Provia 100 rated at 200.**

**David Hall**
*USA*
**HIGHLY COMMENDED**

**SEALION PLAYING WITH A CUSHION-STAR**
Sealions are famously playful creatures. I was photographing starfish in the Galapagos when this young sealion appeared. She gently picked up a Panamic cushion-star in her jaws, turned to show it to me, and then began a series of graceful somersaults and other stunts right in front of my camera. It was a fast-moving performance, but I was lucky – I had the right lens on, plenty of film in the camera and a cooperative subject. When she had finished, the sealion released the starfish, glanced at me one more time (as if waiting for applause), then swam away.

**Nikonos RS with 18mm lens; 1/125 sec at f5.6; Fujichrome Provia 100 with two underwater strobes.**

**Jean-Pierre Zwaenepoel**
*Belgium*
HIGHLY COMMENDED

**YOUNG HANUMAN LANGURS PLAYING**
The word 'Hanuman' in Hindi means 'having a long tail', and these young Hanuman langurs near Jodhpur in Rajasthan, India, were certainly making the most of that identity tag. I watched in delight as the junior members of the troop played 'tug-of-war'. The games would start after the morning's feeding was over. One youngster would initiate play by teasing and chasing another, then others would join in. Within moments, there would be nothing but a furry scrum of arms, legs . . . and those long, thin tails.

Nikon F-100 with 500mm lens; f4; Fujichrome Sensia II; tripod.

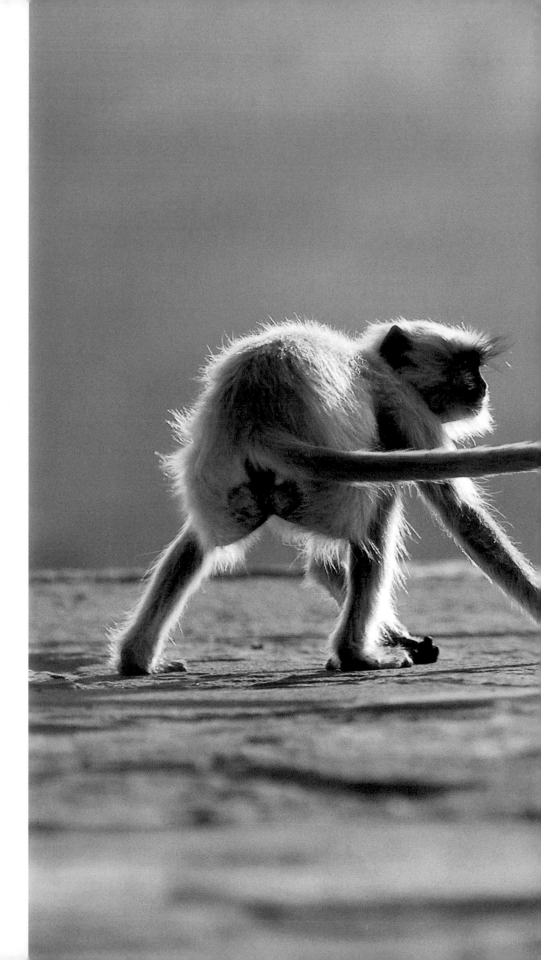

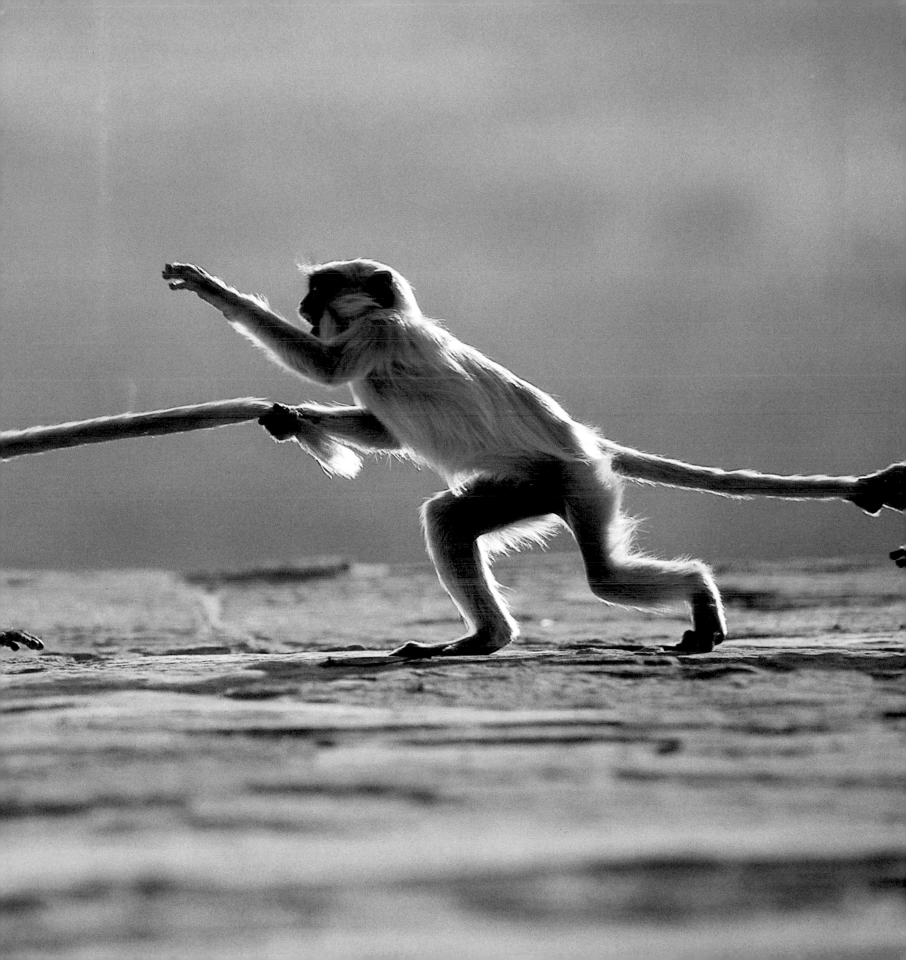

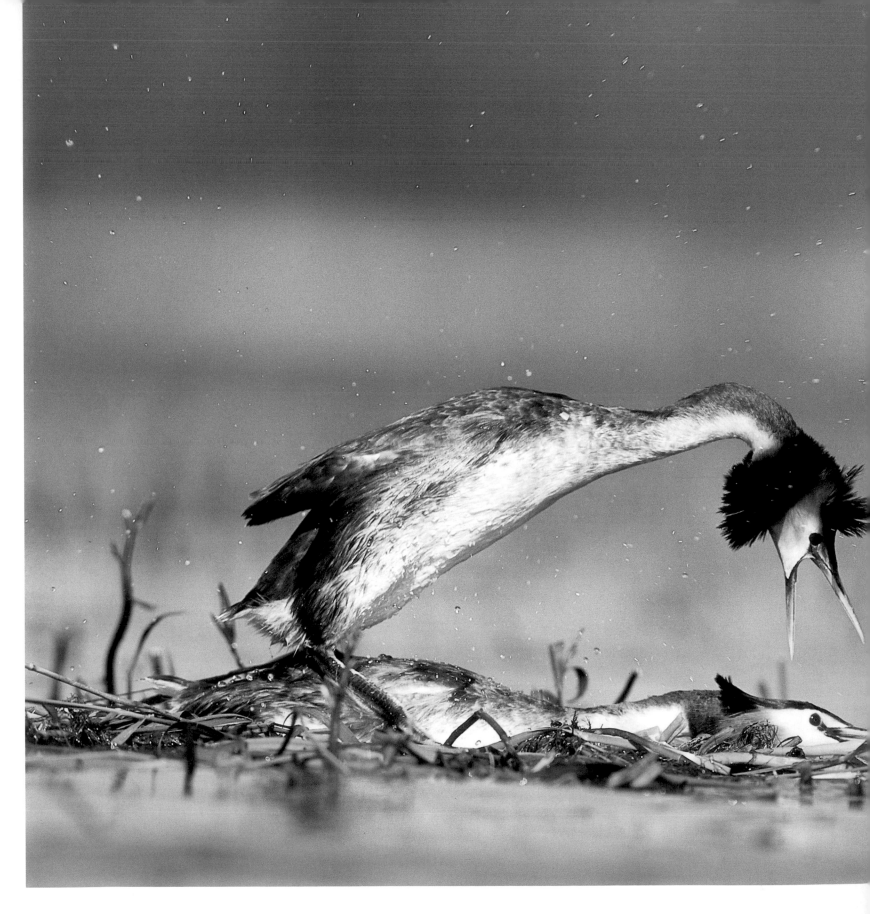

# Animal Behaviour

## Birds

These pictures can't just be record shots or beautiful images – they must have interest value as well as aesthetic appeal.

**WINNER**

**Louis-Marie Préau**
*France*

**GREAT-CRESTED GREBES MATING**
In April, about 15 great-crested grebes gathered on a huge, shallow, temporary lake that formed on one of the numerous flood plains in the Angers region of France. I got up at 5.30am, waded slowly into the water and settled into a floating hide to wait for daybreak. For the next 12 hours, I watched grebes performing their famous courtship dances. They were almost frantic, strutting in front of each other and dashing across the water, then head-shaking and treading water to rise up together, their beaks and bellies touching. Some pairs finally scrambled on to temporary, floating heaps of soggy weeds to mate.

**Nikon F90X with Nikon 500mm AIP lens; 1/800 sec at f5.6; Fujichrome Provia 100F.**

RUNNER-UP

**Norbert Wu**
*USA*

**EMPEROR PENGUINS**
Comical and awkward on land,
emperor penguins turn into
high-speed rockets when they
swim, shooting through the
water at up to 3.4m a second.
They travel in small groups as
a defence against predators
such as leopard seals. When
hunting, they dive to depths
of 600m for up to 20 minutes
at a time, searching for squid
and crustaceans. While
filming in Antarctica, I glanced
up at a V-shaped contour in
the ice-edge just as this group
whizzed by.

Nikonos V amphibious camera with
UW Nikkor 15mm lens; perhaps
1/125 sec at f11; Fujichrome Velvia
(RVP) rated at 100.

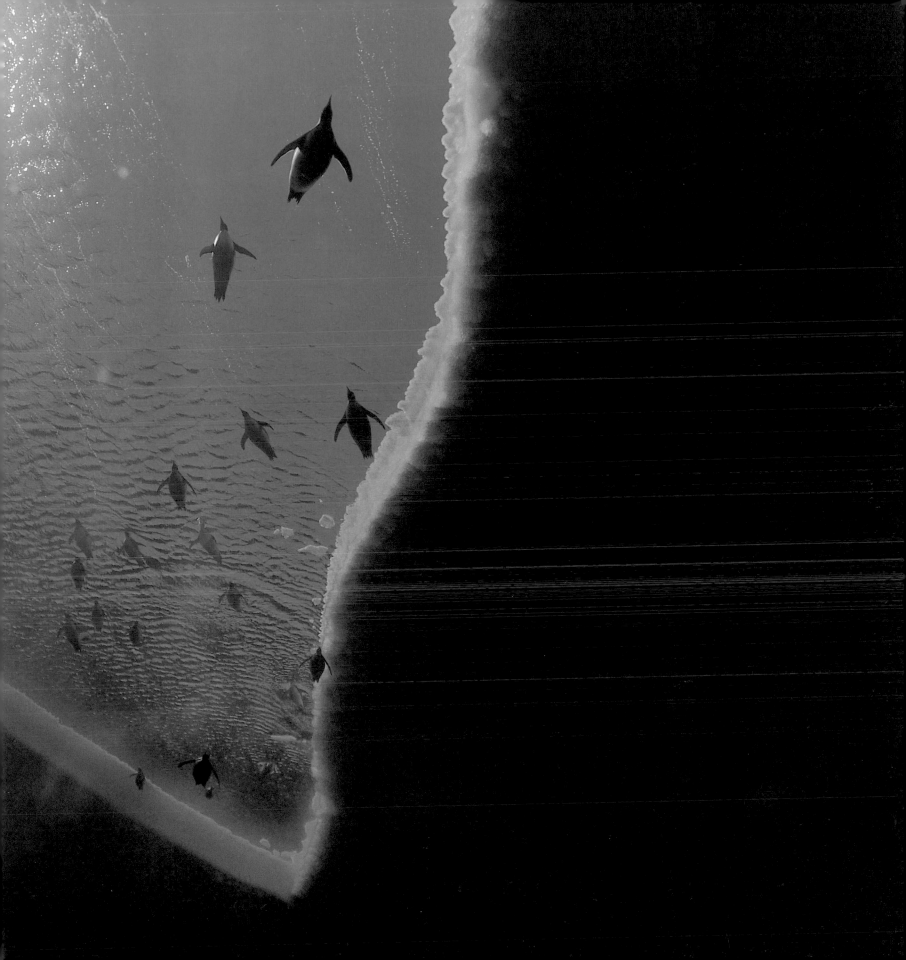

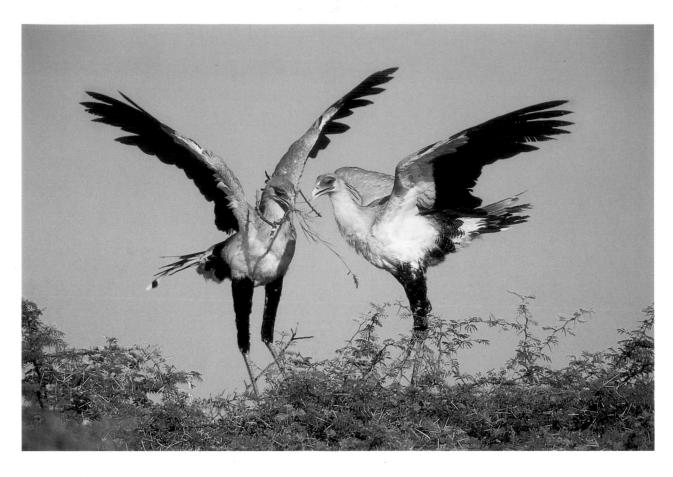

### Florian Schulz
*Germany*
**HIGHLY COMMENDED**

### SECRETARY BIRDS BUILDING THEIR NEST

On early morning drives in the Etosha National Park, northern Namibia, we often saw the same pair of secretary birds hunting side-by-side in the grasslands, searching for insects and snakes to eat. One morning, though, we realised that the birds weren't hunting: they were gathering small twigs and leaves. As soon as they had a beakful each, they flew up together to the crown of a nearby thorn-tree, the thin branches bending under their weight. Then, with wings outstretched for balance, they bounced slowly up and down, dancing gracefully around one another as they wove their nest.

**Nikon F5 with 500mm lens, plus 1.4 teleconverter; 1/250 sec at f5.6; Fujichrome Velvia; tripod.**

### Rafik Khalil & Dina Aly
*Egypt*
**HIGHLY COMMENDED**

### CROWNED SANDGROUSE CHICK DRINKING FROM ITS FATHER'S FEATHERS

The nearest water to this wadi (dry riverbed) near Gebel El-Shaib Mountain, in Egypt's Eastern Desert, was some six kilometres away. Sandgrouse chicks can't fly, and so the adult males go to fetch water. While the female stays nearby to guard the chicks, the male flies to the nearest waterhole. After quenching his own thirst, he then crouches down to soak his belly in water. Sandgrouse feathers are specially adapted to hold water, with a fine bed of hairs that stand erect when wet. When their father returns, the thirsty chicks push under his body and suck water from his sponge-like belly feathers.

**Nikon F4 with 600mm lens; plus 1.4 teleconverter; 1/125 sec at f11; Fujichrome Sensia 100; beanbag.**

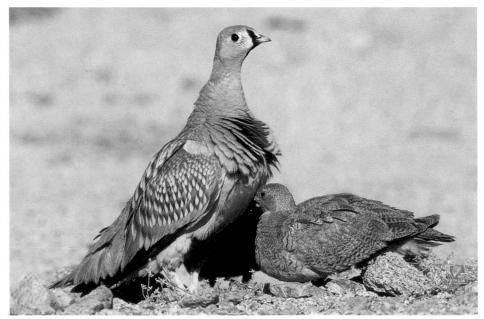

**Karen Ward**
*USA*
HIGHLY COMMENDED

**FAIRY TERNS MOBBING
A BLACK KITE**
While on Midway Island,
Hawaii, I saw these fairy terns
mobbing a black kite close to
their nesting site. The female
fairy tern does not build a
nest but instead balances her
single egg any place that
pleases her. We could see
eggs placed in hundreds of
hidden spots, including bare
branches, swaying palm
fronds and rocks. The raptor
was not interested in the eggs.
After 20 minutes of watching
the kite, we saw it dive into a
crowd of fairy terns and
return with one in its talons. It
did a repeat performance half
an hour later.

Nikon N90 with 80-200mm zoom
lens; 1/60 sec at f5.6; Fujichrome
Provia 100.

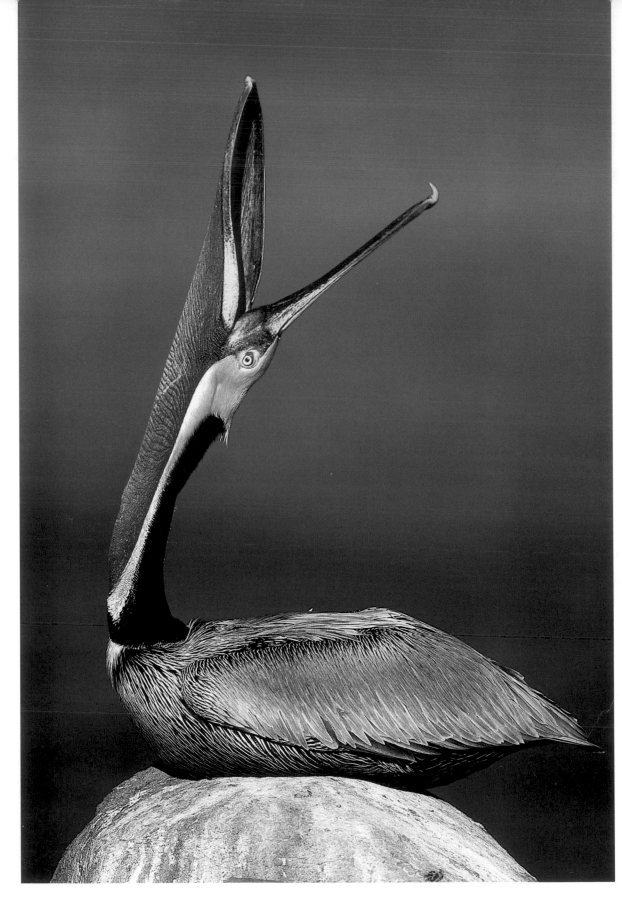

**Arthur Morris**
*USA*
HIGHLY COMMENDED

**BROWN PELICAN**
Head-throwing is thought to be a form of communication among brown pelicans. But this individual must have been talking to itself, as there were no other pelicans on the cliffs that day at La Jolla, California. In breeding plumage, only the endangered Californian race of brown pelican features the scarlet bill pouch.

Canon EOS 1n with EF 600mm lens; 1/2000 sec at f4; Fujichrome Velvia rated at 100.

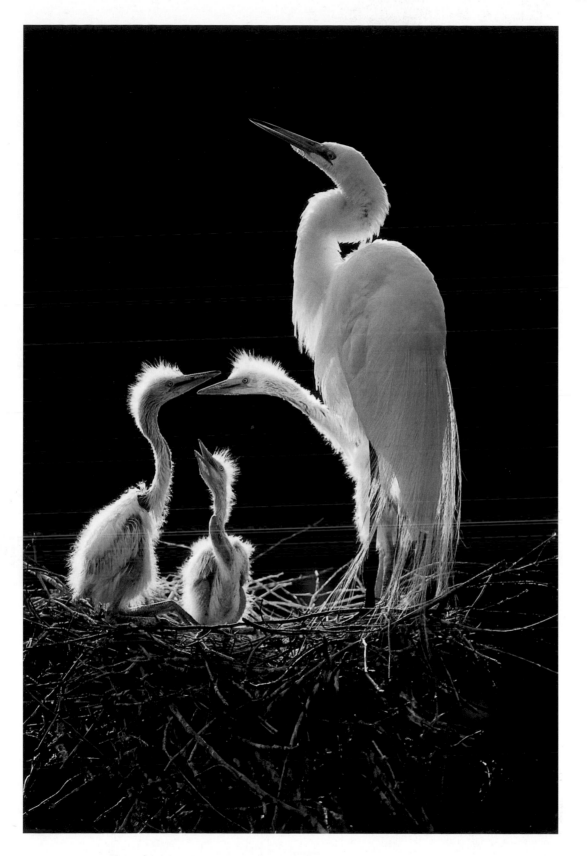

**David M Macri**
*USA*
HIGHLY COMMENDED

**GREAT EGRET FAMILY**
Over some weeks, I watched a pair of great egrets court, build their nest and peacefully incubate their eggs in a coastal swamp in St Augustine, Florida, USA. Once the chicks were born, though, family life turned violent. The chicks were extremely aggressive, both towards each other and towards their parents. They would grab the adults' beaks to get them to regurgitate fish, then the bigger chicks would peck at the smallest chick and steal its share of food. I doubt the youngest chick survived – if it didn't get knocked right out of the nest, it would soon have died of hunger.

**Nikon F5 with AF-S Nikkor 600mm lens; 1/1000 sec at f4; Fujichrome Velvia rated at 40; tripod.**

**David Tipling**
*UK*
HIGHLY COMMENDED

**OSPREY WITH A TROUT**
By waiting in a specially
constructed hide at water
level from dawn till dusk, I
hoped to photograph ospreys
on a fish farm in southern
Finland. Diving into the water
and flying off with a catch
took the ospreys an average
of just three or four seconds,
and so I needed to be quick to
photograph them leaving the
water. The wind had to be in
the right direction for an
osprey to fly towards the hide
with its catch. On the day I
took this photograph, the
wind was good, but the light
was poor. I turned this to my
advantage by using a slow
shutter speed to accentuate
the feeling of movement
and power.

Nikon F5 with 300mm lens;
1/30 sec at f8; Fujichrome Velvia;
two beanbags.

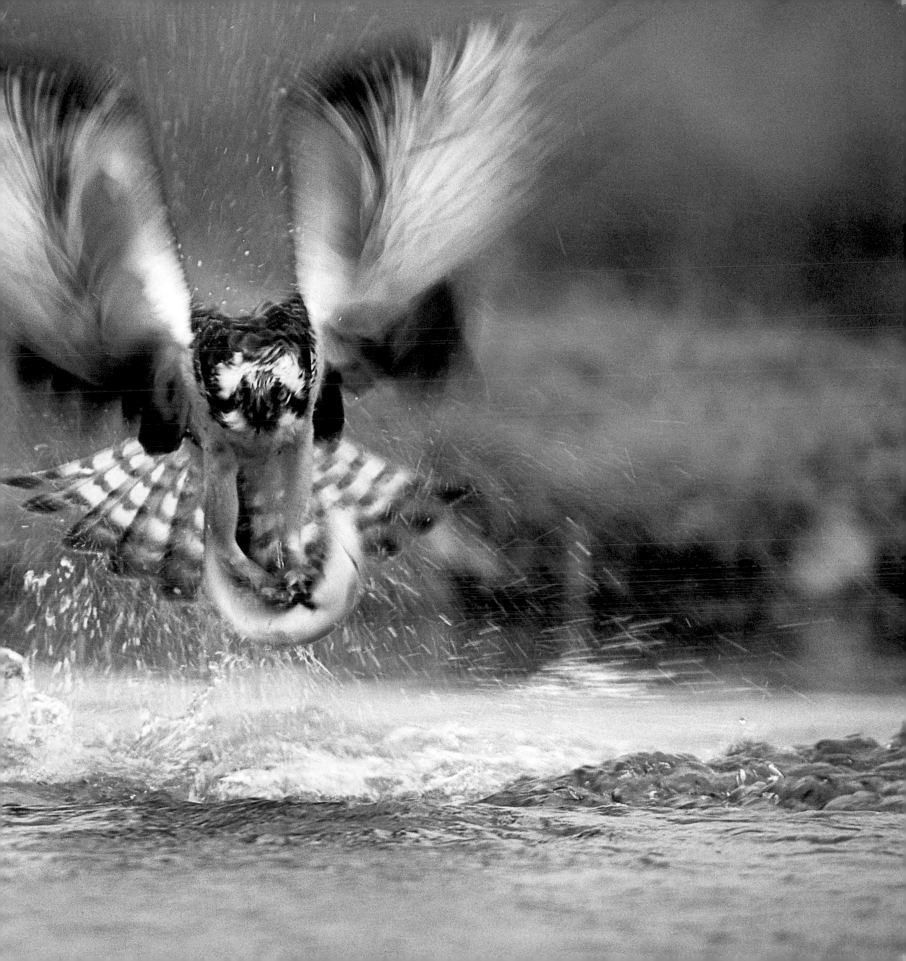

**Kármán Balázs and
Novák László**
*Hungary*
**HIGHLY COMMENDED**

**KINGFISHER FEEDING**
Appearances can be deceptive
– all was not brightness and
light for the kingfishers at this
creek. Harsh Hungarian
winters mean that some
roosting birds may freeze in
temperatures below -15°C. We
set a 'photo trap' for the
kingfishers in a frost-free area
of the creek by throwing in
food, and continued to feed
them until spring, when the
ice melted.

**Canon EOS RT with EF-L 300mm
lens; 1/125 sec at f6.7; Fujichrome
Velvia rated at 40; four Canon EZ
540 flashes; self-made photo-
electronic barrier.**

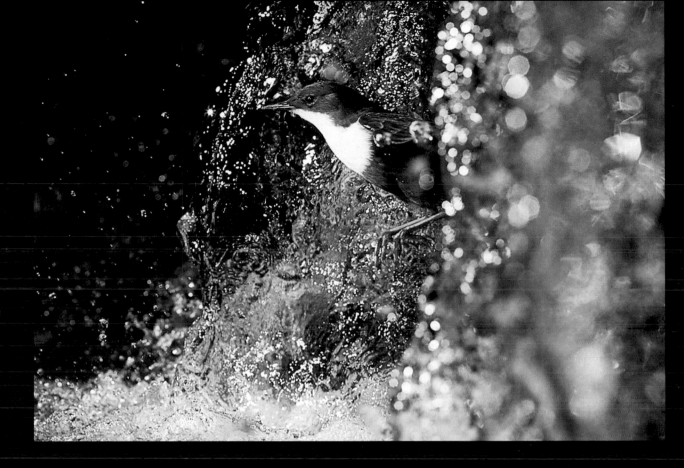

## Kármán Balázs and Novák László
*Hungary*
HIGHLY COMMENDED

### DIPPER FLYING THROUGH A WATERFALL

Dippers are wonderfully aquatic birds, plunging into fast-flowing water to stride along riverbeds in search of invertebrates. They are found throughout much of Europe but are rare in Hungary. They build large, globular nests in crevices under bridges, banks and – we waited 10 years to record it – behind small waterfalls. In spite of the challenge of splashing droplets, we managed to photograph a bird flying through the water curtain.

Canon EOS RT with EF Macro 100mm lens; 1/125 sec at f6.7; Fujichrome Velvia rated at 40; three Canon EZ 540 flashes and cable remote-control.

## Klaus Dierkes
*Germany*
HIGHLY COMMENDED

### RED-THROATED DIVER

Red-throated divers are one of the most northerly breeding birds, some nesting only 800km from the North Pole. They often nest on very small lakes that hold very little food. This means they have to fly to larger lakes or the sea to fetch small fish for their chicks. On this lake in Sweden, I photographed the birds as they flew to and fro throughout the day, but the very early morning light, together with a long exposure, gave me the best results.

Canon EOS 3 with EF 500mm lens; 1/30 sec at f4.5; Fujichrome Sensia 100; tripod.

45

**Thomas Wiemer**
*Germany*
**HIGHLY COMMENDED**

**BROWN PELICAN
'PLAYING'**
In a bird park in Walsrode near my home in Germany, there are brown pelicans living free on the lake. I'm used to seeing them feeding peacefully or paddling sedately through the water. One day, they were a great deal livelier than normal. Some were chasing each other through the water, creating fountains of spray. Others were entertaining themselves by taking off, then diving down to snatch a twig or a stick floating on the surface. They would then drop the sticks back into the water, before swooping down to scoop them up again. I could have sworn they were playing.

**Minolta Dynax 9 with 300mm Apo
G lens; 1/30 sec at f5.6; Fujichrome
Provia 100; flash.**

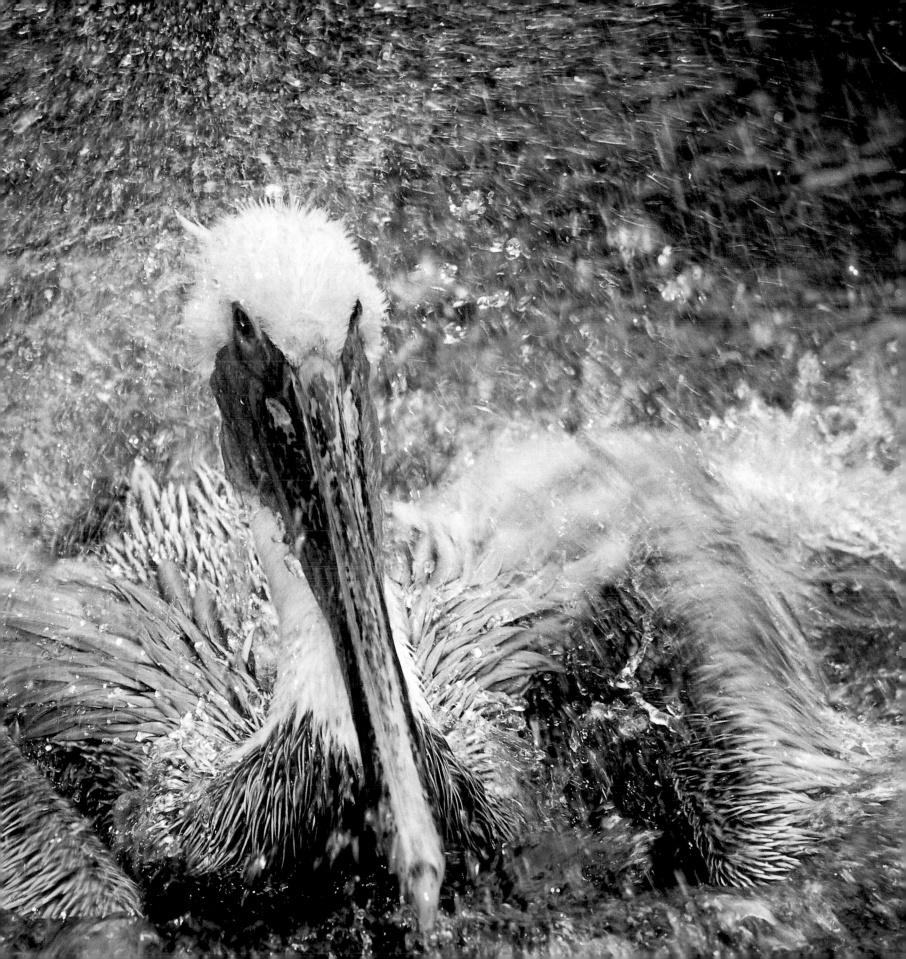

# Animal Behaviour

## Other Animals

This category offers plenty of scope for interesting pictures, as some of the least-known animal behaviour is on a macroscopic level or takes place under water.

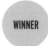

**WINNER**

**Christian Ziegler**
*Germany*

**ARMY ANTS CREATING A NEST WALL WITH THEIR BODIES**
Army ants, found in Central and South America, have nomadic lifestyles. Unlike other ants, which make nests in cavities or build their own structures, these ants form a temporary nest above ground by linking their bodies together. They dismantle and move on after a day of foraging at a particular spot, reassembling themselves at a new site. This colony of up to 300,000 army ants *Eciton hamatum* on Barro Colorado Island, Panama, was in the process of building its nest. To construct the walls, the ants hooked feet with each other, creating a thin curtain, which quickly thickened to create a solid wall of interlocked ants. Within the living nest, the brood is protected and kept at an optimum temperature.

**Canon EOS 3 with 100mm macro lens; 1/30 sec at f8; Fujichrome Velvia; three flashes.**

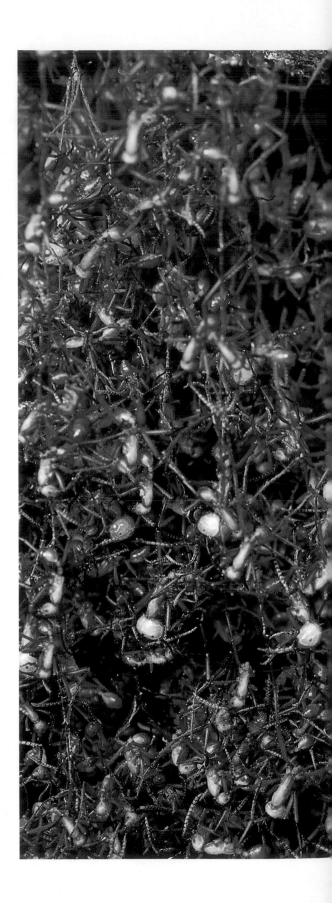

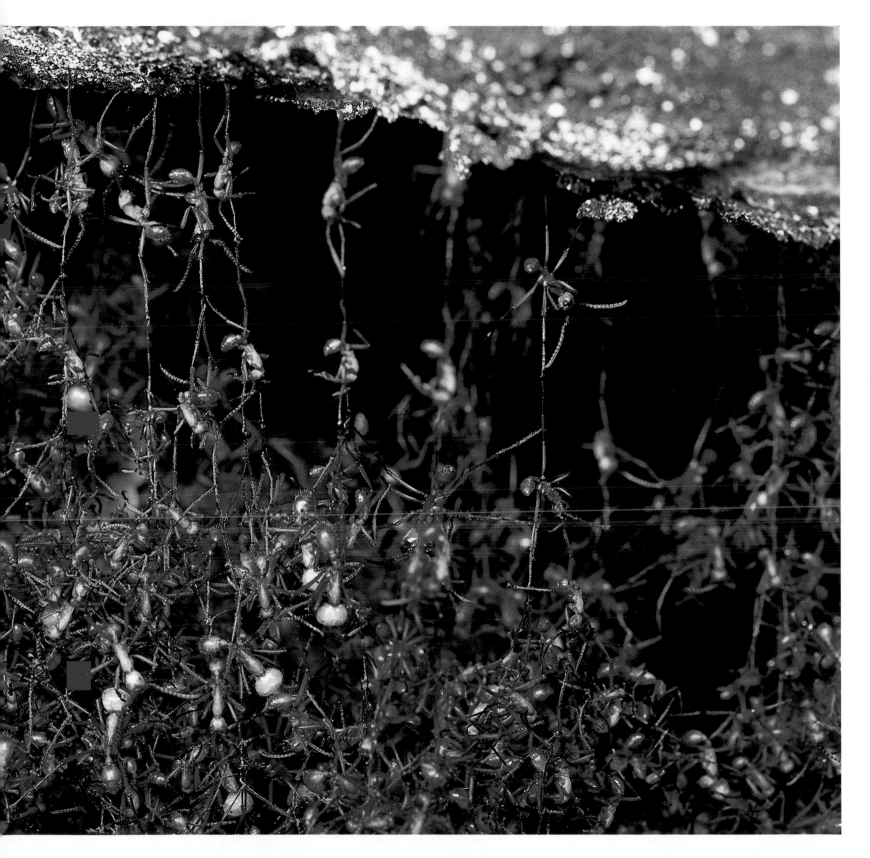

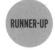
**RUNNER-UP**

**Mark Payne-Gill**
*UK*

**GIANT BULLFROG RESCUING HIS TADPOLES**
Schools of giant bullfrog tadpoles tend to concentrate in shallow, warm water, even though rapid evaporation puts them at risk of becoming stranded from the main pond and consequently dying from desiccation. Able to detect his offspring's distress, this male in South Africa began digging a 30cm canal in temperatures of 35°C through thick, clay mud. Such was the apparent strength of the bond between him and his tadpoles, he even leaped a metre out of the water, jaws agape, to 'attack' me when I got too close to his charges. Five hours later, with little water left, the dam finally burst, and more than a thousand tadpoles vigorously swam to freedom.

**Olympus OM2n with 100mm lens; 1/250 sec at f8; Fujichrome Provia 100.**

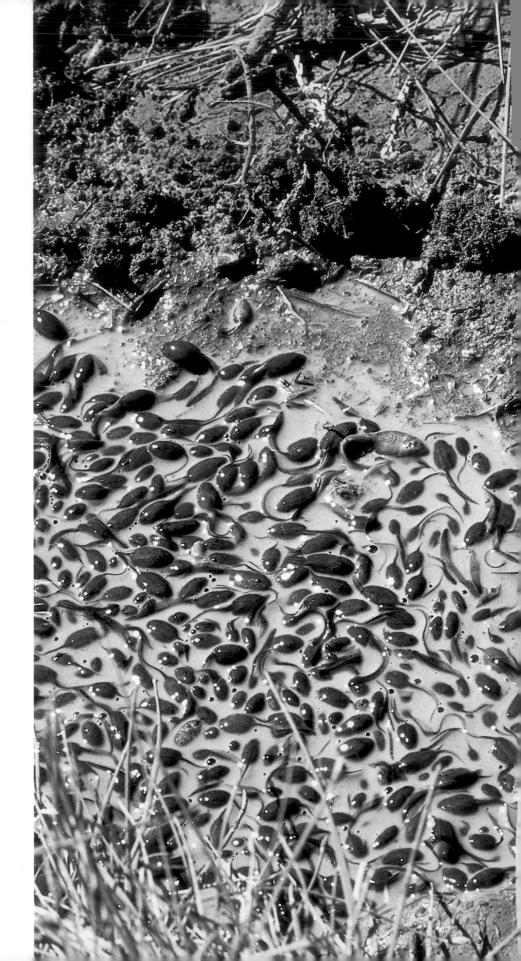

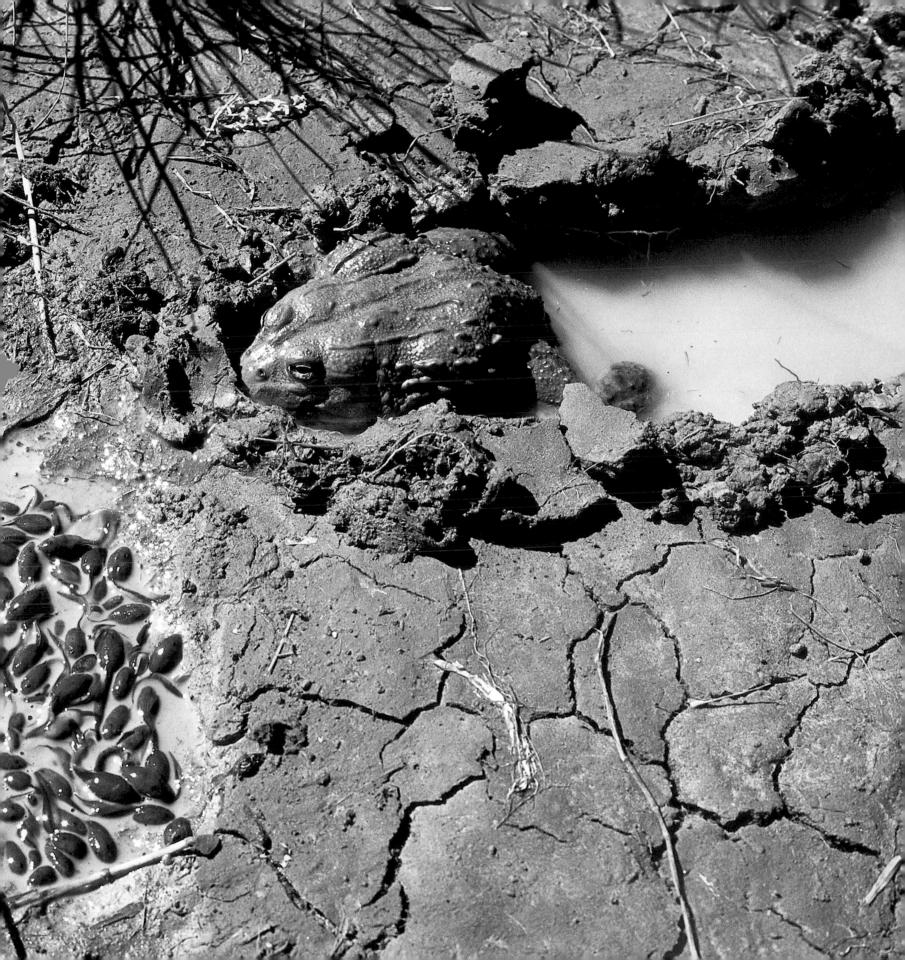

## Bartomeu Borrell Casals
*Spain*
**HIGHLY COMMENDED**

### BEE BUILDING ITS NEST IN A SNAILSHELL

In a warm, sheltered, rocky corner in my home town, near Barcelona, Spain, I saw this solitary bee (*Anthidium* sp.) flying busily in and out of an empty snailshell. She was filling the shell with tiny pebbles and resin from a nearby pine tree, presumably to line her nest. Often, she landed right in the shell and disappeared before I could take a photograph. Inside, she would work for several minutes at a time, sometimes causing the shell to move as she buzzed her wings.

**Canon T90 with Canon 100mm macro lens; 1/250 sec at f22; Fujichrome Provia 100; two flashes; beanbag.**

## Willem Kolvoort
*The Netherlands*
**HIGHLY COMMENDED**

### MATING DAMSELFLIES

While snorkelling in a river in North-east Poland, I saw this female red-eyed damselfly lay her eggs on the stem of a yellow water-lily. The current pulled the stem and both damselflies so far underwater that I was able to photograph them reflected against the water surface. Damselflies mate in mid-air, the male clasping the female behind her neck. She curves her body round to collect the sperm he has transferred from the tip of his tail to where his thorax meets his abdomen. The pair then continue in tandem to the water surface to lay the eggs, the male still grasping the female to prevent other males approaching her.

**XGM with 28mm and three diopter lenses; 1/60 sec at f8; Fujichrome Sensia 2; self-made UW housing with domeport.**

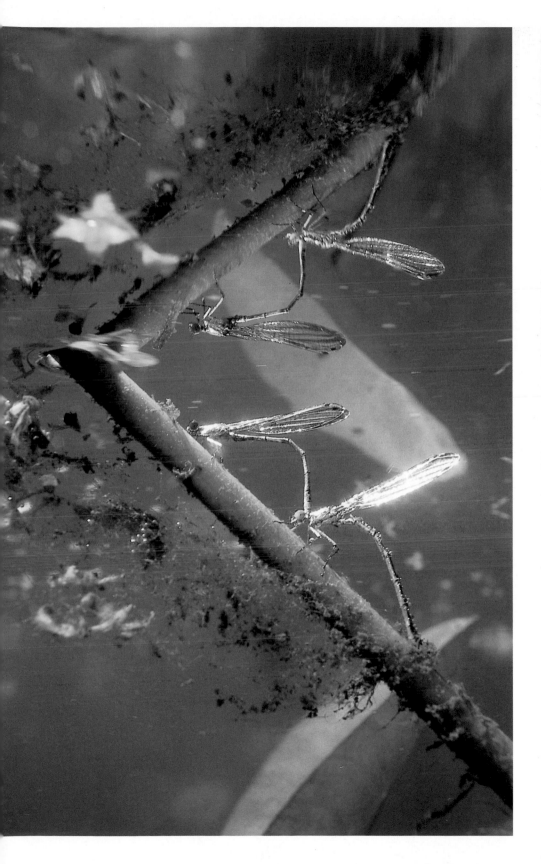

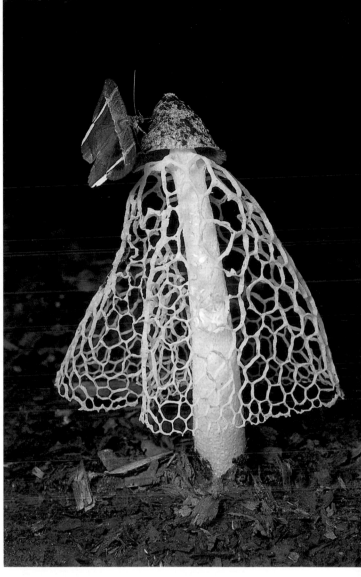

**Kevin Schafer**
*USA*
**HIGHLY COMMENDED**

**MOTH FEEDING ON STINKHORN FUNGUS**
This lacy stinkhorn fungus produces an appealing fragrance to lure insects, which help spread its spores. One evening, I found this unusual, 15cm high specimen on the forest floor in the Sandoval Nature Reserve, near Puerto Maldonado, in South-east Peru (upper Amazon region). I lay on the ground and photographed an endless parade of moths, flying beetles and other insects feeding on the dark, gooey spore coating on the fungus's cap. By morning, the feast was over. The fungus had withered away, and all that remained was a sticky puddle.

**Nikon F100 with 60mm macro lens; 1/250 sec at f16; Fujichrome Velvia; flash.**

# The Underwater World

These photographs can show marine or freshwater animals or plants. Though aesthetic criteria come first, interest value is also important.

WINNER

**Norbert Wu**
*USA*

**WEDDELL SEALS**
The eerie underwater whistles, trills and chirps of Weddell seals filled my ears while I was diving in the Antarctic. These are the only seals that can live in deep Antarctica all year round. When the sea freezes over, they use their strong, angled incisors to carve out breathing holes. The adults in McMurdo Sound were not bothered by my presence, though they wouldn't allow me to swim too close. This pup, though, was very curious. It grabbed hold of my mask and camera while its mother, floating beneath their breathing hole, kept a watchful eye on us.

**Nikonos V amphibious camera UW Nikkor with 15mm lens; probably 1/125 sec at f4; Fujichrome Provia (RDPII) 100; strobe.**

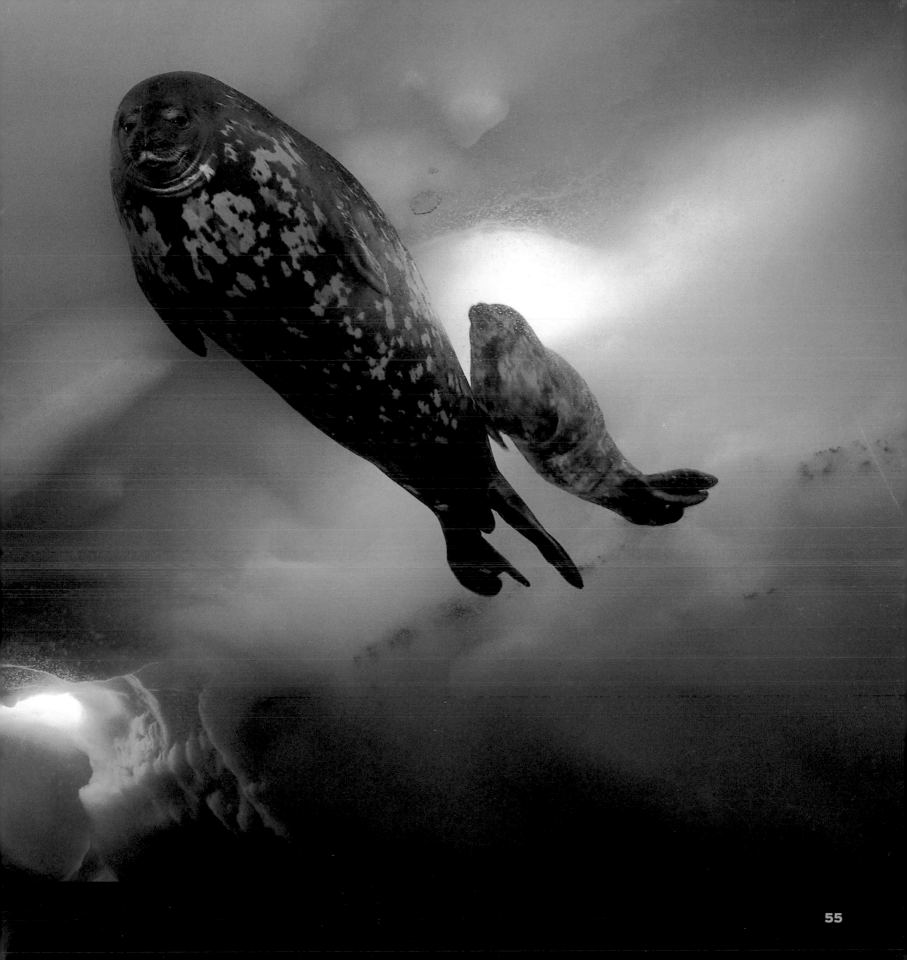

**RUNNER-UP**

**Nick de Voys**
*UK*

**ARROW CRAB
SHELTERING IN
A VASE SPONGE**

By placing the wall of this
azure vase sponge between
the light and the camera lens,
I experimented with the
effects of varying light levels.
The sponge, in the waters
around the Caribbean island
of San Andrés, exhibited a
dazzling array of blues,
intense reds and oranges. Its
intricate internal structure
seemed like something from a
science-fiction film. With the
alien-looking yellowline arrow
crab sheltering inside, the
sense of 'other worldliness'
was complete. It wasn't until
later that I noticed that the
crab seems to be preparing to
attack a small fish in the
corner of the image.

**Nikon F5 Manual Exposure, Matrix
metering, with 105mm AFD Micro
Nikkor lens; 1/250 sec at f32;
Fujichrome Velvia; Aquatica A5
housing; two strobes.**

**Tobias Bernhard**
*Germany*
**HIGHLY COMMENDED**

**BANDED SEA KRAIT**
There must have been
hundreds of sea kraits on this
reef off the island of Niue, in
the South Pacific, probing for
small fish among the coral.
Every 10 minutes or so, they
would meander up to breathe
at the surface. It was like
watching a living, undulating
curtain constantly rising and
falling. Sea krait venom is
deadly, but they are docile
creatures, and these ones
were totally unfazed by our
presence. Sometimes they
even swam through the hoses
of our diving equipment or
the camera cables. This one
had made a detour from its
vertical path to take a closer
look at me.

**Nikon F90X with 15mm lens; 1/125
sec at f22; Fujichrome Astia 100;
two strobes.**

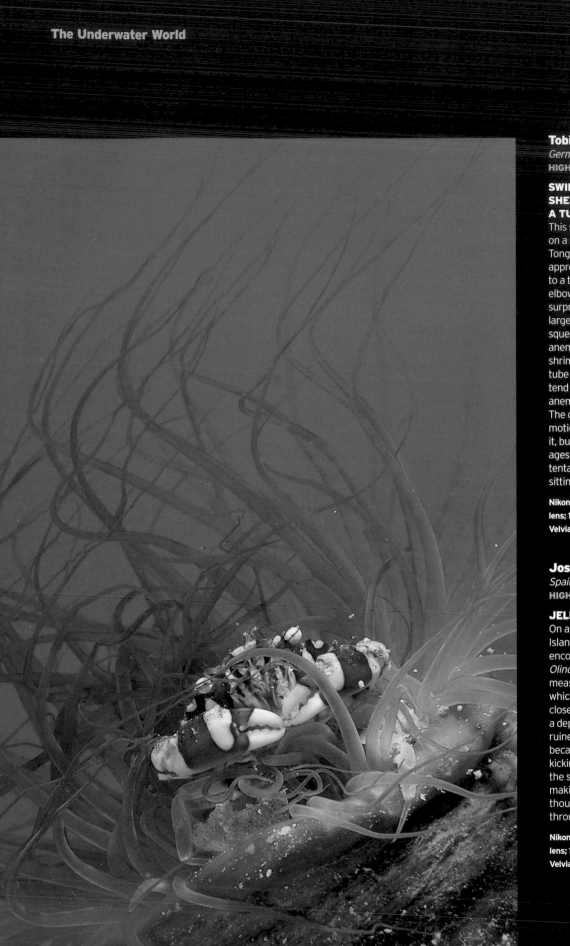

### Tobias Bernhard
*Germany*
**HIGHLY COMMENDED**

#### SWIMMER CRAB SHELTERING IN A TUBE ANEMONE

This swimmer crab was sitting on a sandy slope in Vavau Tong, in the South Pacific. As I approached, it scuttled over to a tube anemone and elbowed its way inside. I was surprised that such a relatively large crab (30mm wide) could squeeze into such a delicate anemone. Usually, only tiny shrimps find protection in tube anemones; these crabs tend to shelter inside larger anemones and on soft coral. The crab remained motionless as I photographed it, but the anemone spent ages tugging its squashed tentacles out from beneath its sitting tenant.

**Nikon F90X with 105mm micro lens; 1/60 sec at f22; Fujichrome Velvia; two strobes.**

### Jose Luis Gonzalez
*Spain*
**HIGHLY COMMENDED**

#### JELLYFISH

On a night dive off Cíes Island, North-west Spain, I encountered this jellyfish, *Olindias phosphorica*, measuring about 40mm, which was swimming very close to the sandy sea-floor at a depth of 15m. I thought I had ruined the photograph, because I couldn't avoid kicking up sand. But in the end, the sand enhanced the image, making the jellyfish look as though it were travelling through outer space.

**Nikon F4S with 60mm micro-nikkor lens; 1/125 sec at f22; Fujichrome Velvia; housing; two flashes.**

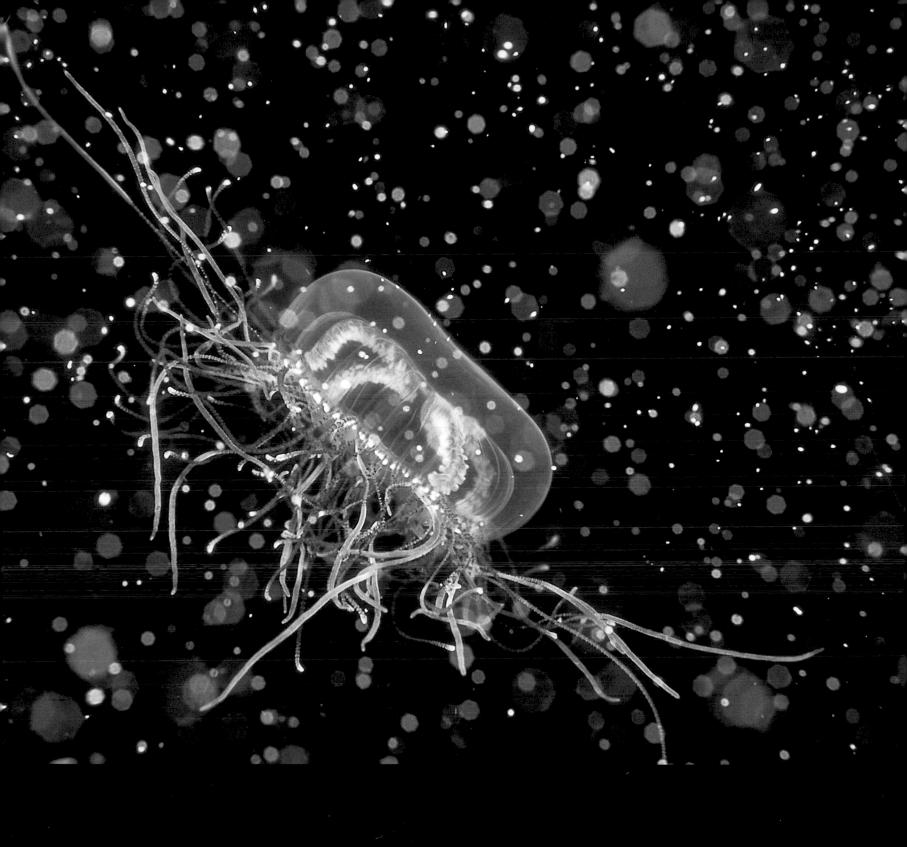

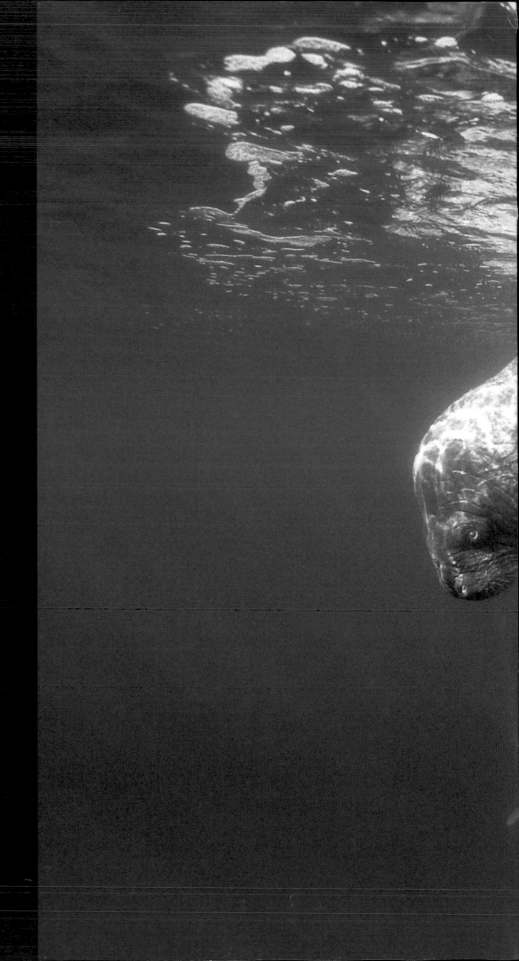

SPECIALLY
COMMENDED

**Paul Nicklen**
*Canada*

**ATLANTIC WALRUS
MOTHER AND PUP**
While diving in Foxe Basin,
Nunavut, Canada, I was lucky
to get as close as this to a
female Atlantic walrus and
her pup, given that walrus
mothers are highly protective.
Females grow to around
1,200kg, and so I was keen to
avoid her wrath. Mating takes
place in January and
February and the female gives
birth to a single calf in the
spring of the following year,
usually in May. Because of this
long pregnancy, females
cannot breed more often than
every two years. There are
two subspecies of walrus: the
Atlantic walrus inhabits
North-east Canada and
Greenland, and the Pacific
walrus inhabits the Bering,
Chukchi and Laptev seas.

Nikon F4; Fujichrome Provia 100;
Nexus Master housing.

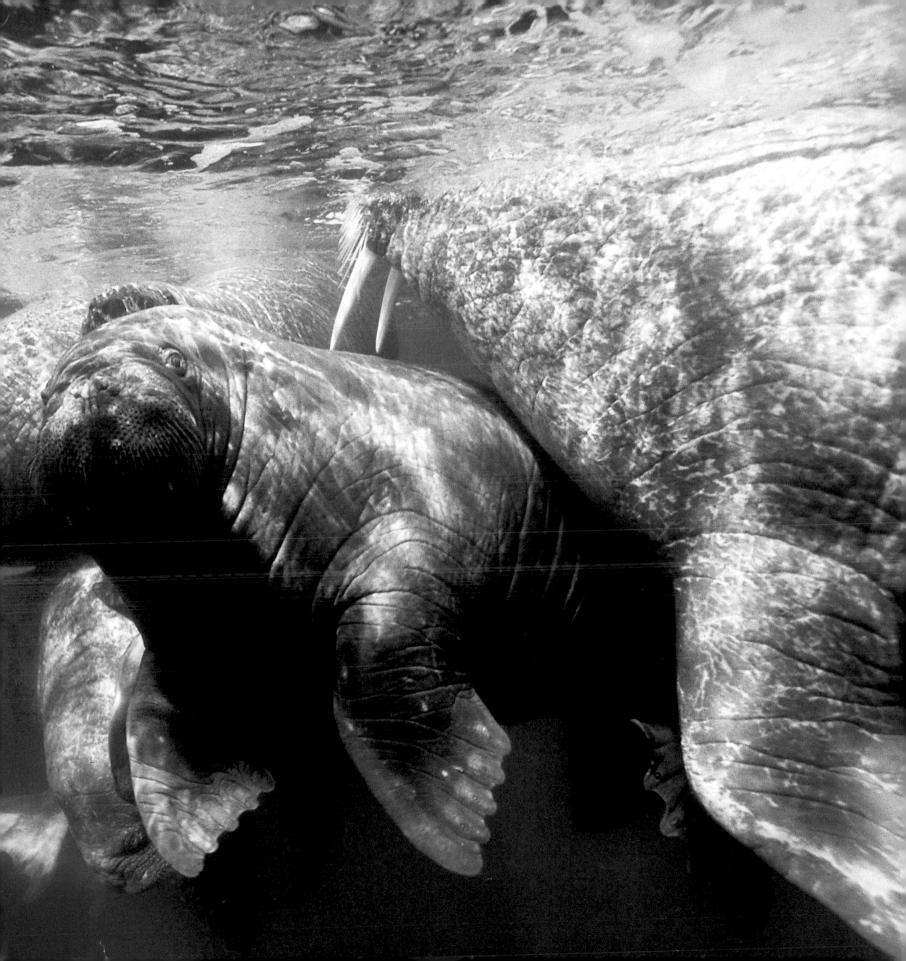

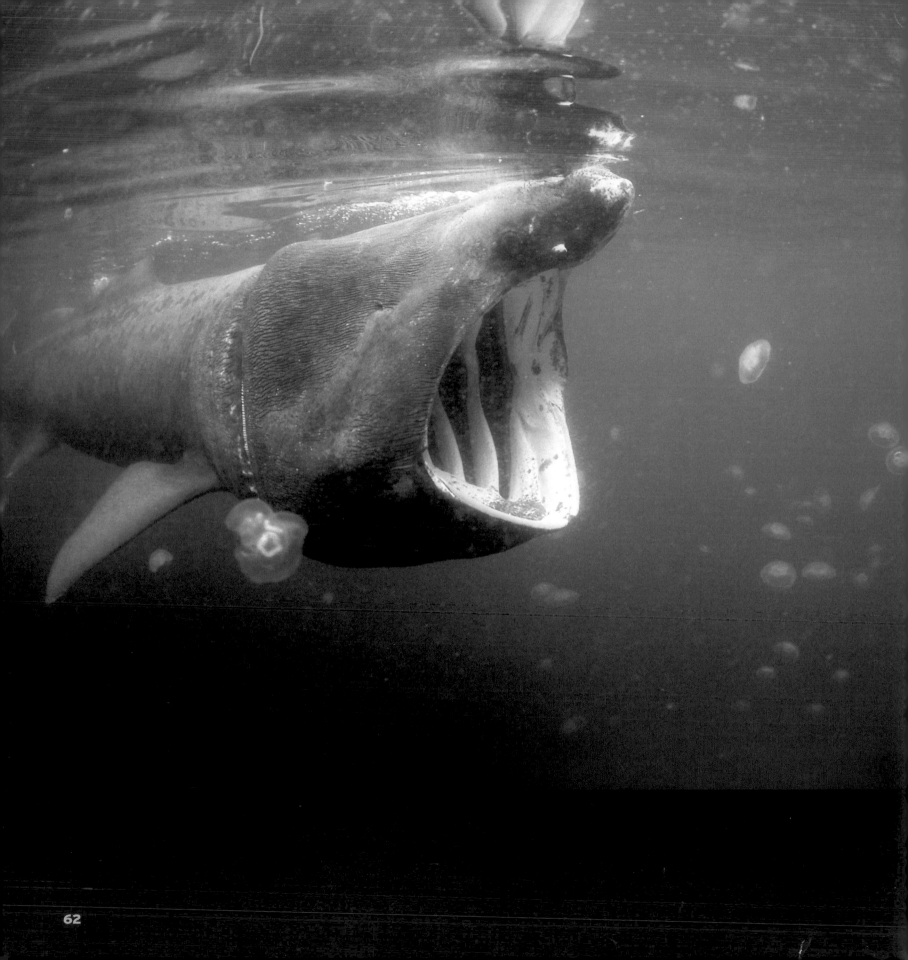

## Douglas David Seifert
*USA*
**HIGHLY COMMENDED**

### BASKING SHARK AND JELLYFISH

The world's second largest fish, after whale sharks, basking sharks are found in temperate waters worldwide but are relatively uncommon. In the Irish sea, near the Isle of Man, I encountered a group of 43 of them, making lazy paths through clouds of copepods, mouths wide open. They faced a problem, though: a swarm of jellyfish had also gathered to feed on the plankton. The sharks somehow detected the jellyfish and would deliberately alter their course to avoid swallowing any.

**Nikon RS-AF with Aumann 18mm lens; 1/125 sec at f2.8; Kodachrome 64.**

## Frédéric Nevoit
*France*
**HIGHLY COMMENDED**

### PIKE IN AMBUSH

Pike, which can grow to 1.4m, are ambush hunters. They hide behind curtains of weeds in the shallows, then shoot out to snatch smaller fish in their powerful jaws. They have voracious appetites, eating anything from insects, leeches and crayfish to frogs, snakes and even ducklings. This pike was loitering among algae in a small river in my home region of Aube, in France, its brilliant yellow eyes gleaming in the gloomy water. No sooner had I taken the photograph, than the pike burst out and grabbed a passing roach.

**Nikonos V with 20mm lens; 1/90 sec at f16; Fujichrome 100 Sensia; flash.**

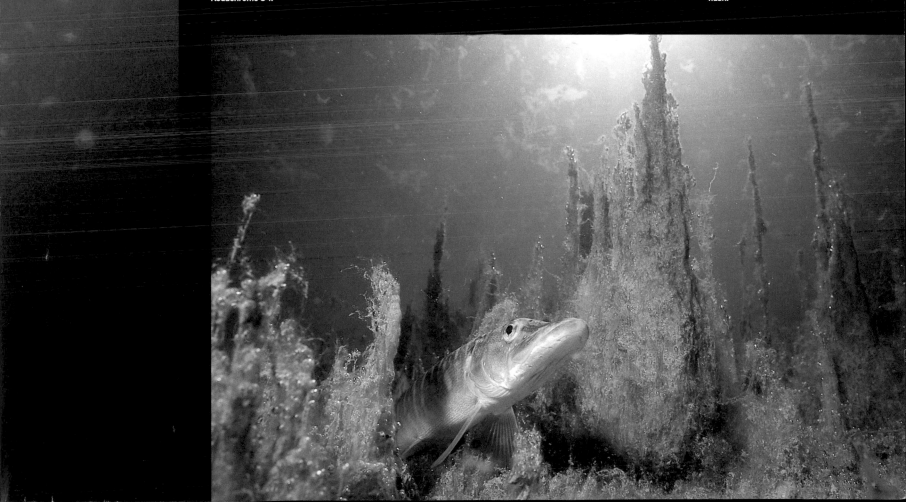

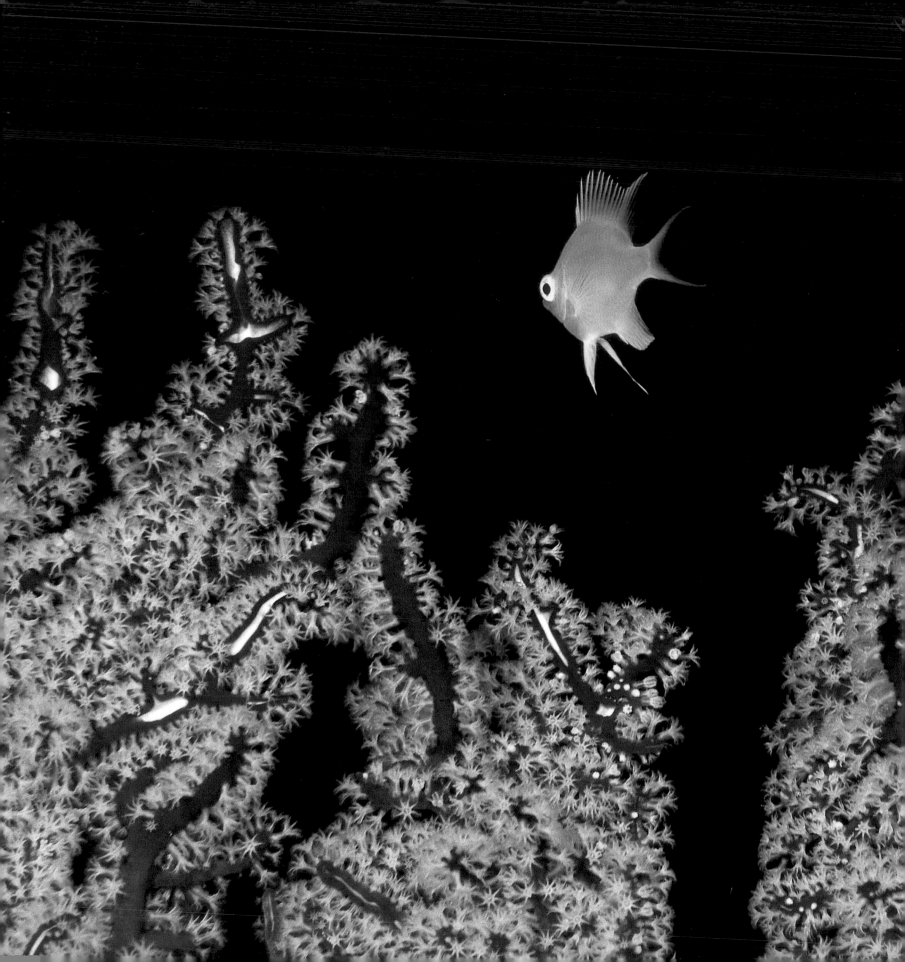

**Fredrik Ehrenström**
*Sweden*
**HIGHLY COMMENDED**

**GOLDEN DAMSELFISH
AND SOFT CORAL**
I didn't think I would take any
good photographs while on a
dive in the Similan Islands
in Thailand. My dive-guide
seemed to be in a hurry, and
I was forever trying to
catch him up. Then we hit
quite a strong current, and
immediately we were
travelling faster than ever.
As we drifted along, I noticed
this juvenile golden
damselfish fish hovering
above a crimson soft coral.
The contrast in colours was
magnificent, and so I quickly
lifted my camera and pressed
the shutter as we swept by.

**Nikon 801S with 16mm Semifisheye
Nikon lens; 1/60 sec at f11;
Fujichrome Velvia; Aquatica 80
UW-housing; two strobes.**

# In Praise of Plants

This category aims to showcase the beauty and importance of flowering and non-flowering plants.

**WINNER**

**Jun Ogawa**
*Japan*

**LYCORIS IN A PLUM ORCHARD**

Each September, wild *Lycoris* lilies – which are in the Amaryllis family – bloom for just one week in their native Japan. I photographed this blaze of flowers, also native to China and Burma, in a plum orchard very early one morning. It was a scene of perfect peace – hard to imagine that, by the following morning, a typhoon would have smashed the blooms to the ground.

Pentax 645 with 80-160mm lens; 1 sec at f22; Fujichrome Velvia rated at 40; tripod.

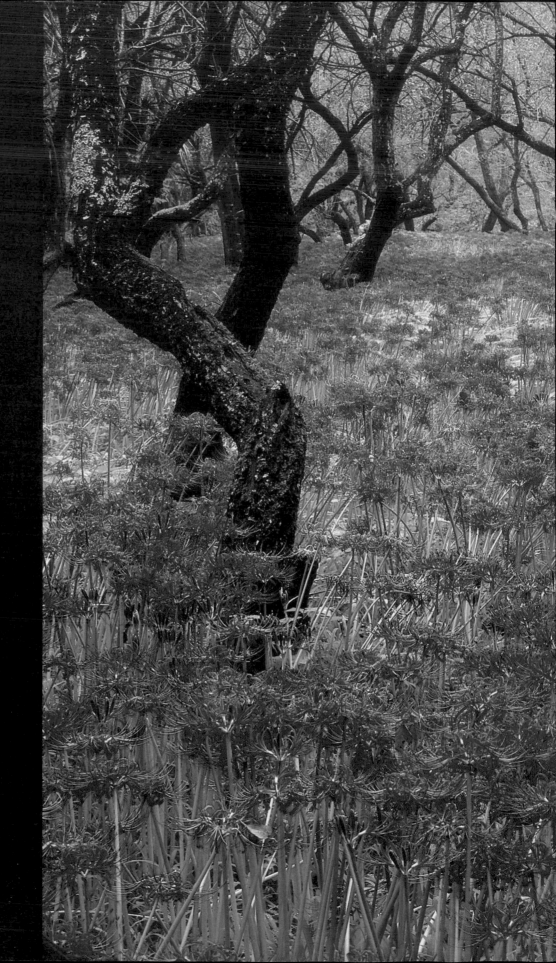

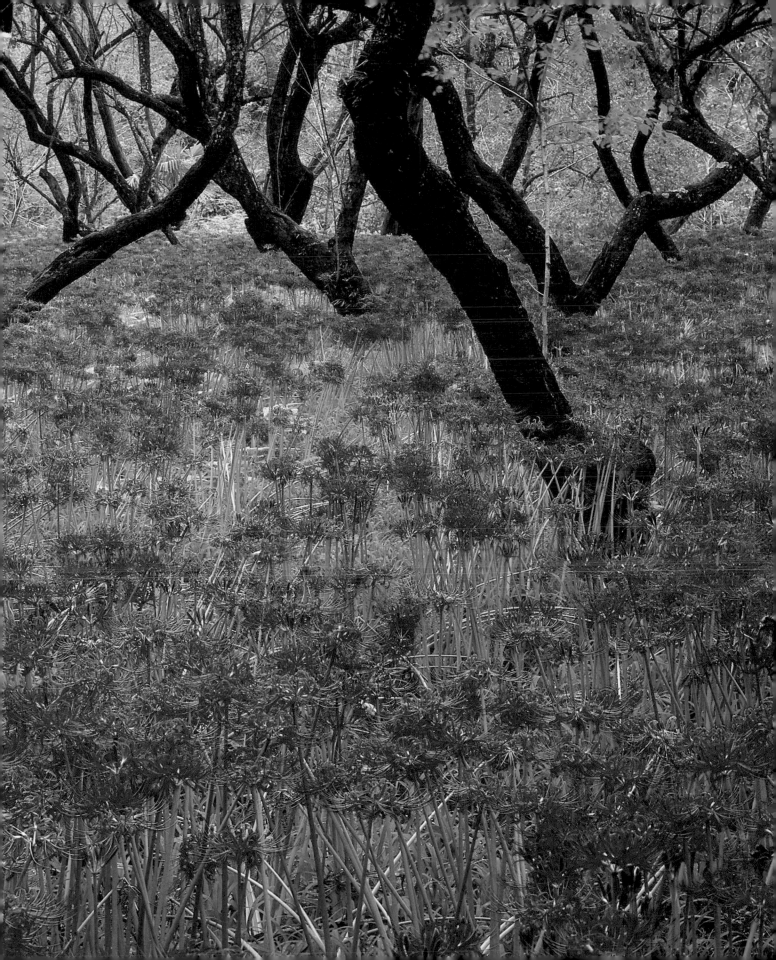

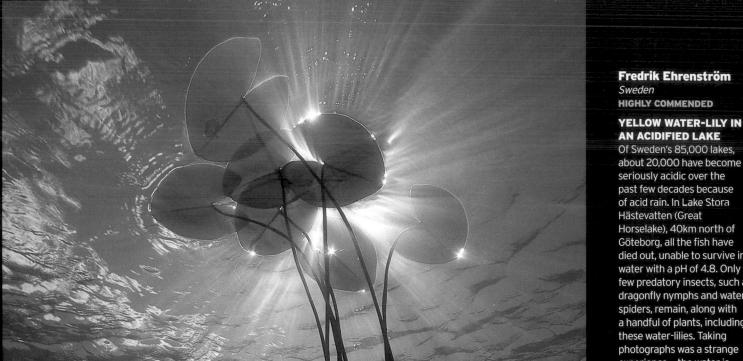

**Fredrik Ehrenström**
*Sweden*
**HIGHLY COMMENDED**

### YELLOW WATER-LILY IN AN ACIDIFIED LAKE

Of Sweden's 85,000 lakes, about 20,000 have become seriously acidic over the past few decades because of acid rain. In Lake Stora Hästevatten (Great Horselake), 40km north of Göteborg, all the fish have died out, unable to survive in water with a pH of 4.8. Only a few predatory insects, such as dragonfly nymphs and water-spiders, remain, along with a handful of plants, including these water-lilies. Taking photographs was a strange

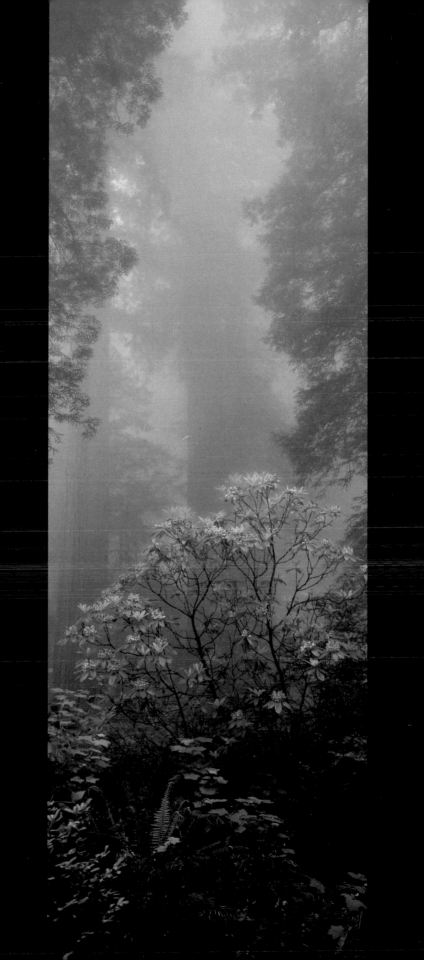

**Colin Varndell**
*UK*

**SNAKE'S-HEAD
FRITILLARIES AT DAWN**
I have a passion for
photographing wildflowers.
Every summer, I attempt to
add new species to my files.
Rare snake's-head fritillaries
grow in pastures and
meadows in the southern and
eastern counties of England.
When I visited the grounds of
Magdalen College, in Oxford,
on a foggy dawn in early May,
I was overwhelmed by the
tens of thousands of nodding,
chequered heads, all dripping
with dew. After finding this
group of flowers isolated
from the rest, I sat in the wet
grass to wait for the sunlight
to lift the fog.

**Nikon FE2 with Nikkor 300mm
lens; 1/250 sec at f2.8; Fujichrome
Velvia; tripod.**

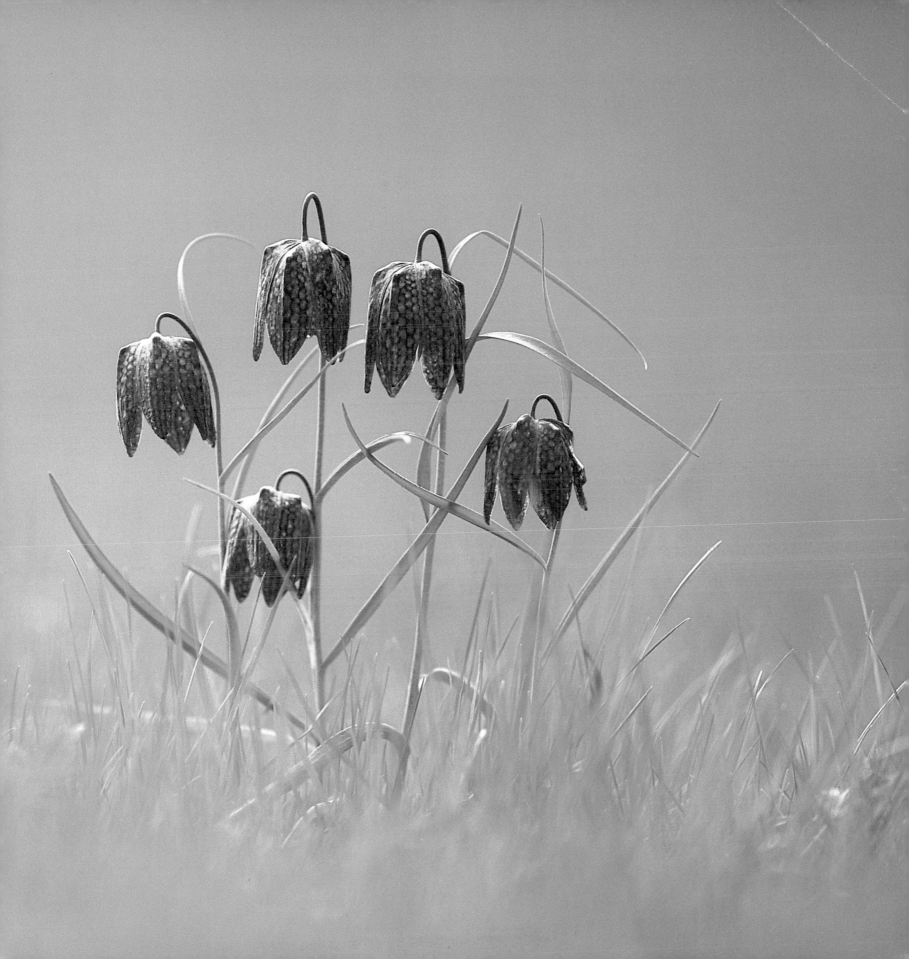

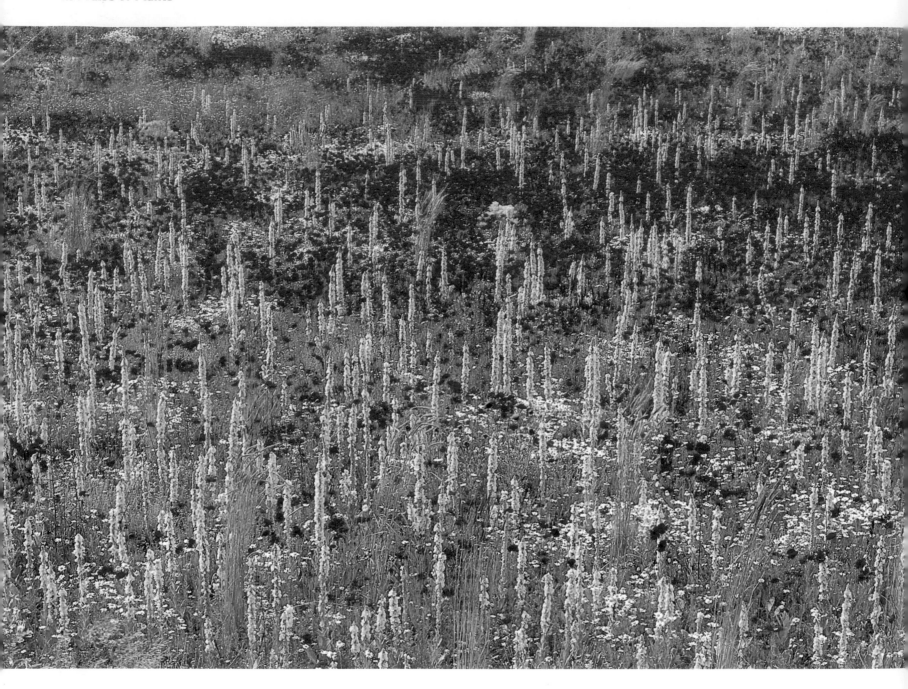

**Maurizio Biancarelli**
*Italy*
HIGHLY COMMENDED

### POPPIES AND AARON'S RODS

In June, I visited the beautiful medieval village of San Stefano di Sessanio in Italy's central Appenines. At 1,300m altitude, the landscape looked stark and barren. Then I found an oasis of colour: a set-aside field bursting with wildflowers, with spikes of great mulleins (Aaron's rods) among the poppies and daisies. The name refers to the rod that Aaron placed before the ark, which miraculously blossomed.

**Nikon F3 with 35mm lens; 1/60 sec at f11; Fujichrome Velvia.**

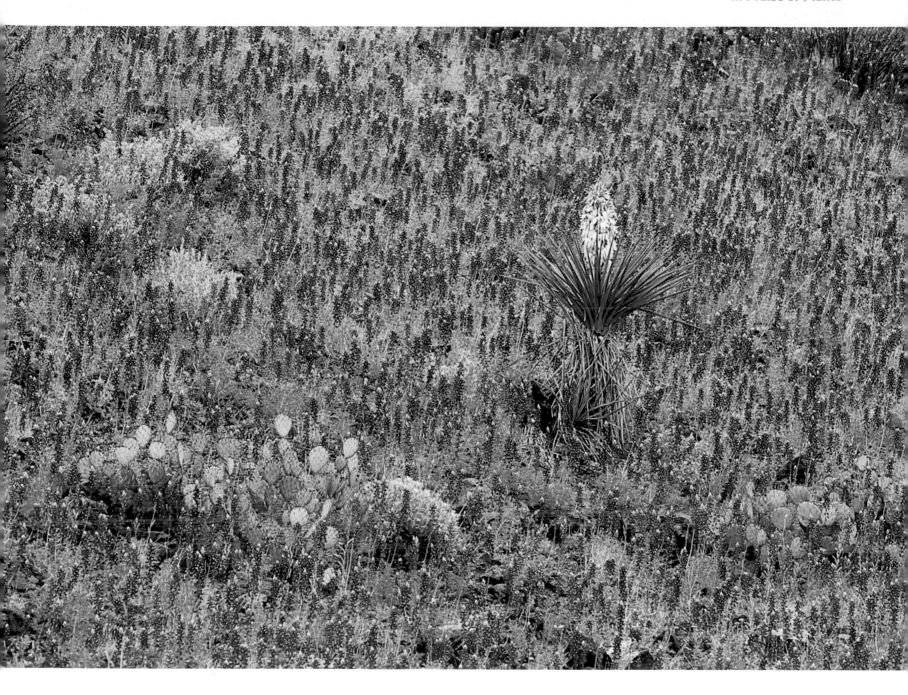

**Olaf Broders**
*Germany*

**TEXAS BLUEBONNETS AND A YUCCA**

Only specialised plants, such as members of the cactus and agave (including the yucca) families, are able to survive the harsh conditions of the Chihuahuan Desert in Texas, USA. One exception is the Texas bluebonnet, a tender plant and a member of the pea family. Its seeds lie dormant in the soil for years, until heavy winter rains cause whole regions to bloom.

Nikon F100 with 300mm lens; 0.5 sec at f22; Fujichrome Velvia; tripod.

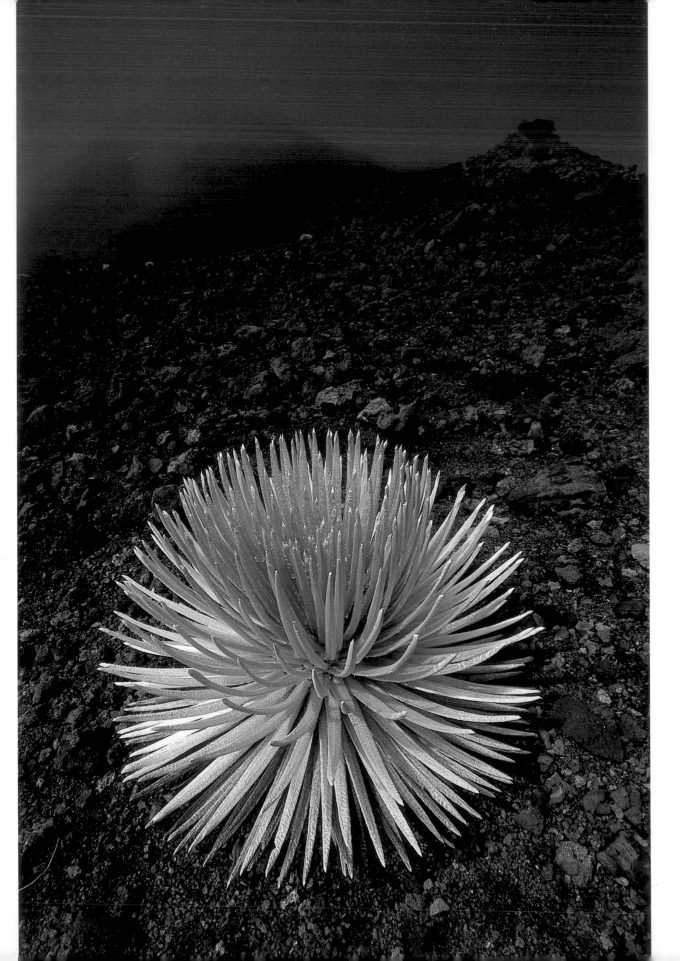

**Olivier Grunewald**
*France*
HIGHLY COMMENDED

### HALEAKALA SILVERSWORD

The silversword is a strange, rare plant, endemic to Hawaii. For 50 years or more, it grows as a compact, globe-shaped rosette covered in a dense layer of silvery hairs. Then, within a matter of weeks, a flowering stalk covered in hundreds of maroon blooms appears. The plant then dies, and its seeds are dispersed. This particular species is found only in a 1,000ha area on the lunar-like outer slopes of the Haleakala Volcano on Maui Island, at 2,100-3,000m. When I saw this plant, its rigid leaves (the 'swords') seemed to be gleaming under the dark, heavy sky.

**Nikon F801S with 20-35mm zoom lens; 1/8 sec at f22; Fujichrome Velvia rated at 40; grey graduated filter; tripod.**

**Thomas Endlein**
*Germany*
**HIGHLY COMMENDED**

**MARSH MARIGOLD**
After a cold, Bavarian winter, marsh marigolds are a welcome though brief burst of colour in early spring. They emerge in swampy areas, growing on small mounds of mud that raise the plant just above the water. When I took this photograph, the stark reflections of the leafless trees against a blue sky accentuated the vibrance of the blossoms.

**Canon EOS 1NRS with 28-80mm lens; 1/15 sec at f22; Fujichrome Sensia 100; tripod.**

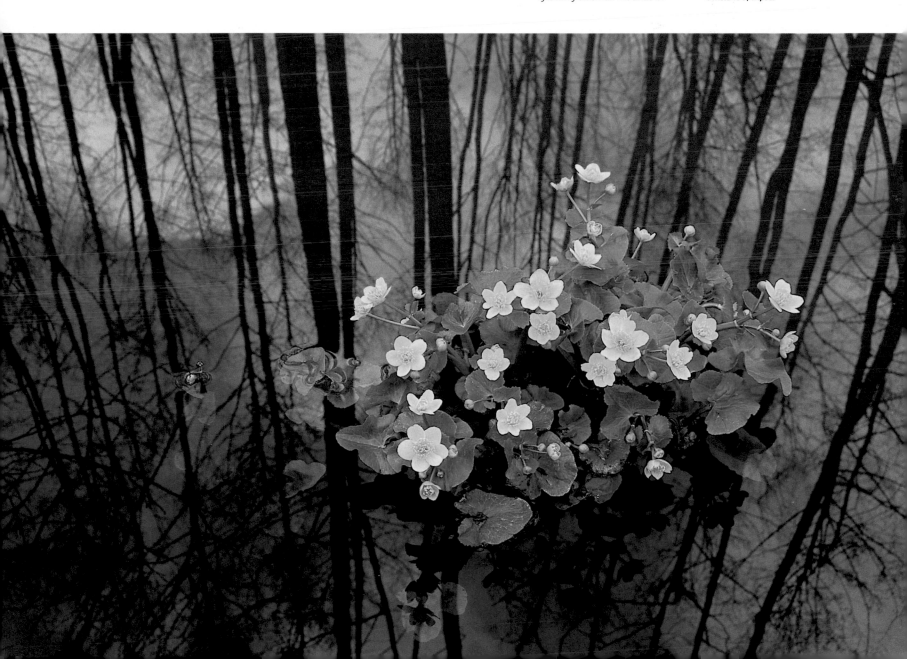

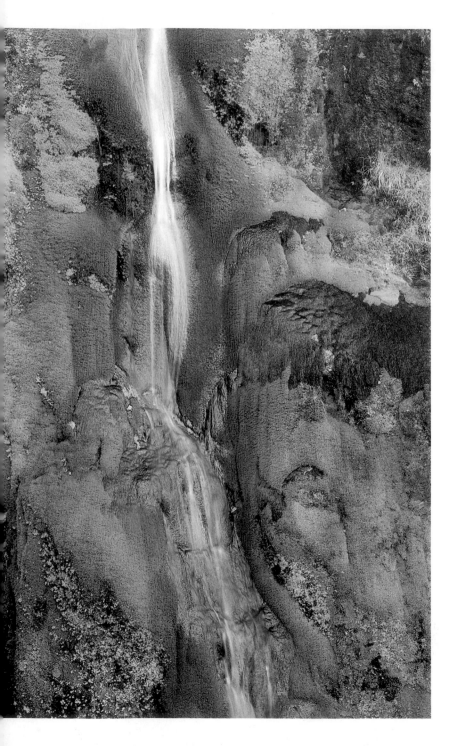

## Lorne Gill
*UK*
HIGHLY COMMENDED

### LIVERWORT- AND MOSS-COVERED ROCKS

As I descended from a peak in the Scottish Highlands, a walker noticed my tripod and told me about a 'mossy waterfall' worth photographing if I made a slight detour from the path. Being an overcast day, the soft light was perfect for revealing the subtle colours, textures and details of the scene. Though these micro-habitats are miles from industrial belts, they are nonetheless under threat from atmospheric pollution.

Nikon F5 with 80-200mm zoom lens; 1/8 sec at f16; Fujichrome Velvia; tripod.

## Hans Strand
*Sweden*
HIGHLY COMMENDED

### EVENING LIGHT ON DOUGLAS FIR TREES AND GIANT SEQUOIAS

I found this grove of trees in Sequoia National Park in California, USA. The giant sequoia is the largest tree in the world (the nearby 'General Sherman' is about 84m tall, 11.5m in diameter and weighs 500 tons). The Douglas fir is one of the tallest trees in the world: one specimen, cut down in the 19th century, was 138m tall. Rather than trying to convey their size, I decided to compose the image tightly.

Linhof Technicardan 23 (6x9cm) with Schneider Super-Angulon 75mm lens; 10 sec at f45; Fujichrome Velvia.

## Jan Töve
*Sweden*
**HIGHLY COMMENDED**

### COTTONWOODS

One cloudless, March afternoon in Zion National Park, Utah, USA, I saw these cottonwoods. The sunlight reflected from the cliff walls lit up the branches and trunks, giving them such a dazzling shimmer that I was reminded of the winter hoarfrost in Sweden.

**Pentax 6711 with 135mm lens plus 81A filter; 1/15 sec at f16; Fujichrome Velvia; tripod.**

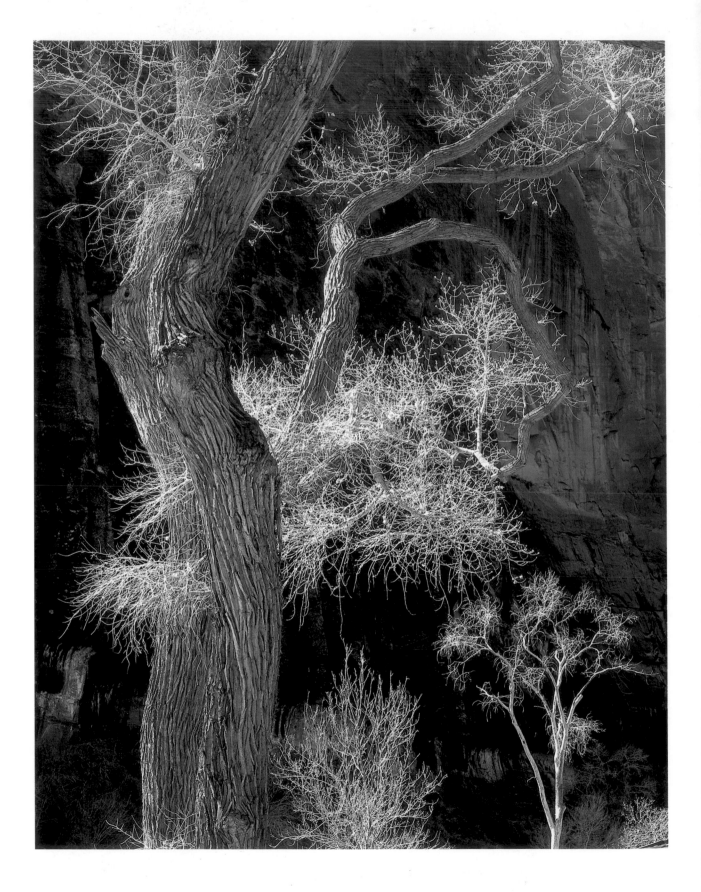

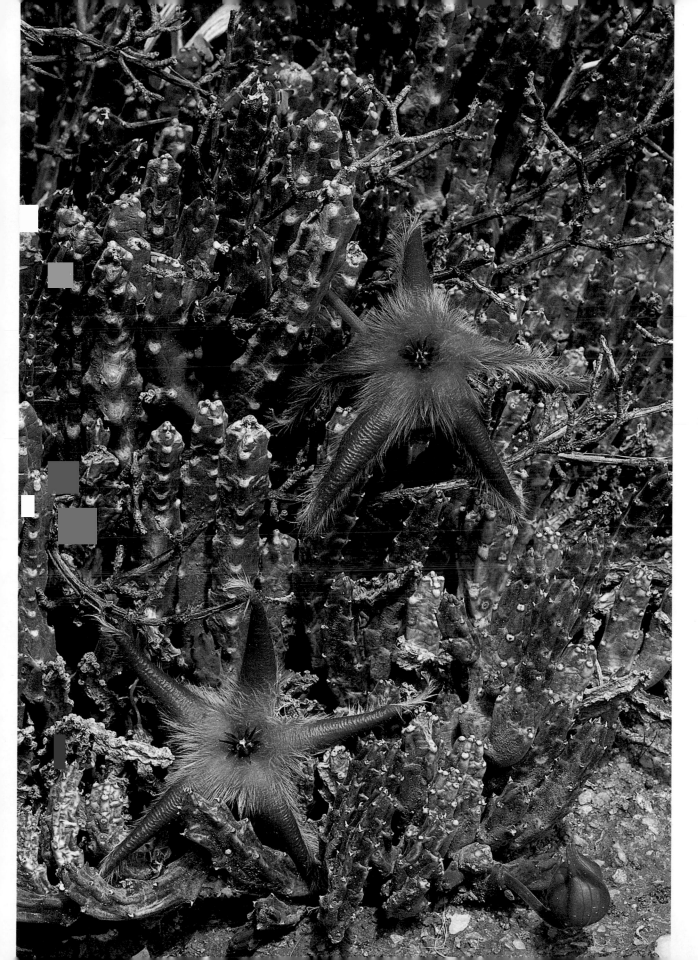

### Heinrich van den Berg
*South Africa*
**HIGHLY COMMENDED**

**DESERT SUCCULENT**
The Richtersveld is a remote and extremely rugged, dry part of South Africa. Good autumn showers, though, and falling temperatures encourage explosions of floral colour. When I visited the area, there had been some of the highest rainfalls in years, and so it was like taking a walk around a botanical rock garden. I found this endemic dwarf-stem succulent, *Stapelia gariepensis*. Its deep-red flowers covered in cat-like fur were most attractive, but they smelt like rotten flesh to attract flies for pollination.

**Canon EOS 1N with 100mm macro lens; 0.5 sec at f16; Fujichrome Velvia.**

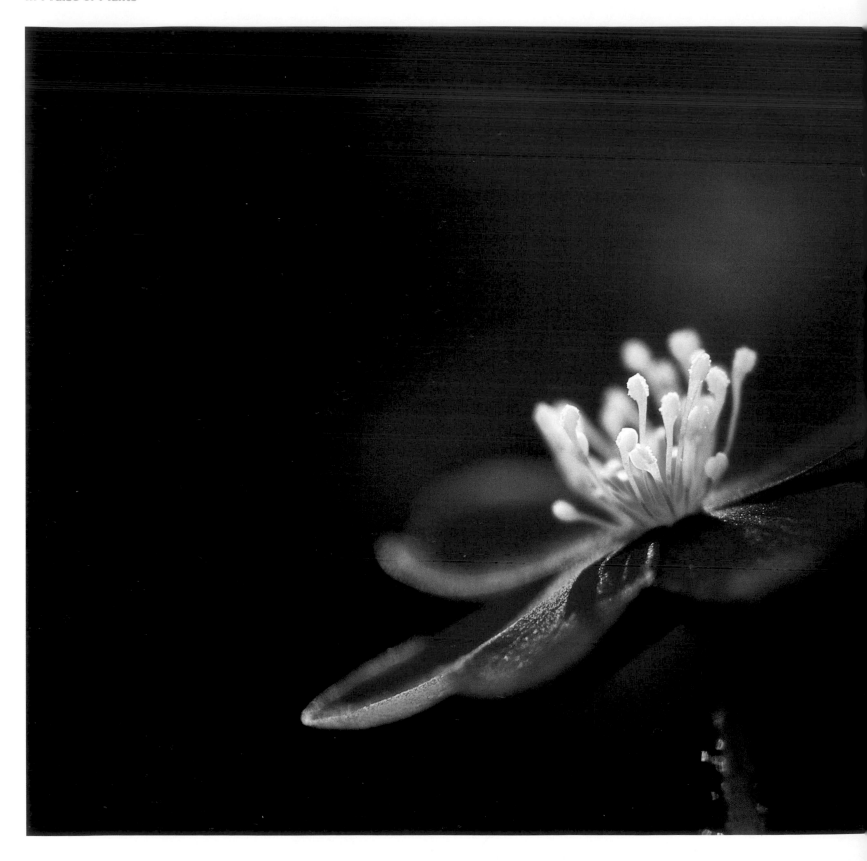

**Janos Jurka**
*Sweden*

**HEPATICA FLOWER**
Spring comes relatively late to my home region of Dalarna, in Sweden, and so is eagerly awaited. The local newspapers often publish items about the first indications that winter is over. Among the earliest flowers to appear are hepaticas, which burst into bloom among the dead needles under the conifers. One day in mid-April, after a particularly long winter, I was walking through a wood near my home when I came across a carpet of hepaticas, spread over an area the size of half a tennis-court. I decided to wait until just a few flowers were illuminated.

**Canon EOS 1 EF 180 L Macro USM; 1/8 sec at f5.6; Fujichrome Velvia; tripod.**

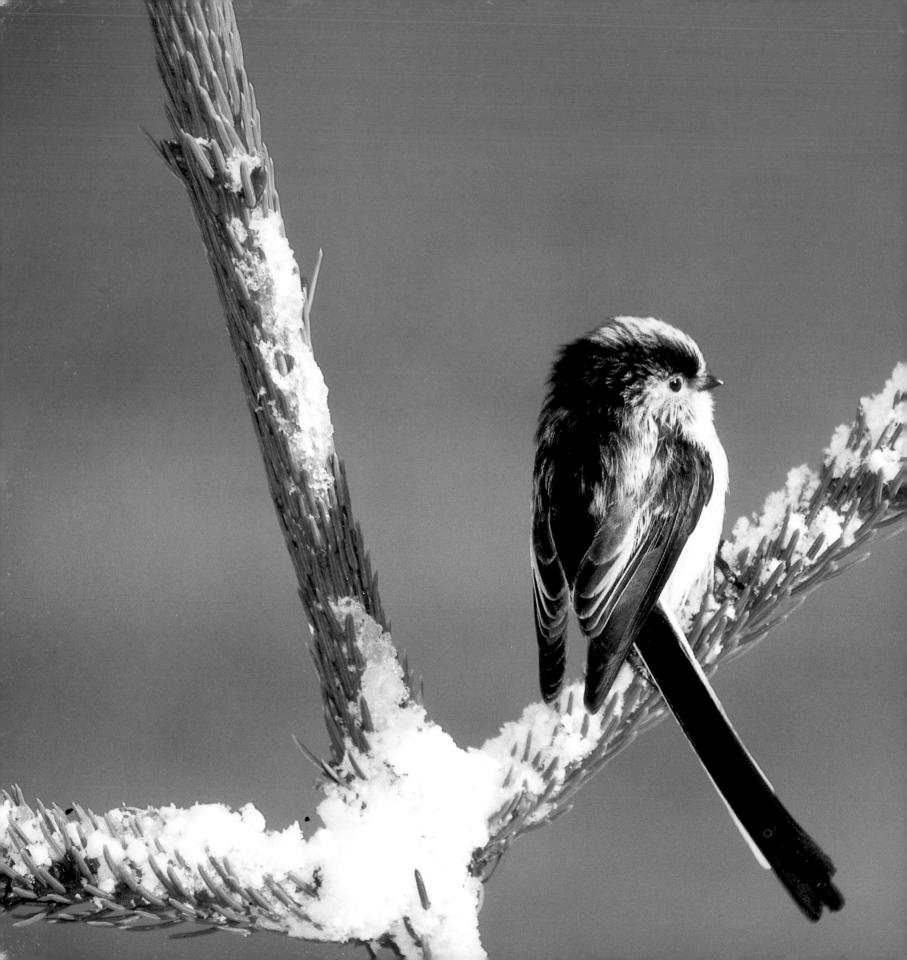

# British Wildlife

This category exists both to encourage UK photographers to look for subjects closer to home and to show that British plants and animals can be the subjects of beautiful pictures.

WINNER

**Doug McCutcheon**
*UK*

**LONG-TAILED TIT**
During a period of prolonged cold weather, a party of long-tailed tits began to visit the feeders in our woodland garden in Blaydon-on-Tyne, in the North of England. I set up my tripod and camera on the bedroom windowsill, and hidden behind the curtains, I watched them for hours. The tits would return about every half hour, sometimes in groups of up to eight. They would often settle on the spruce twigs momentarily before flying off to feed on the peanuts and a ball of fat we had hung up.

**Canon EOS5 with Sigma 170-500mm lens at 500mm; 1/200 sec at f8; Fujichrome Provia 100; tripod; Canon speedlite 380 EX.**

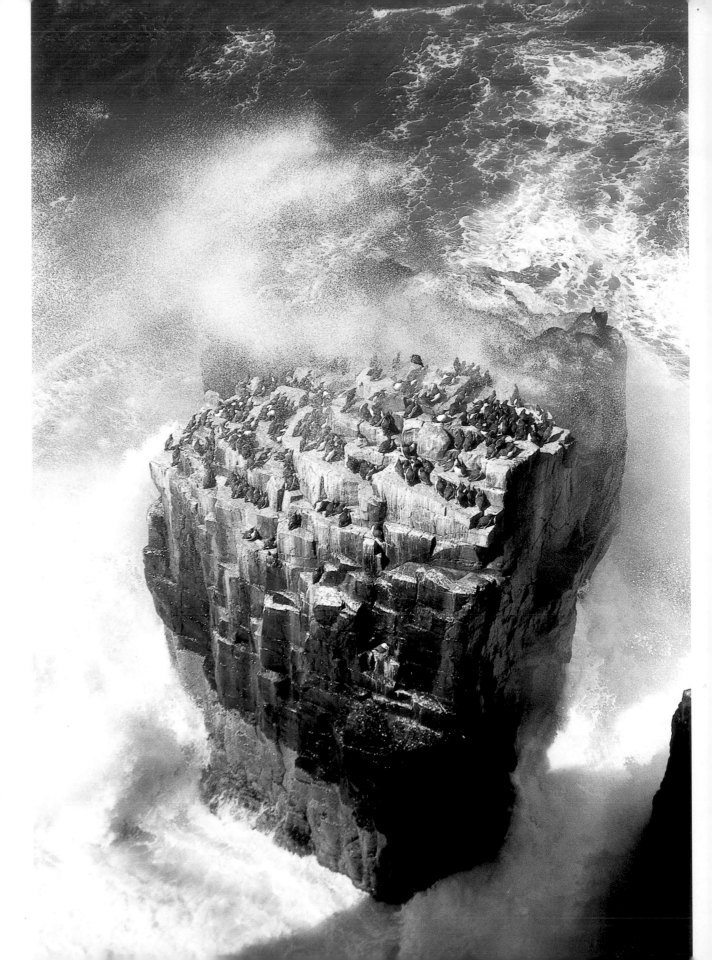

RUNNER-UP

**Kevin Schafer**
*USA*

### NESTING GUILLEMOTS CLINGING TO WAVE-BATTERED ROCK

Gale-force winds and huge waves pummelled the Isle of May off the east coast of Scotland one day in June. Gripping the cliff, drenched with spray and facing into the shrieking wind, I watched as waves crashed over a colony of guillemots nesting on a small rock on the island's windward side, washing away both birds and eggs.

The guillemots clung on as long as they could, but many were forced to abandon their nests. I was constantly wiping my camera and could manage only one frame of this cataclysmic scene at a time before my camera was soaked again.

Nikon F100 with 20-35mm lens; 1/500 sec at f4; Fujichrome Velvia.

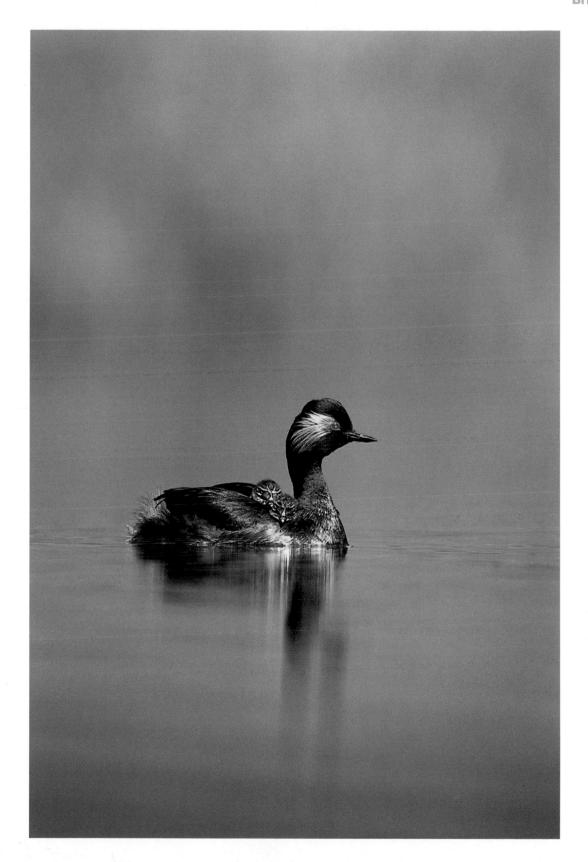

**Rob Jordan**
*UK*

**BLACK-NECKED GREBE CHICKS' FIRST OUTING**

A private lake in rural Northumberland is home to the largest and most important colony of black-necked grebes in Britain. When these nationally rare birds arrive in March, they are in pristine breeding condition, with sleek plumage and streamlined golden 'ear-muff' feathers and fiery-red eyes. The day after these chicks hatched, I watched, chin-deep in the cold, dark water from behind a camouflaged floating hide, as the adults took them on for their very first trip on the lake. Black-necked grebes are particularly vulnerable to persecution by egg-collectors, and so my presence also helps protect them.

Nikon F4S with Nikkor 500mm lens; 1/60 sec at f5.6; Fujichrome Provia 100; floating hide, beanbag.

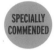

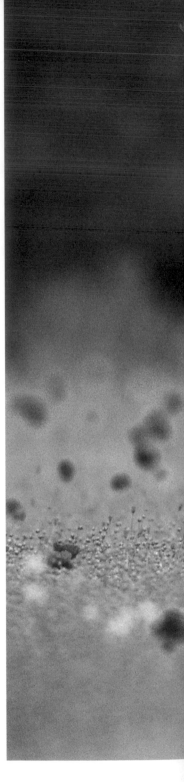

**Andy Rouse**
*UK*
HIGHLY COMMENDED

**ROE DEER BUCK**
All deer are difficult to approach, but roe are especially notorious for their alertness. During the rutting season in late July, I stalked quietly towards this buck, decked out in my finest camouflage gear and keeping a close watch on the direction of the wind. When he saw me, the deer wasn't quite sure what I was and stamped towards me through the poppies. He circled me for some time before my old enemy, the wind, finally gave me away, and the buck bolted, barking all the way across the fields.

**Canon EOS 1V with 100-400mm image stabiliser; 1/60 sec at f5.6; Fujichrome Provia 100.**

**Chris Williams**
*UK*

**PUFFIN EMERGING FROM ITS BURROW**
Skomer, off the coast of West Wales, is famous for its puffins. I visited a particular spot along a cliff path where you're generally guaranteed some close encounters. That day, a puffin landed with a beakful of sand eels and was faced with not only a party of school children mingling in front of its burrow, but also predatory great black-backed gulls menacing from the sidelines. Because of the gulls, the puffin had to dash for its life between the human legs and into its sea-campion-fringed burrow. It re-emerged surprisingly fast, albeit tentatively, which is when I photographed it.

**Minolta Dynax 9 with 70-200mm lens; 1/250 sec at f2.8; Fujichrome 100; tripod.**

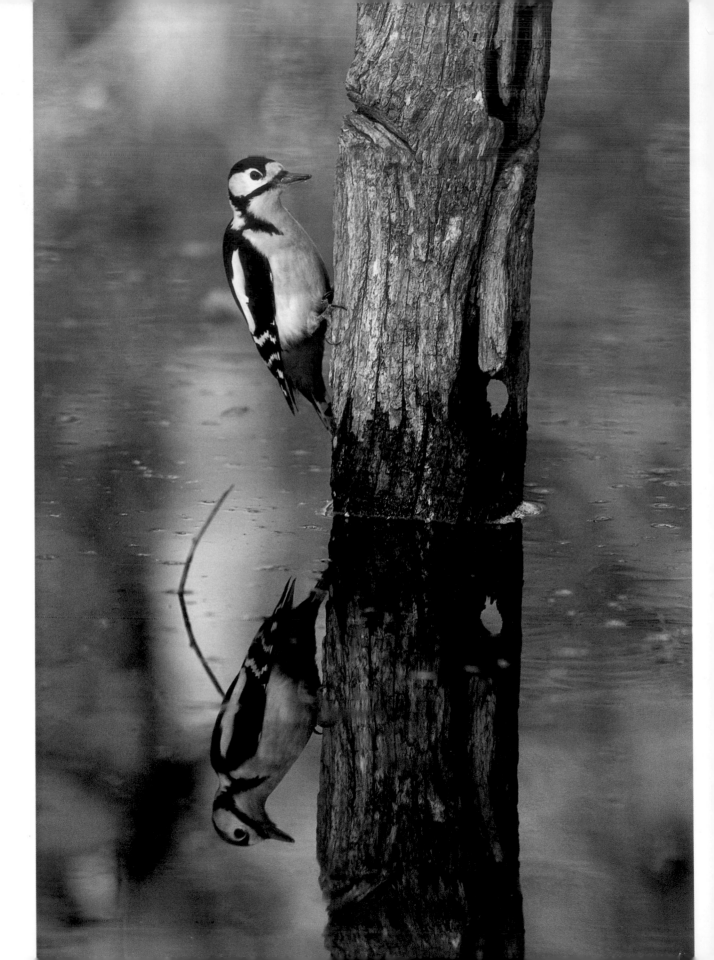

**Mike Wilkes**
*UK*

**GREAT SPOTTED WOODPECKER FEEDING**
While photographing birds last winter in Warwickshire, the stillness of this small pool appealed to me. I put up baiting stations on the water to photograph birds and their reflections. A horizontal branch attracted dunnocks and blackbirds. When I put a vertical post into the pond with peanut-filled holes close to the water's surface, a woodpecker landed, and I got the colour fix I needed.

**Canon EOS 100 with 300mm lens; 1/125 sec at f5.6; Fujichrome Sensia 100; tripod.**

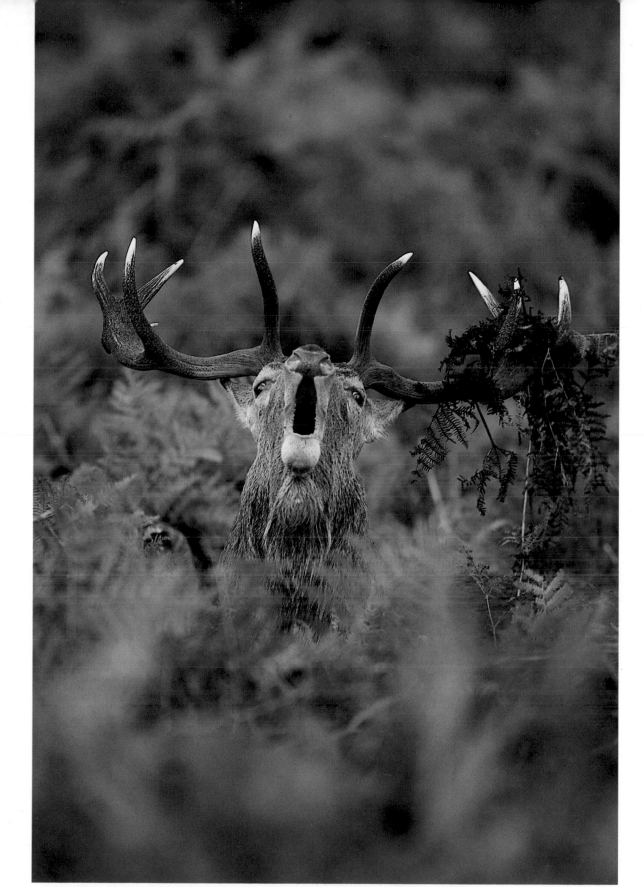

**John Cancalosi**
*USA*

**RUTTING RED DEER STAG**
Red deer stags expend so much energy during their autumn rut that it's exhausting just watching them. This stag, in Surrey, England, had been strutting around his harem, roaring periodically. He then bent his head down and began thrashing at a stand of bracken with his antlers and urinating on himself. Perhaps this eau-de-rut fragrance of the urine mixed with freshly cut vegetation enhances his chances of breeding success. I took the photograph just as he raised his head to roar again.

**Canon EOS IV with 500mm lens; 1/250 sec at f4; Fujichrome Provia 100; tripod.**

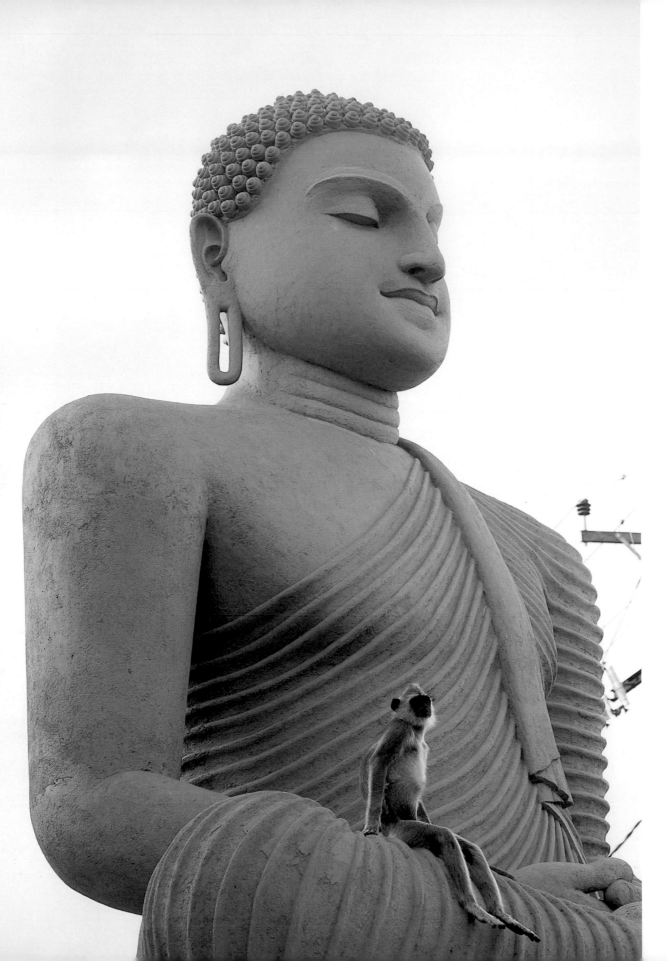

**Elio Della Ferrera**
*Italy*
HIGHLY COMMENDED

**LANGUR RECLINING ON A BUDDHA STATUE**
This monkey, a Ceylon grey langur, subspecies of the Hanuman langur, represents the Hindu monkey god Hanuman. I was struck by the religious symbolism of it sitting on a statue of the Buddha in Polonnaruwa, Sri Lanka. Both these religions are well known for their respect for life. I only had a few seconds to take the photograph before the monkey and its troop moved on.

Canon EOS 1N with 200mm lens; 1/15 sec at f11; Fujichrome Provia; tripod.

# Urban and Garden Wildlife

This is another category that aims to encourage photographers to take pictures of wildlife close to home – in a garden or an obviously urban or suburban setting. Surprisingly, it doesn't attract a large entry.

## Janice A Godwin
*UK*
**HIGHLY COMMENDED**

**WASHING-LINE WREN**
A wren pair nested in the ivy that covers my kitchen wall. Each time the parents returned with insects for the chicks, they perched on the washing-line beside their nest. I pegged baby socks on the line to make a more interesting shot and took the photograph from behind camouflage netting hung across a nearby doorway. After the parents' hard work, I was pleased that all the chicks fledged successfully. I saw one chick take off precariously from the nest and zig-zag like a bumblebee across the nearby 5m-long pond, just making it to the other side.

**Nikon F4S with Sigma 75-300mm apo lens; 1/125 at f4.5; Fujichrome Sensia 100; tripod; remote release.**

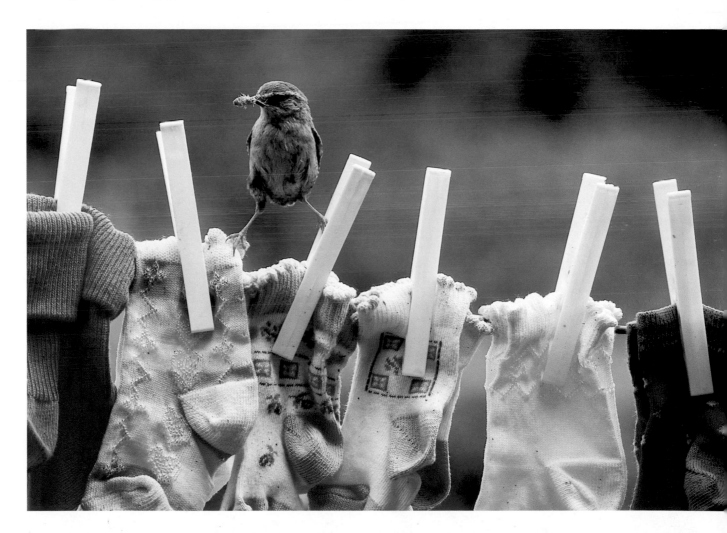

# Wild Places

This is a category for landscapes, but the pictures must convey a true feeling of wildness or create a sense of awe and wonder.

WINNER

## Jan Töve
*Sweden*

### SWEDISH COASTLINE AT DUSK

One night last June, at Hovs Hallar in Skåne, Sweden, I was struck by the contrast between the magnificent black rocks and the soft, bright, summer night. I'm not one for mysticism where nature is concerned, but this night felt mysterious in some way. Maybe that had something to do with the fact that this location is where the knight plays chess with Death in Ingmar Bergman's 1956 film *The Seventh Seal.*

**Pentax 645N with 35mm lens; 60 sec at f22; Fujichrome Velvia; graduated filter.**

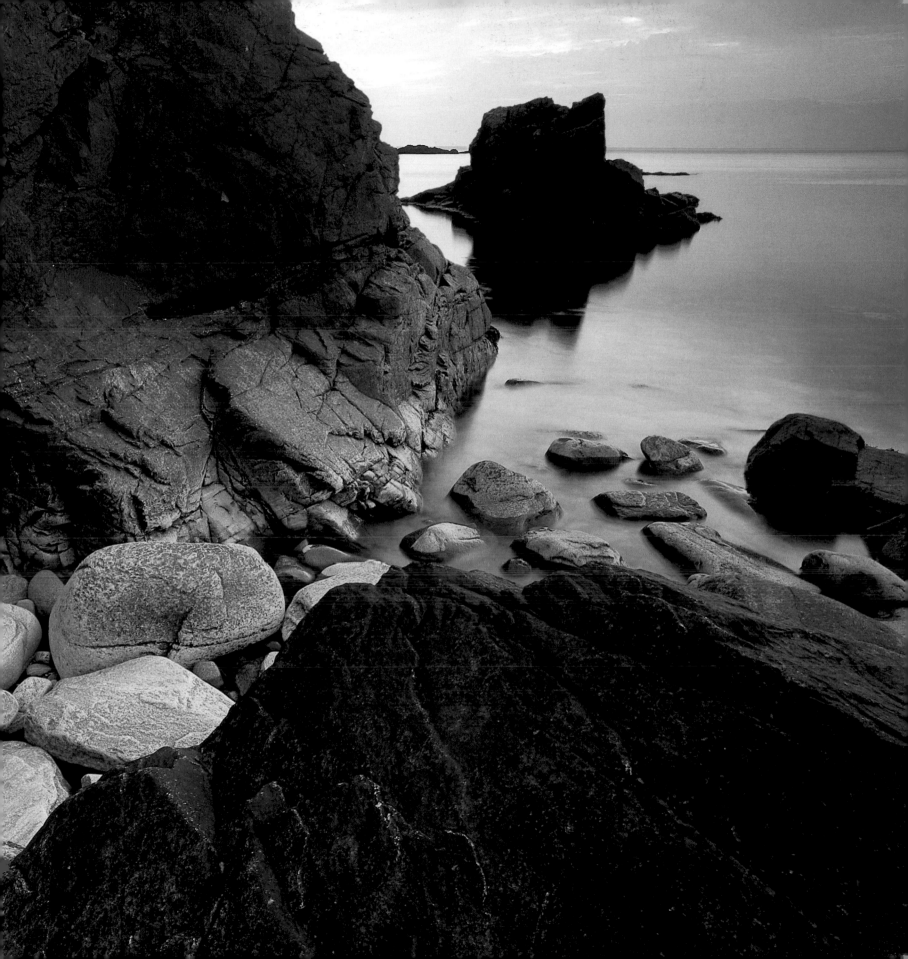

**RUNNER-UP**

## Joel Sartore
*USA*

**GREY WOLVES HUNTING**
In winter, grey wolves travel
across frozen lakes at night.
This means that they can
easily cover 80km or more
in a single night's hunting.
These wolves in Minnesota's
northern woods were so used
to being tracked by plane that
they didn't even glance up as
we flew above. Moments after
setting off, the pack-leader
suddenly stopped, sniffed the
air, then shot into the forest.
The others bounded after
him. By the time we found
them, just minutes later, all
that remained of the night's
first kill was a patch of blood-
soaked snow and the stripped
carcass of a beaver.

**Nikon F5 with Nikon 80-200mm
AF lens; 1/250 sec at f2.8;
Fujichrome Provia.**

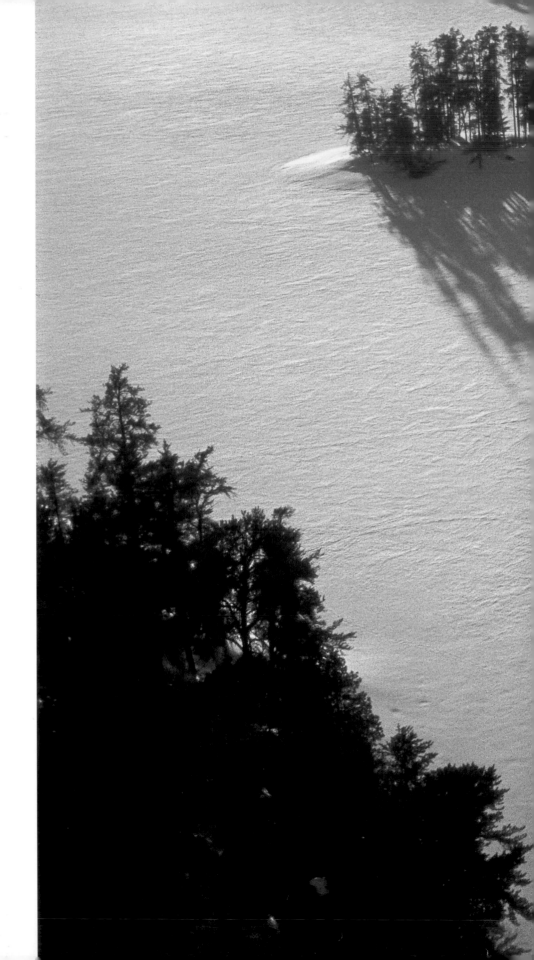

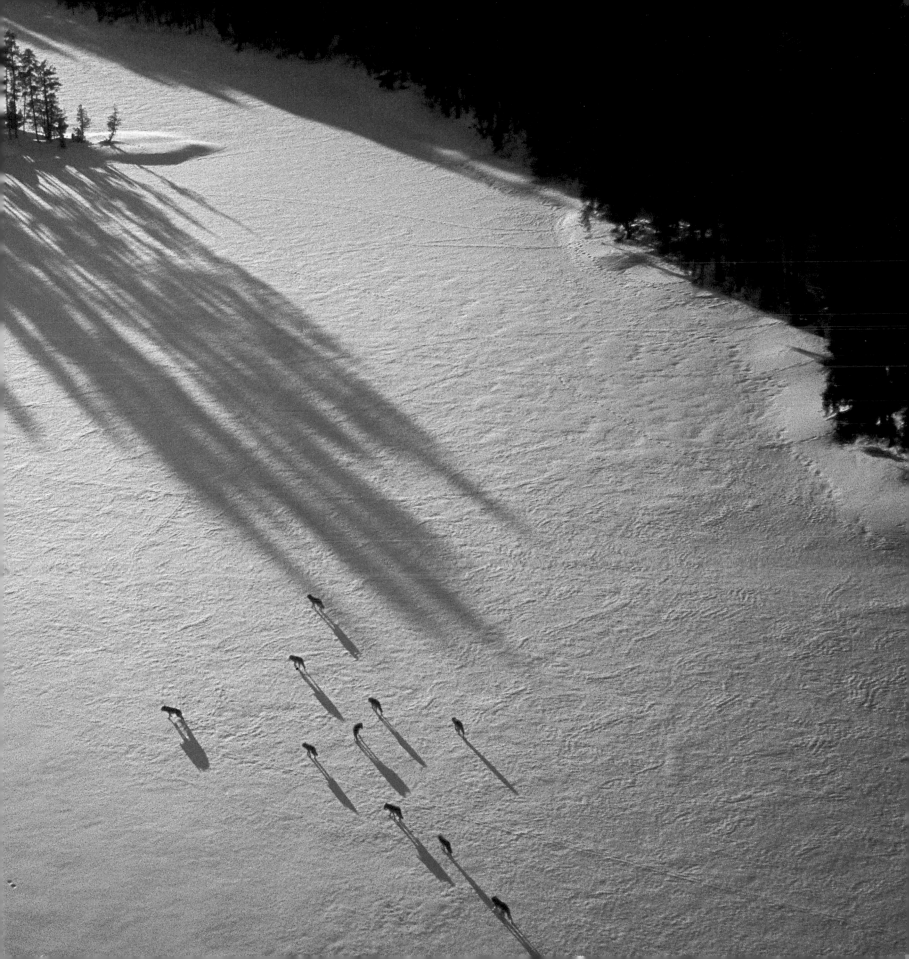

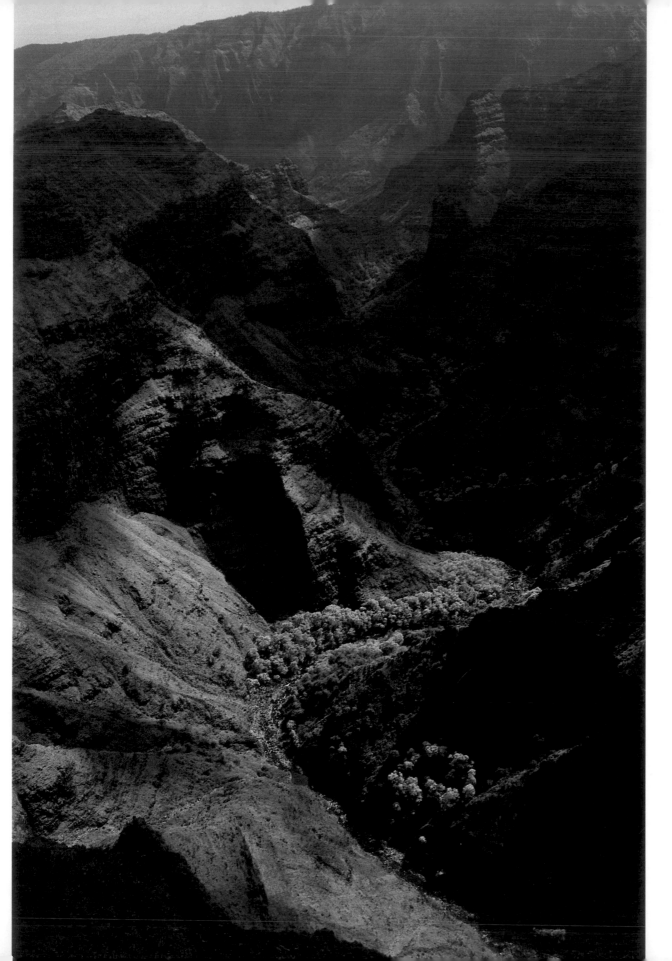

**David M Macri**
*USA*
HIGHLY COMMENDED

**NAPALI COAST, HAWAII**
The NaPali ('the cliffs') Coast State Park on the Hawaiian island of Kaua'i is a 6,500 acre park of wild, unspoiled coastal terrain, with lush valleys, dense rainforests and 24 km of high, steep cliffs plunging straight into the ocean. Late one afternoon, I took a helicopter tour through the more remote areas. Dramatic scenes unfolded before us as we flew from one canyon to the next, where shafts of late evening light added to the sense of rugged wilderness. We passed Mount Wai'ale'ale: with more than 12m of rain each year, it is officially the wettest place on Earth.

**Nikon F5 with Nikkor 35-70mm lens; 1/250 sec at f5.6; Ektachrome E100VS 100.**

**Vincent Munier**
*France*

### MOUNTAIN FOREST
### IN AUTUMN

The Vosges Mountain
forests in eastern France are
bewitching yet savage, and
this is what I set out to capture
on film. The pine forests flank
steep, often rocky, slopes, and
the weather is unpredictable,
with frequent, torrential
rain and fog. Some of the
trees measure more than
40 metres in height and are
about 150 years old. The rich
ecosystem possesses a
huge diversity of animal and
plant life and merits total
protection.

**Nikon F5 with 600mm lens; 1/30
sec at f11; Fujichrome Velvia; tripod.**

**Thomas D Mangelsen**
*USA*
**HIGHLY COMMENDED**

### DENALI NATIONAL PARK, ALASKA

This image seemed to be a diorama of Denali National Park, Alaska. The colours of the dwarf birch foliage were intensified by the setting sun.

highest peaks – it wouldn't be long until all of Denali would be blanketed in white. And centre-stage was one of Denali National Park's best-known mammals, the moose. This bull watched as his harem descended into the valley for the night.

**Fuji GX 617 with Fujinon 180mm**

## Tim Fitzharris
*USA*

### YOHO NATIONAL PARK, CANADA

This beautiful mountain range reflected in a large beaver pond was at Yoho National Park, British Columbia, Canada. I wore chest-waders so that I could get into position to frame the distant peaks with the dead spruces. This done, I had to wait for the wind to die and - the final touch - the rosy glow of sunset to light up the mountains.

**Pentax 645 with 45-85mm zoom lens; 1 sec at f22; Fujichrome Velvia.**

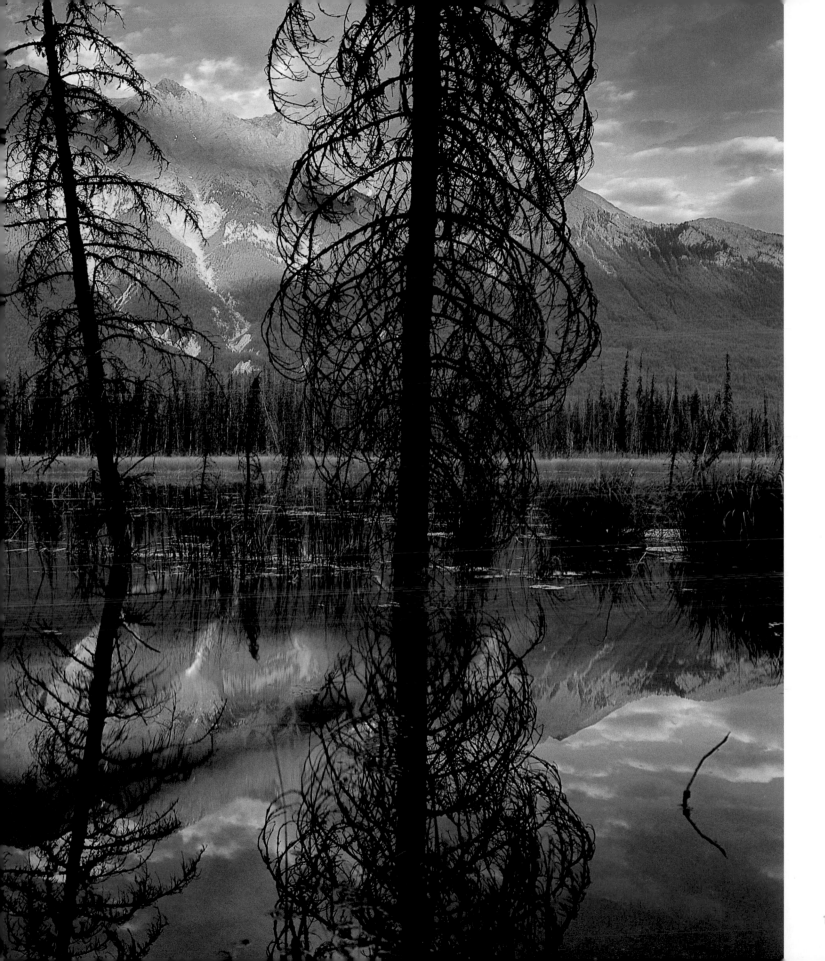

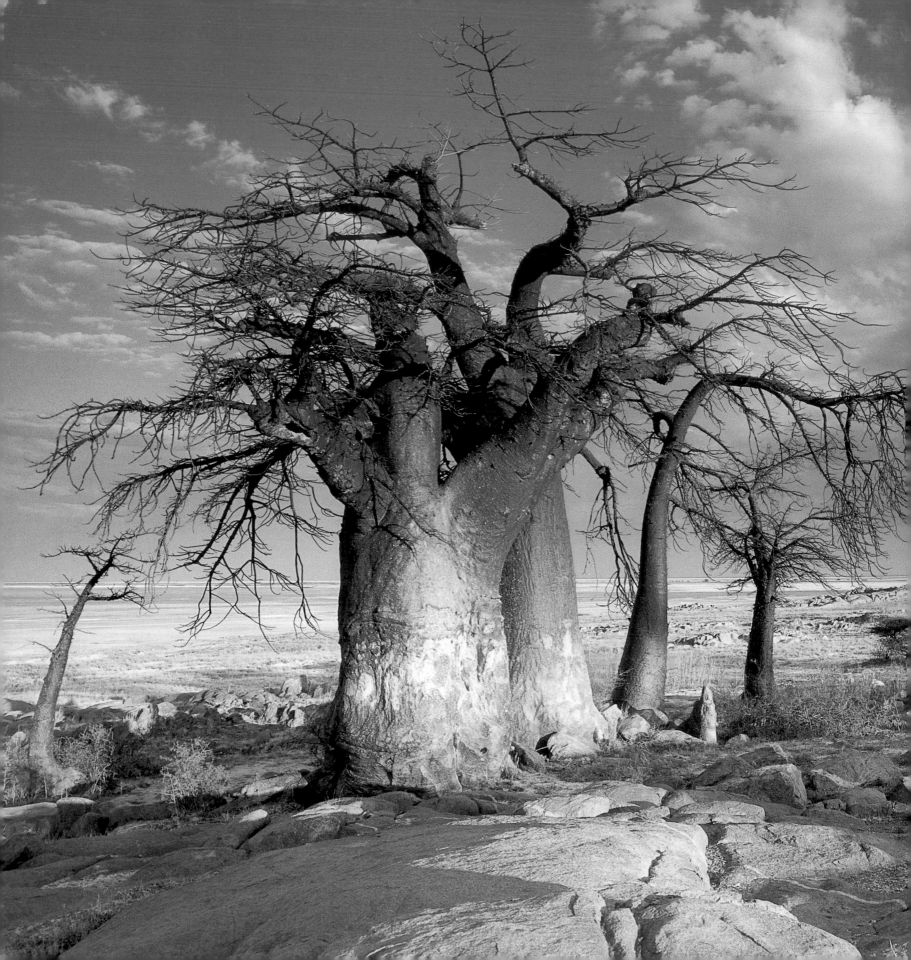

**Johann Mader**
*South Africa*

### KUBU ISLAND, BOTSWANA

The Makgadikgadi Pans in Botswana consists of two pans: Ntwetwe and Sowa. In summer, when the rain falls, these pans form large, shallow lakes that evaporate in the dry season. Kubu Island is a rocky outcrop on the south-western shore of Sowa Pan, decorated with magnificent baobab trees. The vast expanse, remoteness and subtle hues of the late-winter afternoon all contributed to the magic of the scene.

**Nikon F90X with 24-120mm lens; aperture priority at f16; Fujichrome Velvia; graduated grey filter.**

103

**J M Yong**
*Malaysia*
**HIGHLY COMMENDED**

**DAWN AT CERRO TORRE, PATAGONIA**

After several days of incessant wind, rain and cold during one of the worst summers in the Cerro Torre, Patagonia, in Argentina, the skies finally cleared one day, just before dawn. I left my tent and clambered up the moraine (area covered by rocks and debris dumped by a glacier) overlooking Lago (lake) Torre. At the top, I sat and waited for dawn – and what a light show it was. Within just 90 seconds of the first rays of sun striking the summit, the whole mountain was bathed in red. Two minutes later, it turned a glowing orange, then yellow.

**Nikon 90X with 35-105mm AF lens; approx 1/15 sec at f5.6; Fujichrome Velvia; beanbag.**

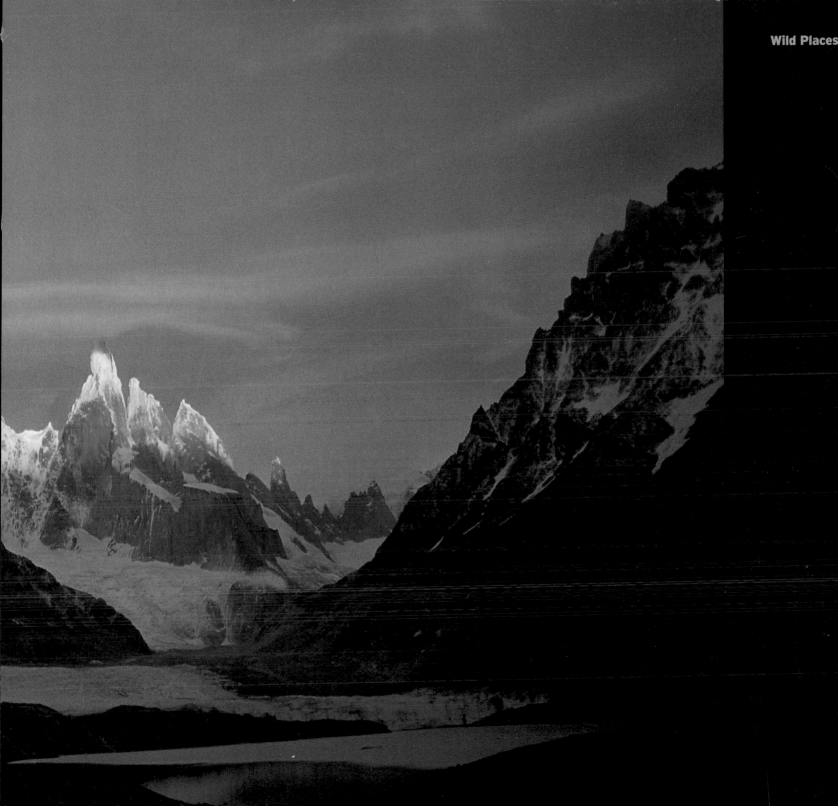

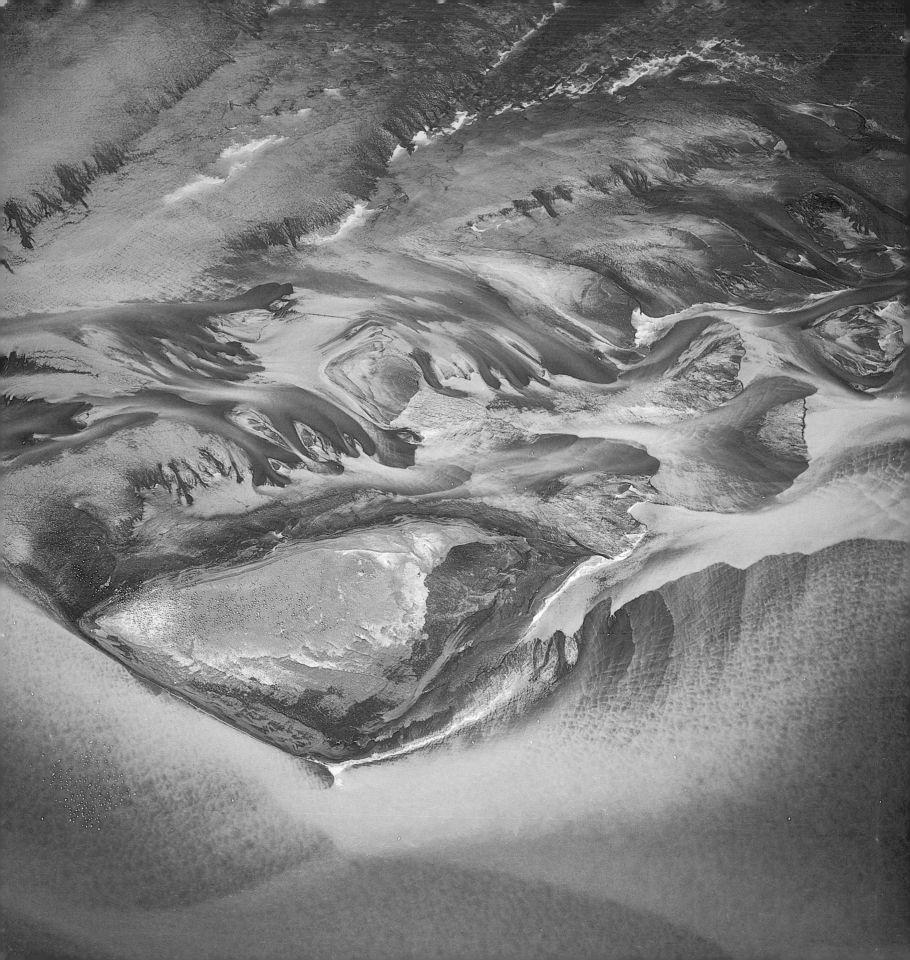

# Composition and Form

Here, realism takes a back seat, and the focus is totally on the aesthetic appeal of the pictures, which must illustrate natural subjects in abstract ways.

**Hans Strand**
*Sweden*

### RIVER DELTA WITH IRON OXIDE DEPOSITS

The source of the River Rangá is in the foothills of the Hekla, the most active volcano in Iceland. Rainwater washes iron from the lava fields into the Rangá, and iron-oxide particles are deposited along the banks. By the time the river reaches the south coast, the entire estuary looks, from an aeroplane, as though it is rusting. We kept on circling the delta until I finally got the composition I wanted, with a flock of several hundred kittiwakes on one of the riverbanks.

**Hasselblad 203 FE with CF 100mm lens; 1/1500 sec at f4; Kodak E 100VS 160 (pushed 2/3 stops).**

**Jan Töve**
*Sweden*

### IMPRESSION OF A BEECH FOREST

Last October, in a beech forest near Lake Tolken, Sweden, I was attracted by the varied colours of the leaves. I struggled for hours to find the best way to photograph them. By concentrating on the blurred shapes of leaves and trunks rather than keeping everything in sharp focus, I achieved an impression rather than a straight reproduction of the beech forest.

**Pentax 67 with 300mm lens; 1/125 sec at f4; Fujichrome Velvia; tripod.**

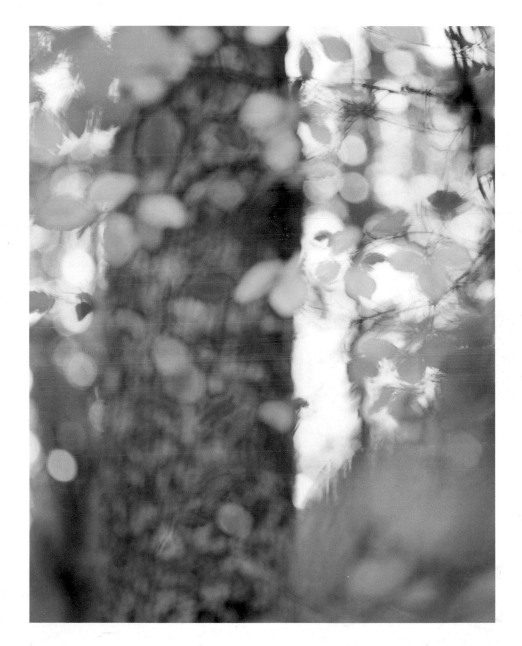

**Patricio Robles Gil**
*Mexico*

**WHITE-COLLARED SWIFTS EMERGING FROM A SINKHOLE**

Every morning, hundreds of thousands of white-collared swifts fly simultaneously out of 'El Sótano de las Golondrinas' ('the pit of the swallows') in La Huasteca Potosina, near the Gulf of Mexico. This is the sixth deepest sinkhole in the world. Its base, some 376m below, narrows to a lip 50m wide at the top. When the swifts set off, you can hear them screaming faintly below. They spiral up until they pour out of the top like a tornado, the noise from their beating wings like rushing wind. Some are so tired that they crash straight into the vegetation.

**Nikon F5 with 80-200mm lens; Fujichrome Provia 100.**

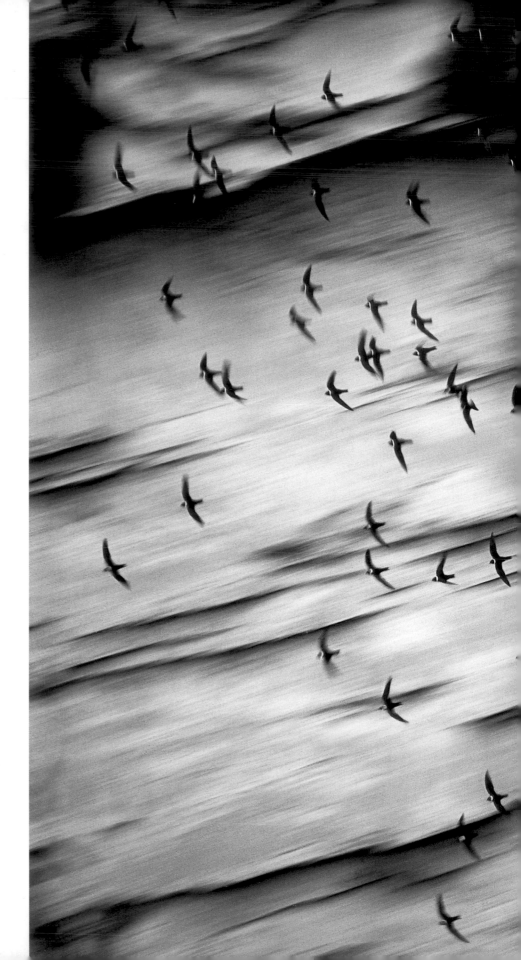

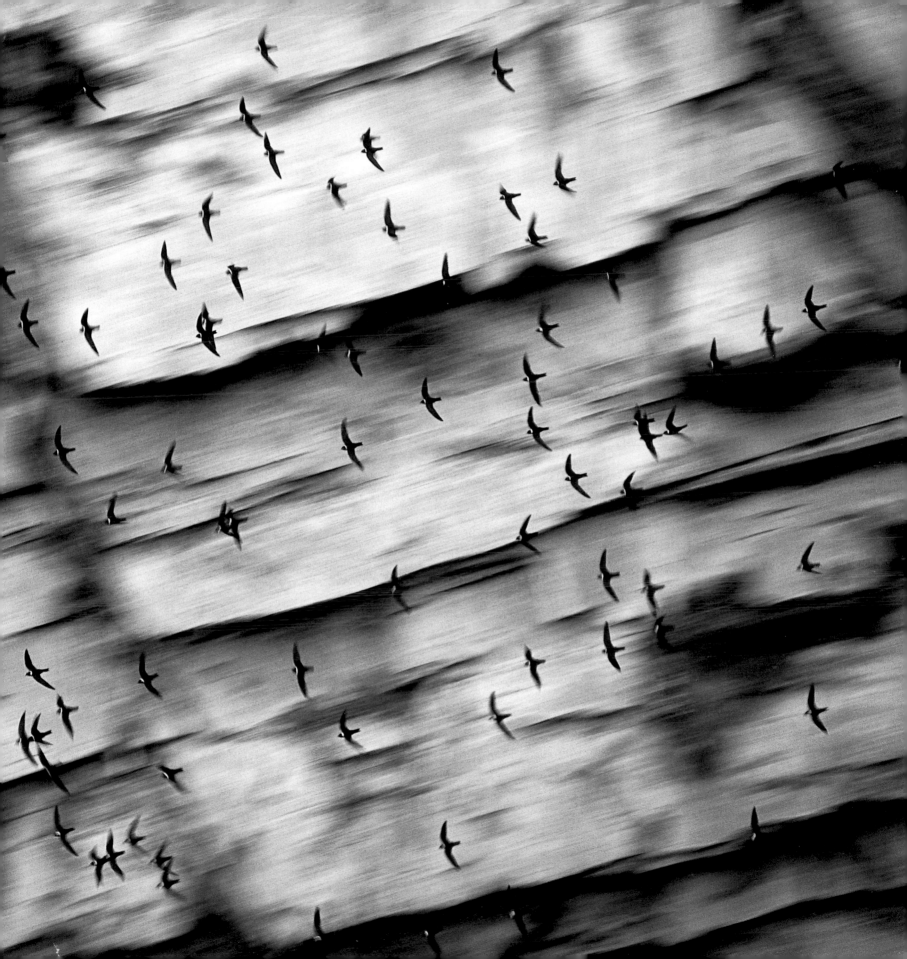

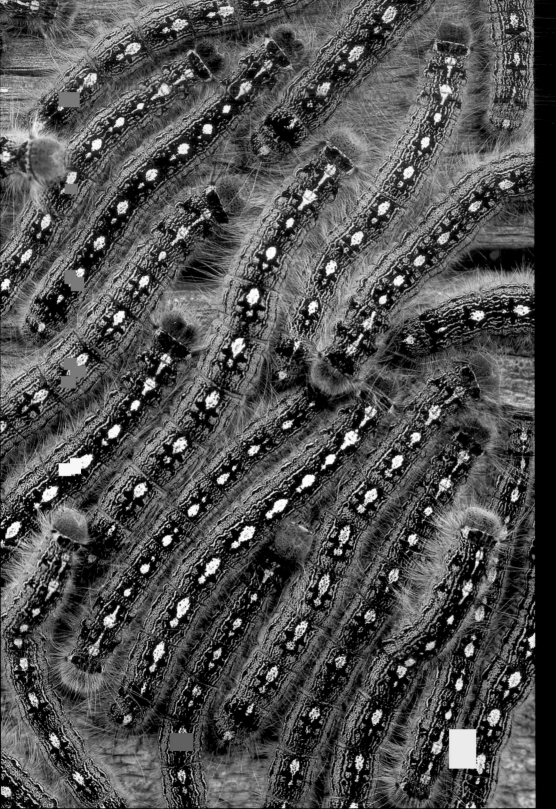

## Alan K Charnley
*USA*
**HIGHLY COMMENDED**

### EASTERN TENT MOTH CATERPILLARS

While on holiday in Canada, I found this cluster of tent caterpillars on our cabin. Their curved bodies looked like sections of track stacked in a miniature railway yard. Tent caterpillars spin a thick, communal silk marquee in a fork of the trees and shrubs. The caterpillars (there may be up to 100) emerge to feed, retreating inside at night or in bad weather. Dozens of these silken tents may adorn individual trees. When the caterpillars are fully grown, as these ones are, they leave their tent in search of somewhere to make their cocoons.

**Nikon F4 with 200mm macro lens; 0.5 sec at f16; Fujichrome 50; tripod.**

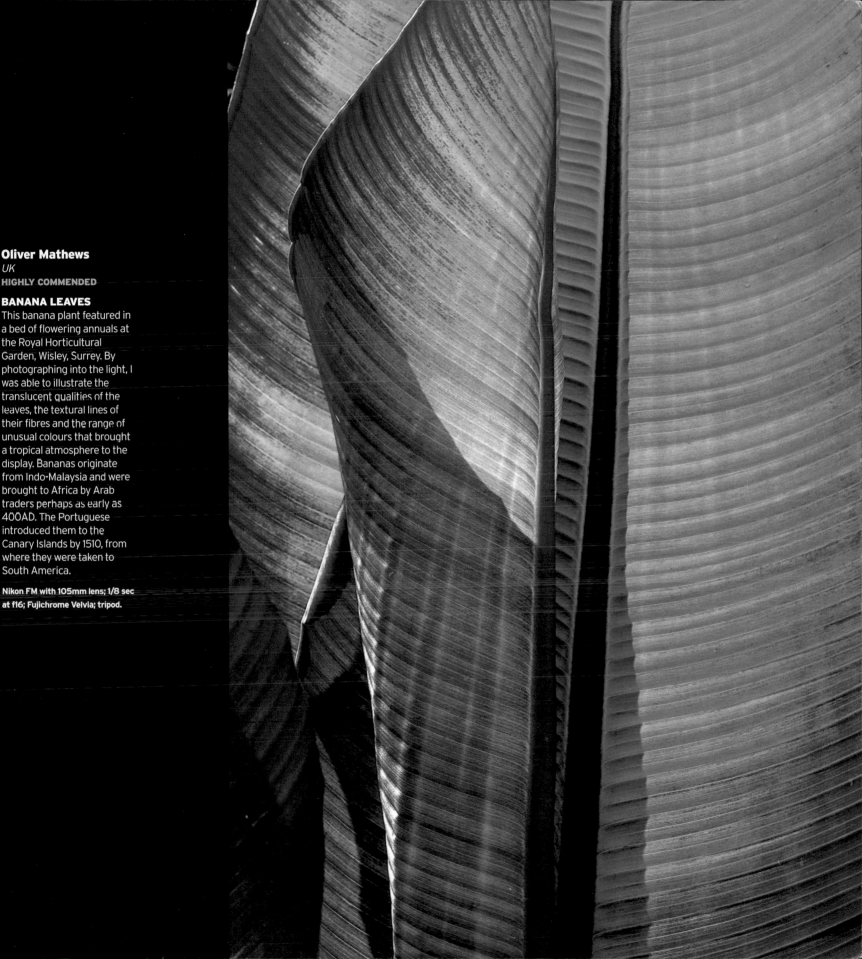

**Oliver Mathews**
*UK*
HIGHLY COMMENDED

## BANANA LEAVES

This banana plant featured in a bed of flowering annuals at the Royal Horticultural Garden, Wisley, Surrey. By photographing into the light, I was able to illustrate the translucent qualities of the leaves, the textural lines of their fibres and the range of unusual colours that brought a tropical atmosphere to the display. Bananas originate from Indo-Malaysia and were brought to Africa by Arab traders perhaps as early as 400AD. The Portuguese introduced them to the Canary Islands by 1510, from where they were taken to South America.

**Nikon FM with 105mm lens; 1/8 sec at f16; Fujichrome Velvia; tripod.**

### Reinhold Schrank
*Austria*
**HIGHLY COMMENDED**

### ICE PATTERN
Every winter, the slow-flowing Raab River near my home in Austria freezes over. The ice-crystals create ornate shapes, and I often search among them for interesting patterns to photograph. The morning light was shining on the edge of the river, and it was there that I spotted this tiny 'face' in the ice. It was no more than 2mm wide, and I had to stand in the river to photograph it. This was tricky: the air temperature was -12°C, and the quick-lock mechanism of the tripod froze immediately.

**Nikon F90X with AF Micro-Nikkor 200mm lens; Fujichrome Velvia; tripod.**

## Nusret Nurdan Eren
*Turkey*

### WATER PLANTS WITH AUTUMN REFLECTIONS

The Yedigöller (Seven Lakes) National Park at the west Black Sea region of northern Anatolia is the most beautiful mixed natural forest in Turkey. In autumn, the different colours and shades of its trees reflect on the water of the lakes, like one vast Impressionist painting. Strolling around the shores of Derin Göl (Deep Lake) one November afternoon, I noticed that the reflections of the yellowing trees on the opposite shore were forming beautiful compositions with the turquoise leaves of floating-leaf pondweed. I took the photograph immediately, as this phenomena appears only at certain times of day.

Canon T90 with 100-300mm zoom lens; 1/8 sec at f22; Fujichrome Velvia; tripod.

# The World in Our Hands

These pictures illustrate, whether symbolically or graphically, our dependence on the natural world or our capability for damaging it.

**WINNER**

**Pete Oxford**
*UK*

**GREEN IGUANAS DESTINED FOR CURRY**
A favourite delicacy in Guyana, South America, is iguana curry. Early in the morning at the main market in the capital Georgetown, the vendors line up their catch, trussed up and still alive. The huge demand means the iguanas are sold out early. Though iguanas are increasingly hard to find in the wild, there has been no effort to farm them for human consumption.

**Nikon F5 with 20-35mm lens; Fujichrome Velvia.**

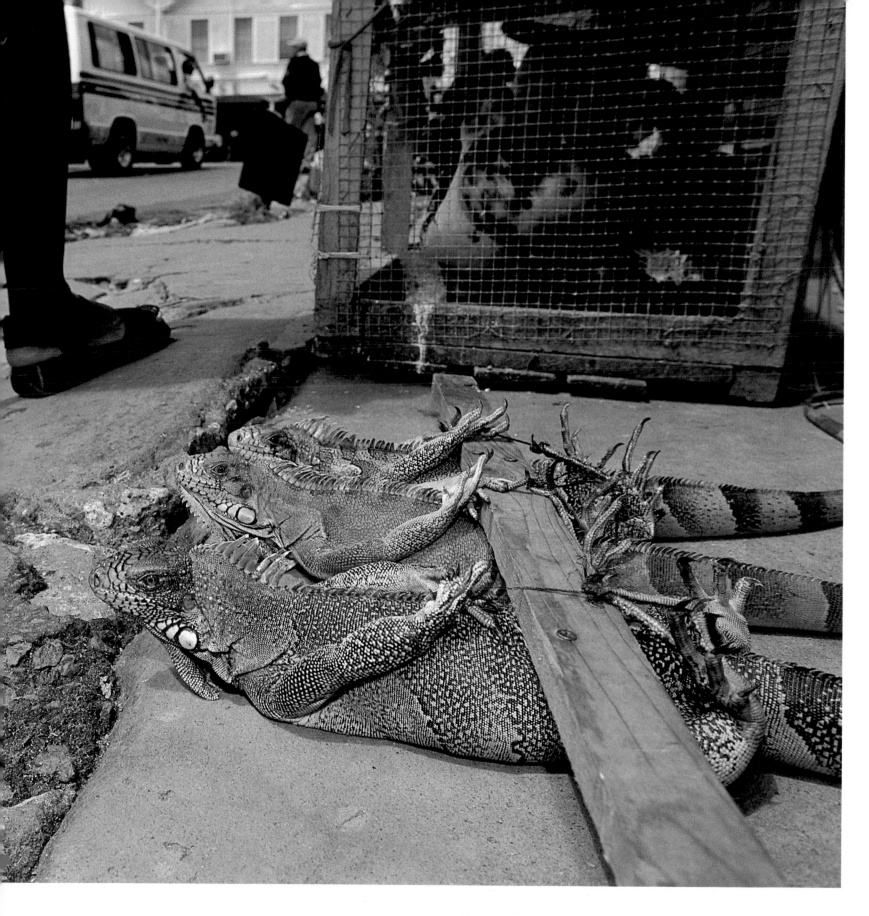

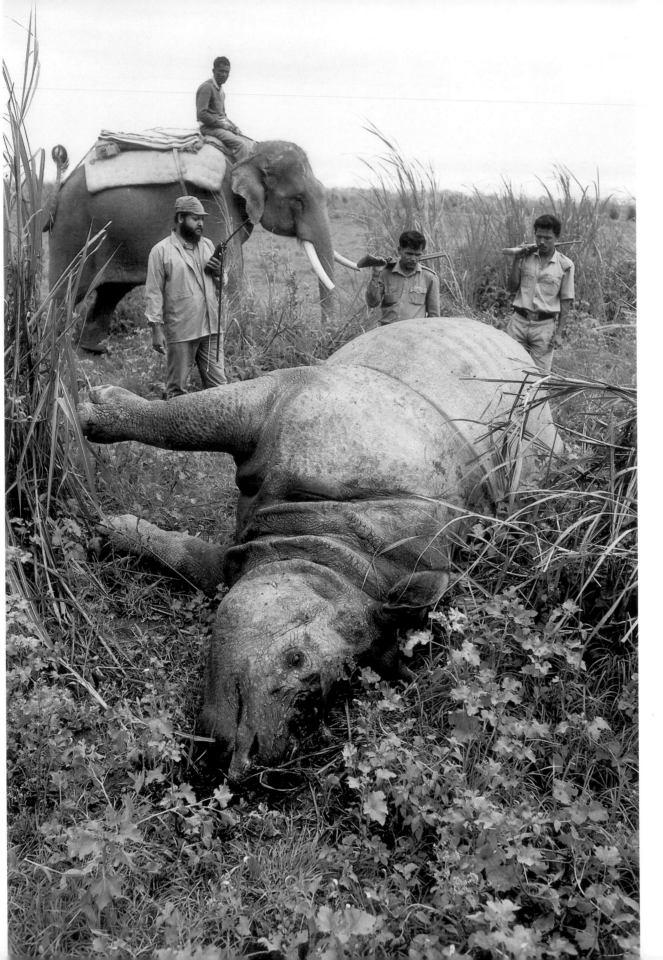

**Rajesh Bedi**
*India*

### INDIAN RHINO KILLED FOR ITS HORN

This male Indian rhino was one of two that were shot one night in Kaziranga National Park. Its single horn had been carved off by poachers and was probably destined for the Chinese medicine industry, to be sold as an aphrodisiac. All five remaining rhino species are now highly endangered.

Canon EOS 1NR with 20-70mm lens; 1/60 sec at f8; Fujichrome 100.

RUNNER-UP

**H Heinz Rauschenberger**
*Germany*

### SLOTH BEAR IN A ZOO

This sloth bear in the zoo in Colombo, Sri Lanka, was in a damp, concrete enclosure. It was out of condition and clearly miserable. In the wild, sloth bears feed extensively on termites, and their long muzzles are specially adapted for inserting into termite nests, with nostrils that can be closed voluntarily, protruding lips, and missing teeth that form a gap through which termites can be sucked.

Canon EOS 50E with 28-105mm lens; 1/125 sec; Fujichrome Velvia; onestand-pod.

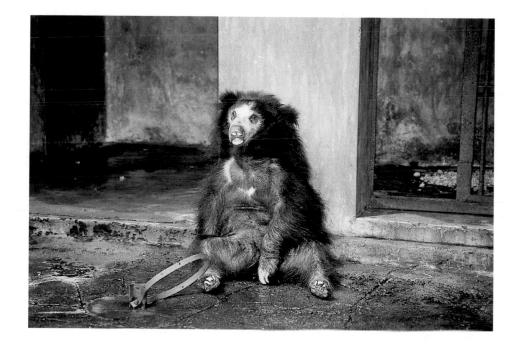

**Martin Harvey**
*South Africa*

### JACKASS PENGUIN OIL-SPILL VICTIM

On 23 June 2000, the carrier *Treasure* sank off the Atlantic Cape Coast, South Africa. Four hundred tons of heavy fuel oil spewed out into the sea, putting 40 per cent of the world's population of jackass penguins in danger. This bird, on Robben Island (one of the penguins' most important breeding colonies), was so weak that I was able to photograph it from just a couple of metres away. Thanks to an immediate, intensive rescue operation, most of the adult birds (about 20,000) were captured and cleaned. But without healthy adults to care for them, many of the eggs and chicks perished.

Canon EOS 1n with Canon EOS 17-35mm lens; f2.8; Fujichrome Velvia.

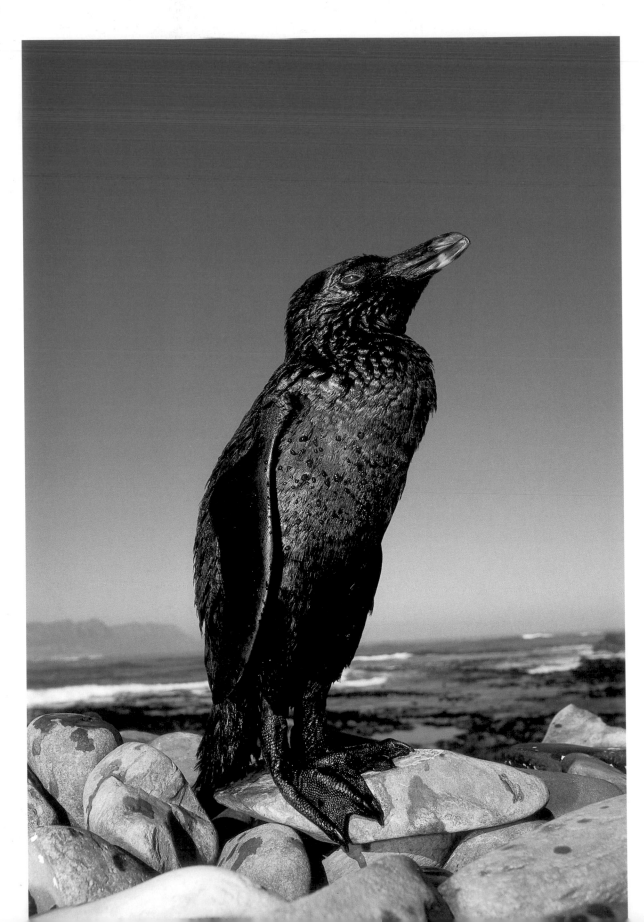

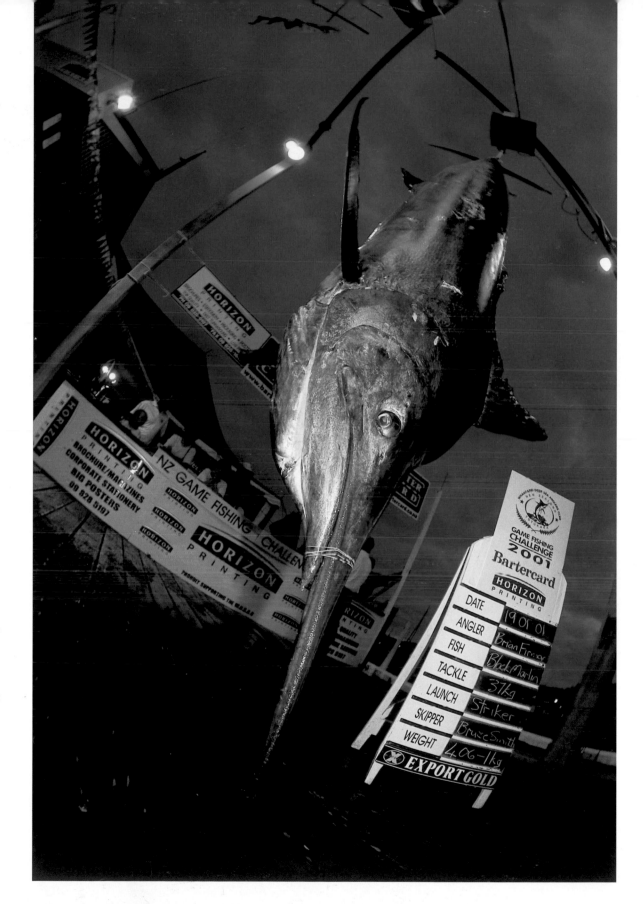

**Tobias Bernhard**
*Germany*
HIGHLY COMMENDED

**BLACK MARLIN
AT A FISHING-CLUB
WEIGHING STATION**
In New Zealand, fishing
contests are held almost every
summer weekend. They
attract a great deal of public
attention – and, of course,
sponsorship. It's not
uncommon to see magnificent
animals such as mako sharks
and marlin strung up and
displayed in the name of sport
and weekend entertainment.
This black marlin was being
weighed at a game-fishing
club in Tutukaka. The ghostly
green floodlights seemed to
provide a fitting backdrop to
the death in the marlin's eye.

**Nikon F90X with 20mm lens;
1/10 sec at f8; Fujichrome Astia
100 with SB 26 flashgun.**

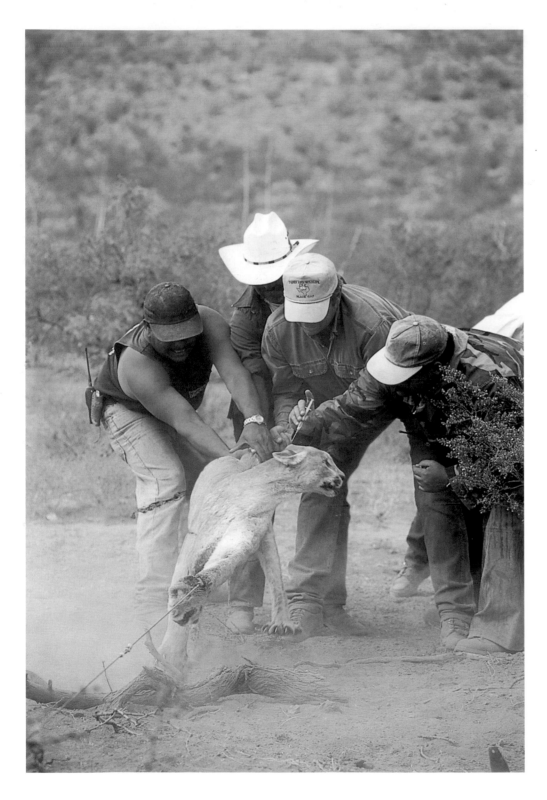

### Patricio Robles Gil
*Mexico*
**HIGHLY COMMENDED**

### MOUNTAIN LION BEING TRAPPED FOR RELOCATION

Wild desert sheep are being reintroduced into a 5,000ha area in Mexico's Chihuahua Desert, where they have been locally extinct for 60 years. But first, potential predators have to be relocated. After evading capture for a week, this female mountain lion, or puma, was finally trapped in a humane snare. The most experienced trapper crept up behind her, then grabbed her by the tail and immobilised her. As soon as he did this, the biologists rushed in to inject a sedative as quickly as possible, in order to minimise stress to her. Hours later, the mountain lion was released about 10km away.

**Nikon F5 with 500mm lens; Fujichrome Provia 100; tripod.**

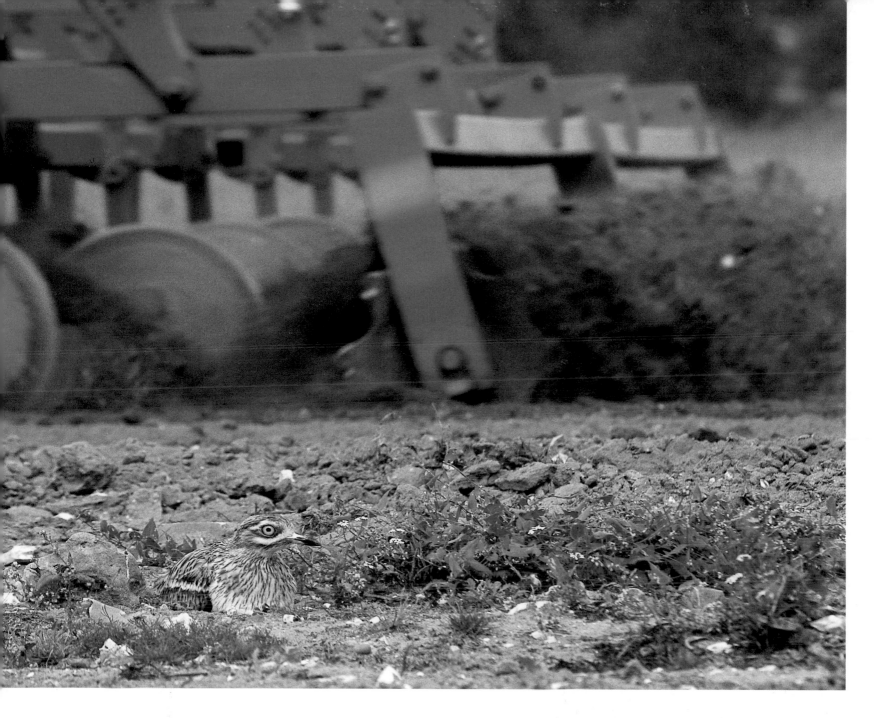

## Chris Knights

*UK*

### NESTING STONE CURLEW

Most farmers in the Brecklands – a sandy, flintstone region in Norfolk and Suffolk – look out for nesting stone curlews. Usually, a 20m box is left around a nesting pair. In this instance, the cultivator driver spotted the nest, but not until he passed within 2m of it. Even so, the female bird sat completely still. Later, she successfully raised another brood, again with two chicks. I first photographed stone curlews in 1957 and have had their interests at heart ever since.

**Canon 100-400mm lens; 1/400 sec at f8; Fujichrome Sensia 100.**

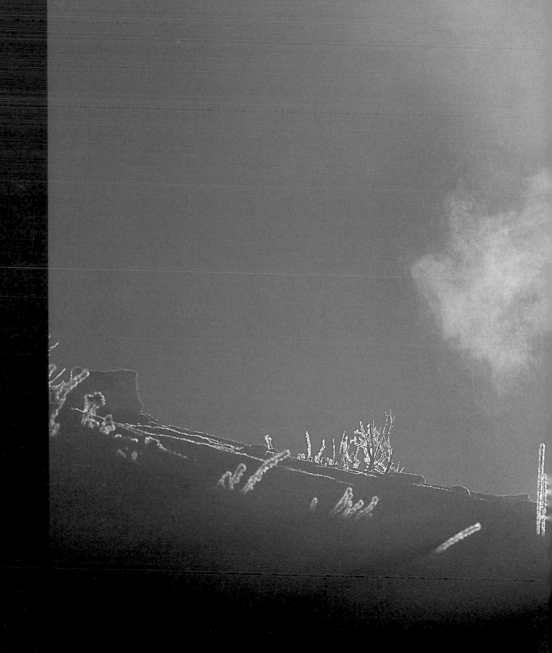

# Animal Portraits

This has become the most popular category of the competition. Pictures must show the animal in full- or centre-frame and convey the spirit of it.

WINNER

**Mervin D Coleman**
*USA*

**AMERICAN BISON
DE-FROSTING**
Early one bitterly cold morning in the Yellowstone National Park's Lamar Valley, I came across three bison standing by the side of the road. It had been – 26˚C that night, and they were still covered in frost. I noticed that the sun was just beginning to peek over the far ridge, silhouetting one of the bison. As steam began to rise from his frost-covered body, it added moisture to the air, creating a prism of colours around this classic symbol of the American West. It was a magical, almost spiritual moment.

Canon A2-EOS with Canon EF 300mm lens plus Canon 1.4 Tele-extender attached for a focal length of 420mm; Fujichrome Velvia; tripod.

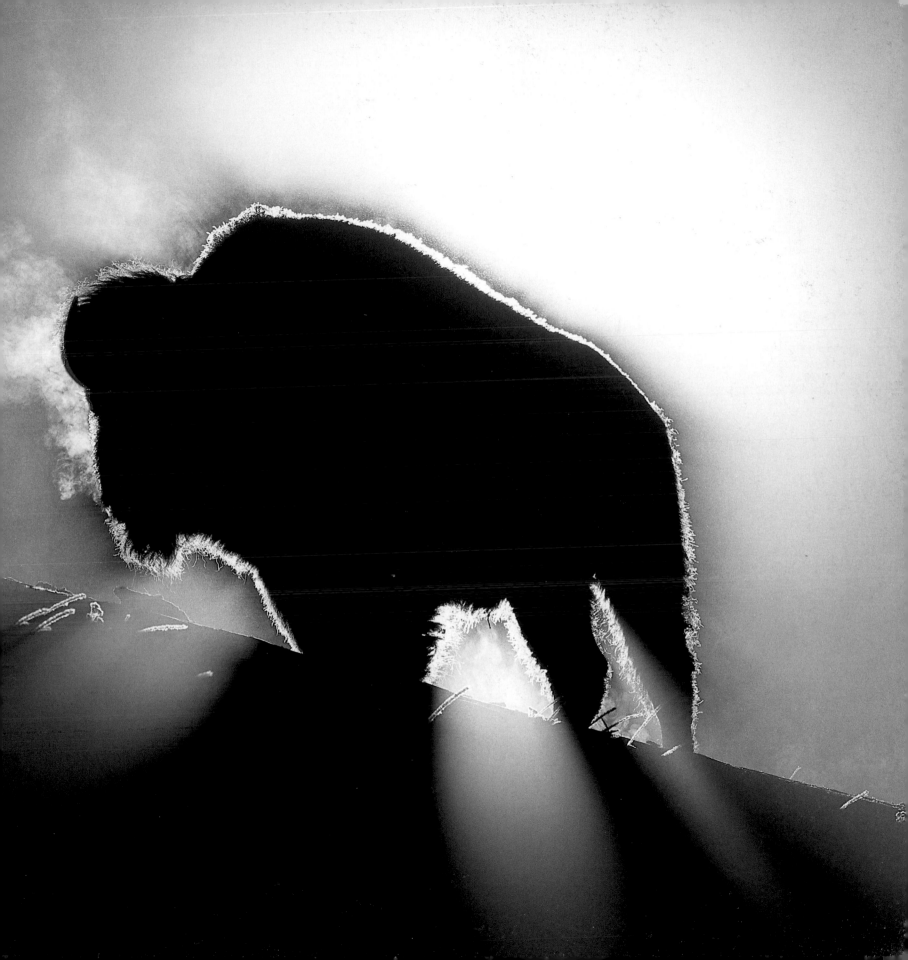

**RUNNER-UP**

**Richard Kuzminski**
*USA*

**HARLEQUIN DUCKS
IN SPRAY**
With their habitat being
destroyed by development
and contamination, fewer
than 1,500 harlequin ducks
remain along the North
American Atlantic coast.
Designated as endangered in
Canada, the sea ducks winter
in a harsh environment, where
ocean surf pounds against
rocky coastlines. The ducks
here were sheltering from the
turbulent conditions to bask in
the February sun. While they
relaxed, though, spray from a
powerful wave hit them, and
they fled. Meanwhile,
positioned between two
boulders to get the shot, my
camera and I took the brunt
of this massive wave.

**Canon EOS-1V with 400mm lens
plus Canon 2X extender; 1/50 sec
at f16; Fujichrome Astia 100.**

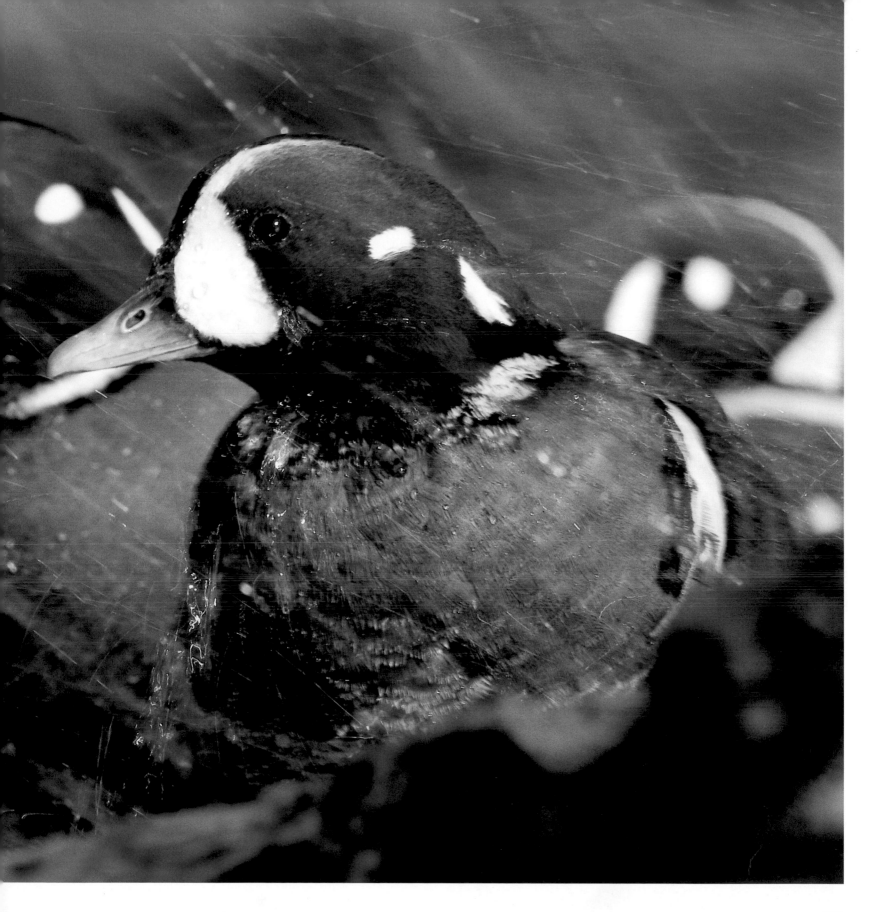

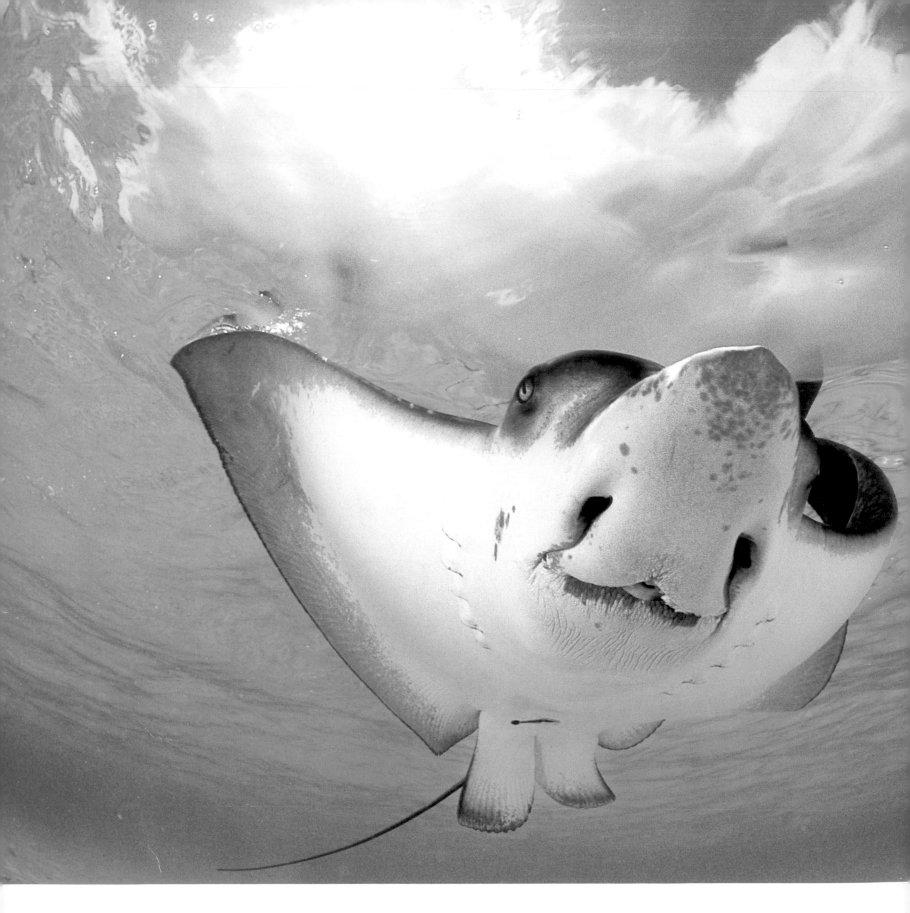

**Doug Perrine**
*USA*

**SPOTTED EAGLE RAY**
Fishermen used to clean their catch at this shallow sandbar in the Caribbean, which attracted stingrays and nurse sharks. Eventually, tour guides realised they could earn money by bringing tourists to the sandbar to see these fish, and now they use bait to draw the rays and sharks close to the boats. This spotted eagle ray came so close I could see a wad of copepod parasites on the upper side of its snout (not visible in photo). After the bait was gone, the ray stayed in the area, ploughing through the bottom sediments for molluscs.

Nikonos RS with 13mm lens; Fujichrome Velvia; twin substrobes with diffusers.

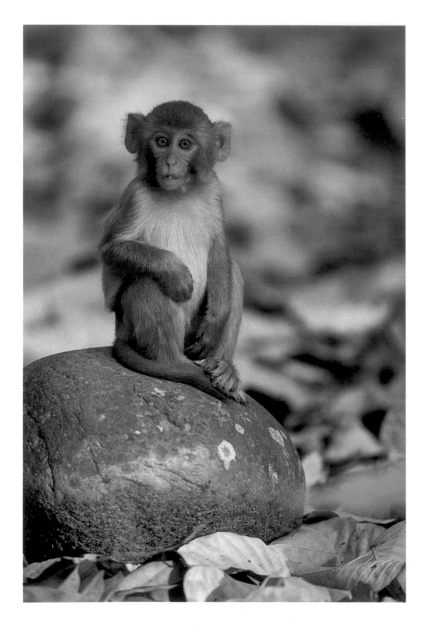

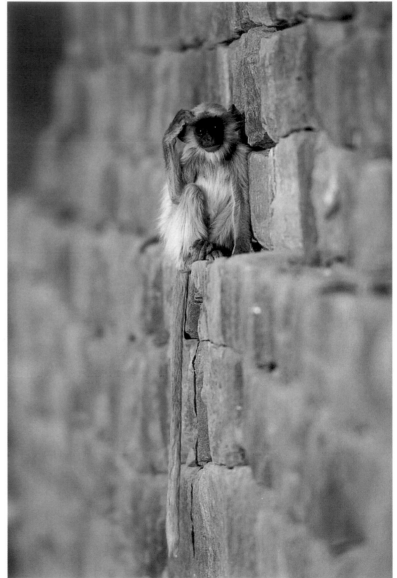

**Frédéric Fève**
*France*

**YOUNG RHESUS MACAQUE**
I came across a small group of about 15 rhesus macaques in the Corbett National Park, in Uttar Pradesh, India. It was late afternoon, and most of them were foraging quietly through the leaf-litter. This youngster, though, was resting alone. When we stopped, the macaque stared at us with a mixture of surprise and curiosity.

Nikon F100 with Nikon 500mm lens; 1/40 sec at f4; Fujichrome Sensia II 100; tripod.

**Jean-Pierre Zwaenepoel**
*Belgium*

**JUVENILE HANUMAN LANGUR**
While other youngsters from its troop played among the walls of a temple complex, this young, bright-eyed Hanuman langur took a break to watch me as I set up my cameras. The troop is part of an isolated population of around 2,000 that have adapted to life in the city of Jodhpur at the edge of the Thar Desert in western India. They live in scattered groups of between 10 and 60 individuals.

Nikon F-100 with 500mm lens; 1/250 sec at f5.6; Fujichrome Sensia II rated at 125; tripod.

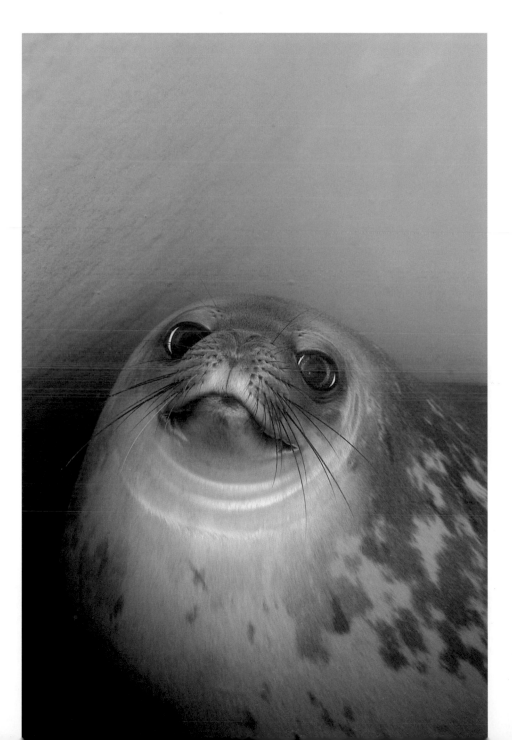

**Norbert Wu**
*USA*

**WEDDELL SEAL RESTING IN AN ICE-CAVE**
Weddell seals are champion divers; they can descend to at least 600m and hold their breath for up to 82 minutes. Around Antarctica, the seals swim along underwater passageways created by the sea-ice buckling and splitting along pressure ridges. I came across this adult seal taking a nap underwater. I surfaced to change cameras, and when I went back down 30 minutes later it was still there.

Nikon N90 with 24mm lens; maybe 1/30 sec at f2.8; Fujichrome Sensia 100; Sea and Sea housing; flash.

*Overpage*
**Franco Banfi**
*Switzerland*

**STAR-GAZER**
Nutrients flowing through the Lembeh Strait in North Sulawesi support a wealth of marine life. Among the creatures on my wish-list was a star-gazer. This strange-looking fish buries itself at the bottom of the seabed, visible only to those who look closely enough. We found this one at night, its broad, upside-down grin poking out from beneath a blanket of volcanic sand.

Nikon F90X with 105mm macro lens; 1/100 sec at f22; Fujichrome Velvia rated at 40; strobes.

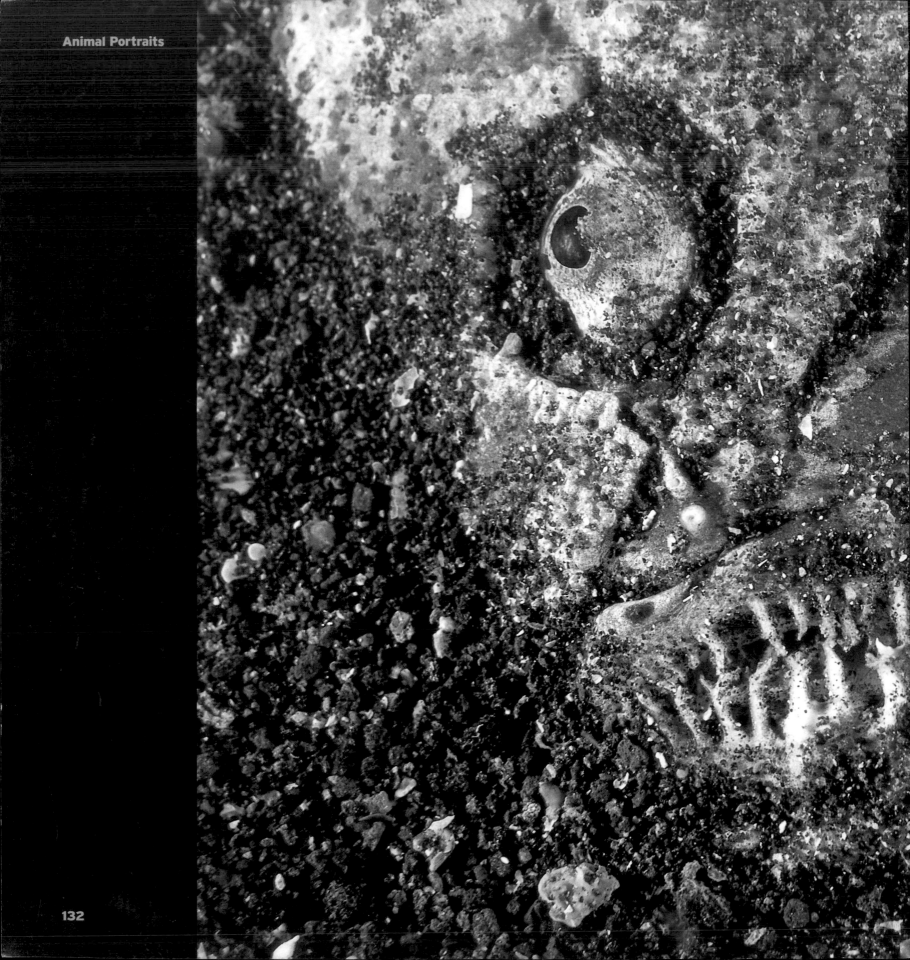

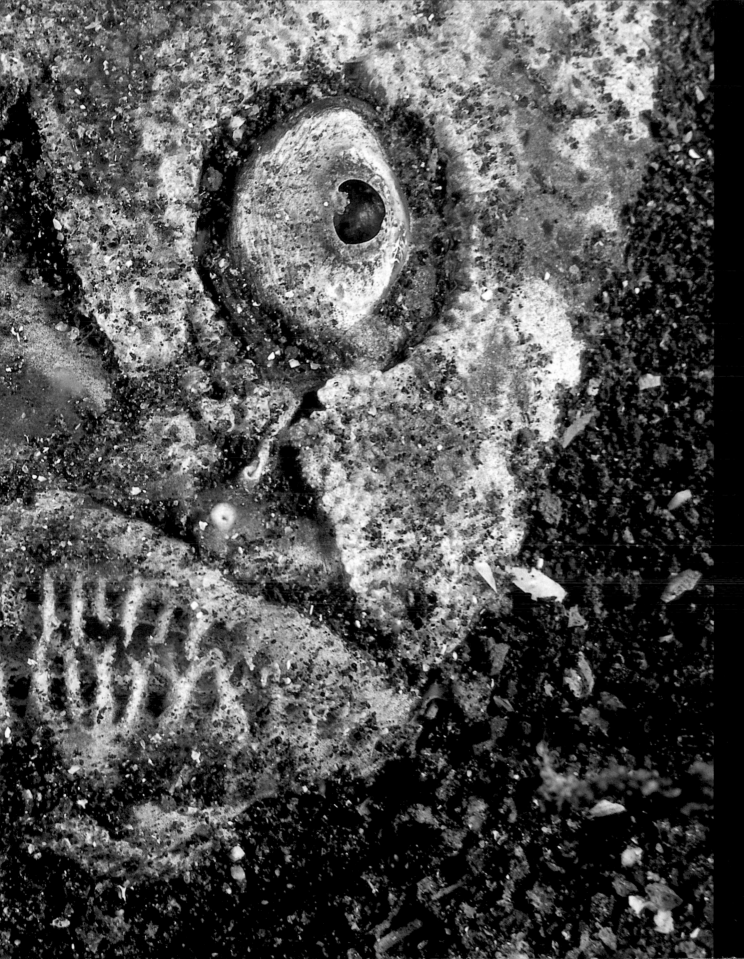

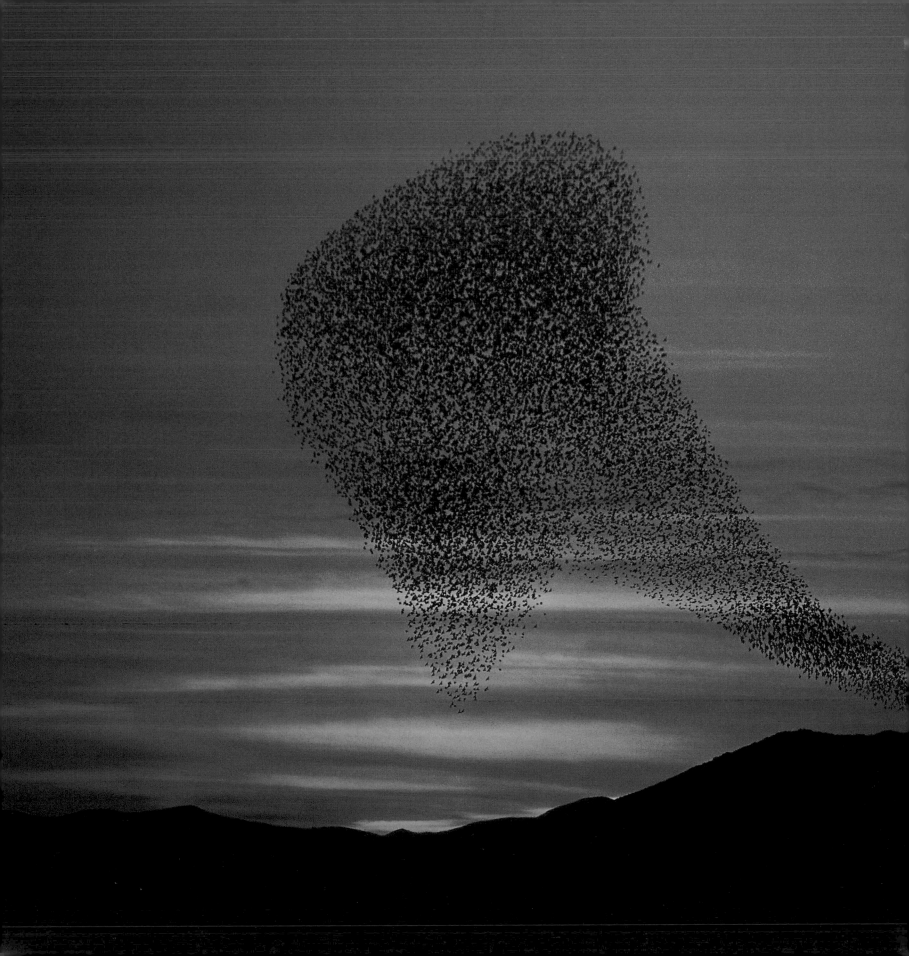

# From Dusk to Dawn

The criterion for this category is strict: the wildlife must be photographed between sunset and sunrise; the sun may be on but not above the horizon.

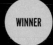

**WINNER**

**José L Gómez de Francisco**
*Spain*

**STARLINGS FLYING IN TO ROOST**
Near Logroño, in northern Spain, there's a small lake where starlings used to roost. Each evening, the birds massed together, flying in amazing movements as though they were iron filings being swept around the sky by a huge, invisible magnet. They would eventually settle in the reedbed to spend the night. It took me several days one December to get the image I wanted against a red sunset backdrop. This wasn't easy because the birds moved so quickly, and the sun was very low. When I visited last winter, the starlings were no longer roosting there.

Nikon F-801S with Sigma 70-210mm APO lens; 1/125 at f4; Fujichrome Provia 100; tripod.

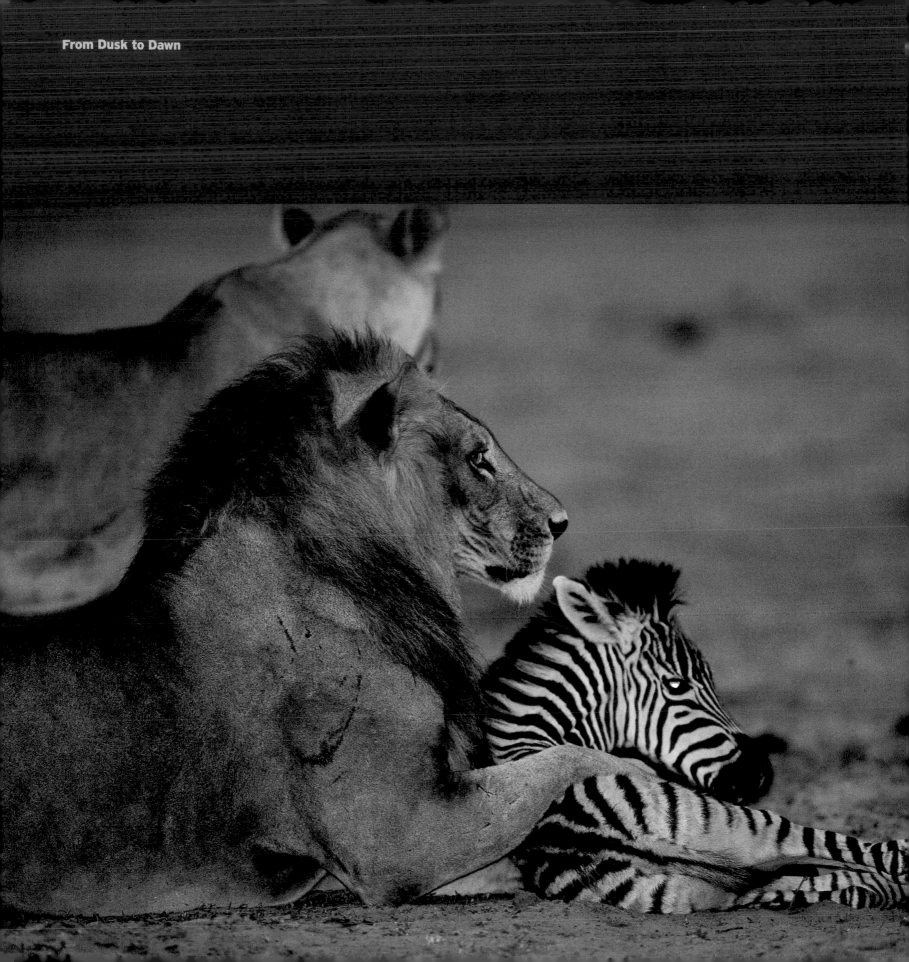

### Adrian Bailey
*South Africa*

### LION WITH A ZEBRA FOAL

As the summer rains begin in northern Botswana, thousands of Burchell's zebra migrate to fresh grazing grounds further south. This zebra foal in the Chobe National Park's Savute region had become separated from the rest of its herd. A pair of lions arrived, and the male promptly captured the foal and held it in this grotesque pose for a few minutes. When he released it, the foal stumbled to its feet and began to run away. By then, though, the rest of the pride had arrived. Within half an hour, all that remained were a few tatters of striped hide.

**Nikon F5 with 500mm lens; Fujichrome Velvia; flash.**

### Paul Funston
*South Africa*
**HIGHLY COMMENDED**

### LION AND ADVANCING STORM

Four large, adult, male lions had killed a giraffe in Kruger National Park, South Africa. Hungry spotted hyenas gradually homed in, waiting impatiently for the lions to finish. After two days, their numbers had increased to such an extent that they were becoming bothersome to the feeding hunters. When a late afternoon thunderstorm gathered overhead, the lions finally deserted the carcass, walked across the dam wall and stood silhouetted against the dramatic sky, which is when I took this photograph.

**Nikon F90X with 300mm lens plus 2x converter; 1/60 sec; Fujichrome Velvia; beanbag.**

137

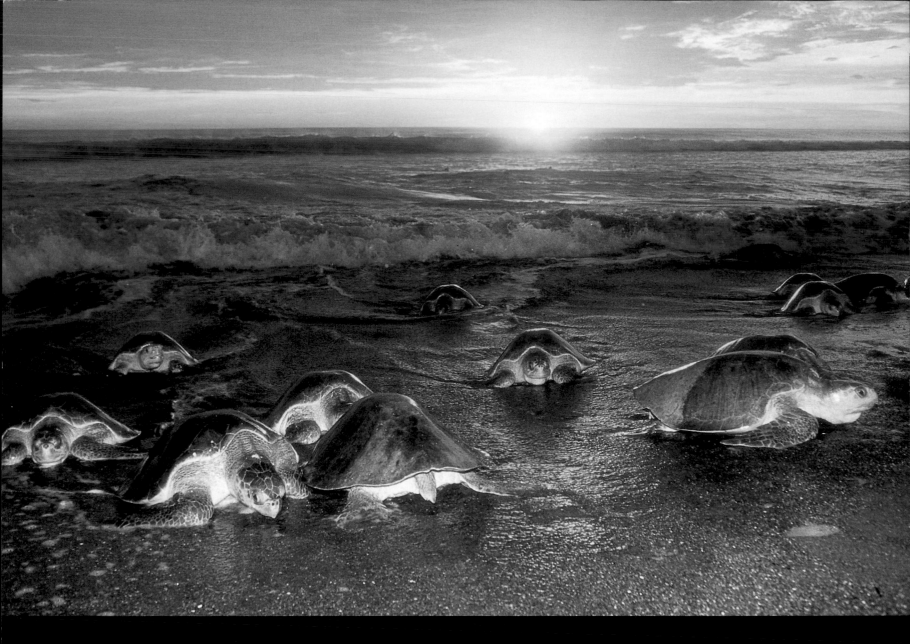

## Doug Perrine
*USA*
**HIGHLY COMMENDED**

### OLIVE RIDLEY TURTLES AT SUNSET

This is an 'arribada' (Spanish for 'arrival') of olive ridley sea turtles on the Pacific coast of Central America. The olive ridley is one of the world's seven species of sea turtle, of which only two nest in these large, highly synchronised aggregations.

1960s, by which time they were already suffering from heavy exploitation, with both the eggs and turtles being harvested for food. Stringent conservation measures mean that some arribadas have begun to swell in numbers again – the nesting aggregation in the photo was estimated at half a million turtles, nesting over five days.

**Nikon N90 (F90) with 35-70mm**

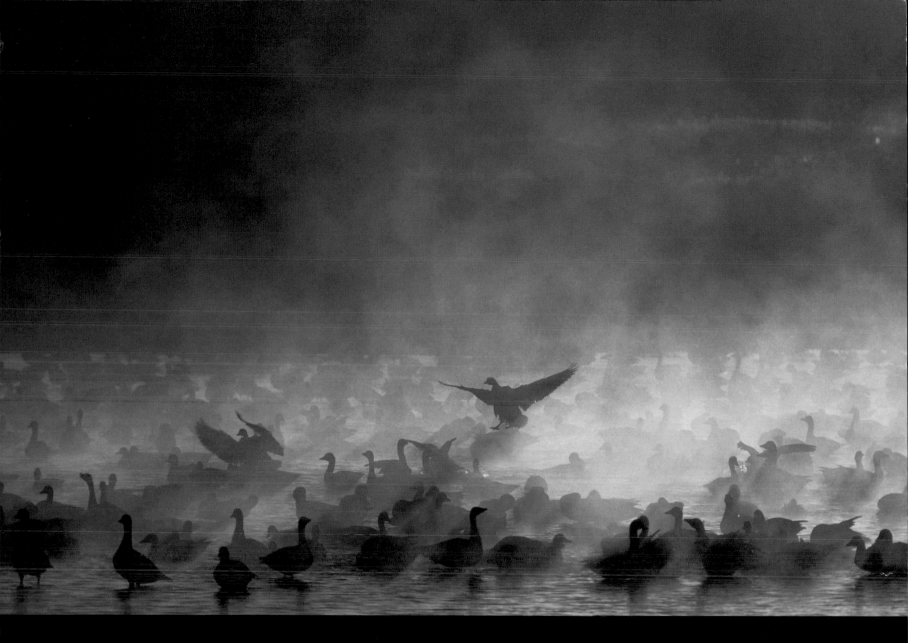

**Arthur Morris**
*USA*
**HIGHLY COMMENDED**

### SNOW GEESE IN MORNING LIGHT

About 30,000 snow geese overwinter in Bosque del Apeche National Wildlife Refuge in New Mexico, USA. They arrive from the North in November, and stay until March. In the past 8 years, I've spent more than 200 winter days taking photographs of them and have experienced 'fire-in-the-mist' only twice in all that time. As the early morning sun burned through the ground fog, it gave the impression of a huge blaze.

*Canon EOS 1N with EF600mm lens; evaluative metering + 2/3 stops; 1/320 sec at f5.6; Fujichrome Velvia.*

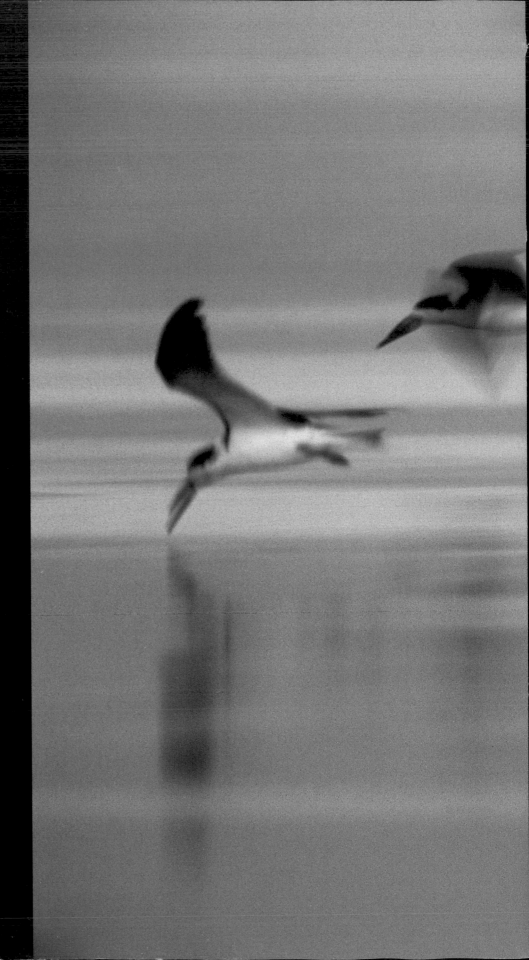

**Laszlo Perlaky**
*USA*
**HIGHLY COMMENDED**

**BLACK SKIMMERS FISHING**
I was photographing the feeding behaviour of different birds at the Bolivar Peninsula in Texas, USA. One January, just after sunset, a group of black skimmers began to fish. They flew fast and low over the surface, beaks wide open like a pair of scissors, the lower beak cutting through the top layer of the water. When a skimmer sensed a fish, it would snap its upper beak shut and poke its head into the water.

Nikon F5 with Nikon AF-I EDIF 600mm lens; 1/15 sec at f4; Fujichrome Sensia 100; tripod.

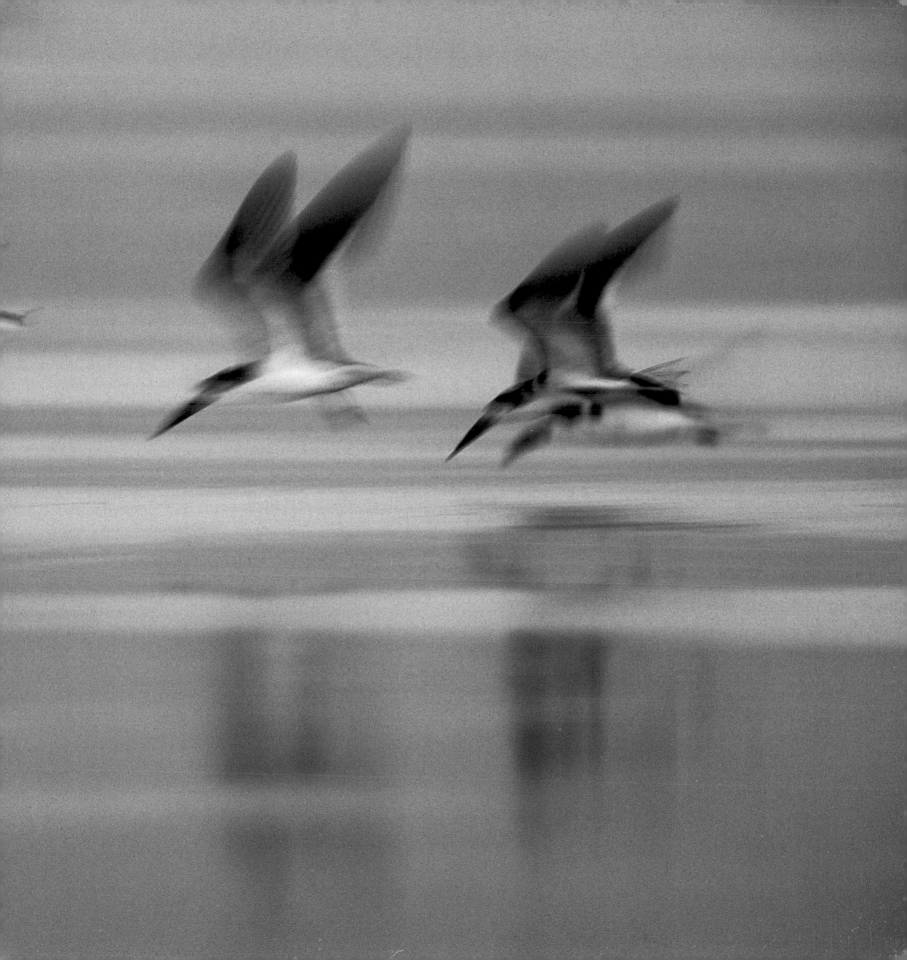

# The Eric Hosking Award

This award aims to encourage young and aspiring photographers to develop their skills in wildlife photography and give them the opportunity to showcase their work. It was introduced in 1991 in memory of Eric Hosking - Britain's most famous bird photographer - and goes to the best portfolio of six images taken by a photographer aged 26 or under.

The winner of this award for the second year running, Vincent Munier has been photographing wildlife since the age of 13, when he began taking pictures of foxes, roe deer and buzzards in the back garden of his home in eastern France. He soon became enchanted by the nearby Vosges Mountains, and always took his camera with him when exploring the high ridges and forest slopes. Though his interest in wildlife photography has taken him further afield, the inhabitants of the Vosges Mountains, especially the capercaillies and chamois, remain his specialist subjects. Vincent feels that successful wildlife photography depends on understanding the animal and its habitat, as well as gaining the confidence of the subject through patience and respect.

**WINNER**

## Vincent Munier
*France*

**CHARGING CHAMOIS**
During the night, chamois graze at heights of 1,000m in the Vosges Mountains, returning to the forest slopes early in the morning. One day in November, I was halfway up a slope at 6am, binoculars in hand, watching a group of chamois quietly grazing below me. Suddenly, just as the first rays of sun filtered through, this male charged. I hadn't noticed a female standing behind me.

Nikon F5 with 300mm lens; 1/30 sec at f2.8; Fujichrome Velvia; tripod.

**CANADIAN LANDSCAPE**
I was impressed by the sheer scale and beauty of the wild, eastern Canadian landscape, enjoying the contrast with the more intimate landscapes of my own region in France. After several days trekking, I reached this lake in the heart of the Selwyn Mountains, on the edge of the Provincial Park of Mount Robson. Tracks showed that bears and moose also visited the lake. A photographer's dream.

**Nikon F801S with 20mm lens; 1/40 sec at f16; Fujichrome Velvia; tripod.**

## COMMON CRANE LIFTING ICE

Early one April in Sweden, I noticed cranes stamping on and pressing against the ice on this lake, trying to drink the water below. After hiding for several hours, I managed to photograph this crane delicately lifting the ice blocks. I had to pull out my telephoto lens to more than 50cm and remain stock still so that I didn't frighten the birds.

**Nikon F5 with 600mm lens; 1/125 sec at f5.6; Fujichrome Velvia; tripod.**

## GREY HERON FISHING

In a calm spot of a mountain river in the Vosges Mountains of eastern France, several herons arrived to fish before sunrise. I had constructed a hide from reeds and lay in wait from 4am, until there was enough light to photograph the herons fishing.

**Nikon F5 with 300mm lens; 1/60 sec at f2.8; Fujichrome Velvia; tripod.**

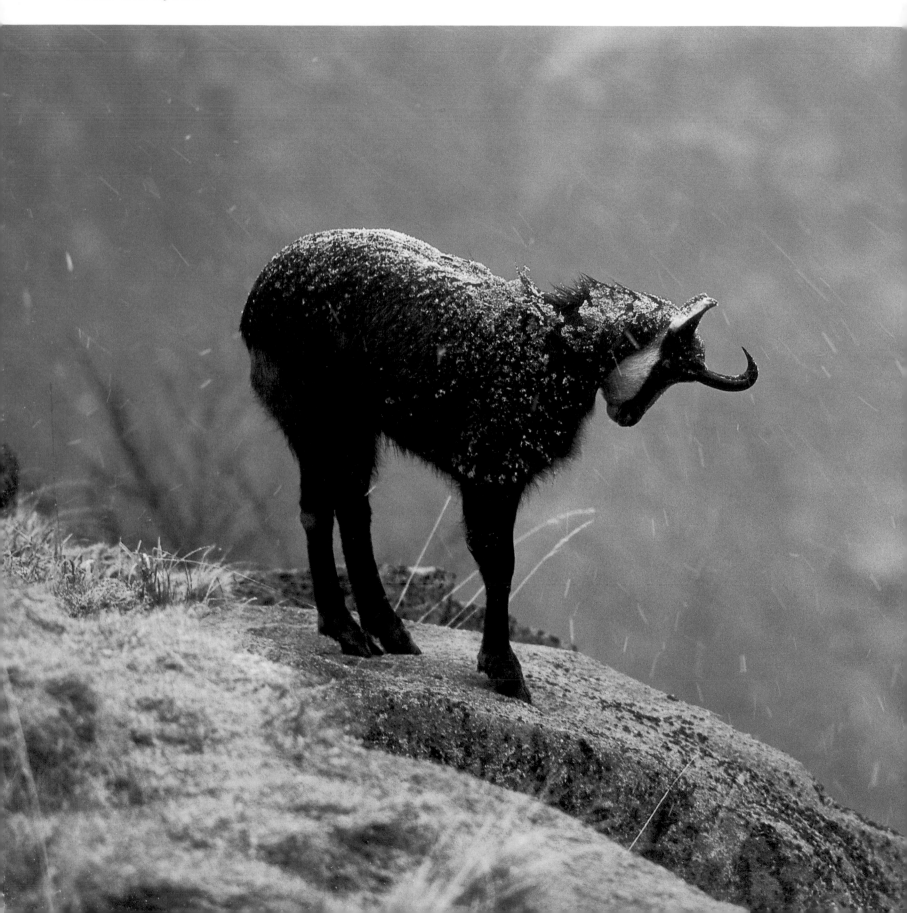

### RESTING CHAMOIS

In the depths of winter in the Vosges Mountains, this male chamois tired of the rut and rested alone for an hour or so. He was aware of me, even though I was on a cliff several metres above him hidden behind a rock. After his siesta, he rose to find shelter from the snow and rain that had set in, freezing the hairs on his back.

**Nikon F801S with 180mm f2.8 lens; 1/30 sec at f4; Fujichrome Velvia; tripod.**

### CAPE GROUND SQUIRREL IN EVENING LIGHT

The ground squirrels in the Kalahari in South Africa were particularly curious and obliging for my camera. One sunset, I was in Mata-Mata, one of the camps in the Gemsbok National Park, where I positioned myself against the sun and waited for the golden light to highlight the squirrel's magnificent whiskers.

**Nikon F5 with 600mm lens; 1/125 sec at f5.6; Fujichrome Velvia; tripod.**

# The BG Young Wildlife
# Photographer of the Year Award
# Rony Vander Elst

The young photographer (aged 17 or under) whose single image is judged to be the most striking and memorable of all the pictures entered in the three categories for young photographers is awarded the title BG Young Wildlife Photographer of the Year.

From the age of 12, Rony spent many mornings birdwatching at nature reserves near his home in Belgium, and he was soon inspired to capture the experience on film. He used his father's old camera to take his first pictures, before buying a Nikon F90X and a Sigma 400mm lens. Rony then joined a local photography club, and, later, a national association for nature photographers. A year ago he bought a 200mm macro lens, which he now uses to take most of his pictures. He concentrates on subjects close to home, often cycling to a nearby nature reserve. When he leaves school, Rony plans to study photography and his dream is to buy a small van and travel Europe as a professional wildlife photographer.

BG
YOUNG WILDLIFE
PHOTOGRAPHER
OF THE YEAR
2001

**Rony Vander Elst**
*Belgium*

**FLY ON BOLETUS FUNGUS**

In October, I saw this boletus among some moss in the woodland near my home in Belgium. The next day, I returned with my macro lens. I lay flat on the ground, using my coat to stabilise the camera, and turned my head to one side so I could put my eye to the viewfinder. It was quite uncomfortable, and bugs kept biting me. Just when I'd got the composition right, a fly landed on the boletus. It stayed only two seconds, but that was enough for me to focus on it and take two photographs.

**F90X with 200mm macro lens; 1-2 secs at f11; Fujichrome Provia 100.**

**WINNER**

### Jaco Weldhagen
*South Africa*
**10 YEARS AND UNDER**

**LAMMERGEIER LANDING**
In Giant's Castle Reserve, South Africa, there is a hide in the mountains where my family spent five days watching lammergeiers (bearded vultures). This adult landed but immediately took off again without feeding. The lammergeier has a wingspan of up to 3m. It feeds on sick or dead animals, often cracking the bones open on rocks to reach the marrow inside.

**Nikon N90S with Tokina 80-400mm lens; maximum lens aperture auto exposed; Fujichrome Velvia rated at 100; beanbag.**

**RUNNER-UP**

### Gemalla Dalsy Symons
*Australia*
**10 YEARS AND UNDER**

**DUCK FAMILY**
I stayed on Lord Howe Island, Australia, for a week last October and often saw three or four ducks on the beach. On the last day, a mallard appeared with a big brood of ducklings, and she trooped them into the rough sea. They had to follow her, even though they kept getting dunked by the waves. The ducklings were a hybrid between the native Pacific black duck and the introduced mallard.

**Minolta with 38-140mm zoom lens; Kodak 100.**

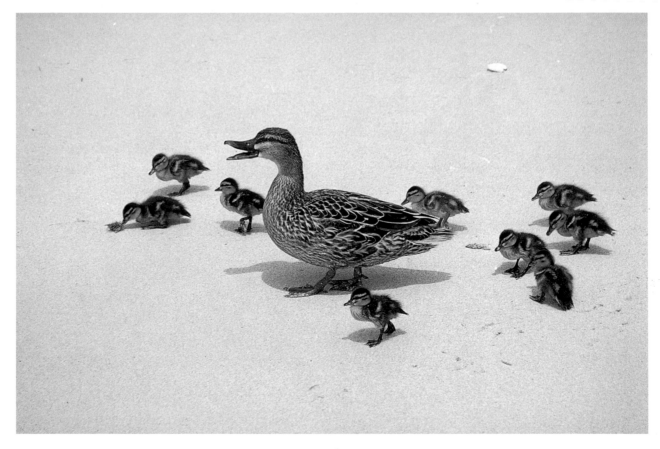

**WINNER**

**María Cano**
*Spain*
**11-14 YEARS OLD**

**BARBARY APE**
When I visited Gibraltar, the barbary macaques, known as barbary apes, noisily chided the tourists for food, trying every trick in the book to steal a chip or a handful of macaroni. But this female macaque took time out from the bedlam, sitting quietly on the cliff's edge with the town and the sea behind her. Barbary macaques are native to North Algeria and Morocco and were introduced to Gibraltar, making them the only wild monkey found in Europe. There are about 5,000 left in the wild, mostly in Morocco.

**Olympus with 38-140mm zoom lens; Fujichrome Sensia II.**

RUNNER-UP

**Ashleigh Rennie**
*South Africa*
**11-14 YEARS OLD**

**WATERBUCK**
During a visit to the Kruger National Park in South Africa in August, we stopped late one afternoon to watch a group of waterbuck grazing. While I was looking at this female, I realised that the backlighting really emphasised the long hairs on her neck. I asked my grandfather to position the car where we could see the waterbuck against a dark background. Just as I was composing the photograph, some of the other waterbuck ran off, and this one looked up, alert, to see what was happening.

**Canon EOS 5 with Canon 100-400mm zoom lens; camera set on centre-weighted programme; Fujichrome Sensia 100; beanbag.**

**WINNER**

**Iwan Fletcher**
*UK*
**15-17 YEARS OLD**

**WHITETHROAT**
Every spring, migrant warblers
that have spent the winter in
Africa return to breed in fields
about 10 minutes' walk from
my home near Caenarfon,
North Wales. The area is quite
marshy and attracts several
warbler species, including
willow warbler, sedge warbler
and grasshopper warbler.
This whitethroat was in
an area where they often nest
and was feeding on insects
and caterpillars among the
brambles. I particularly like the
photograph because it shows
the bird taking a moment's
rest on a bramble spray, lit by
the soft evening light.

**Nikon F90X with Sigma 500mm
lens; 1/250 sec at f6.3; Fujichrome
Velvia rated at 100; tripod.**

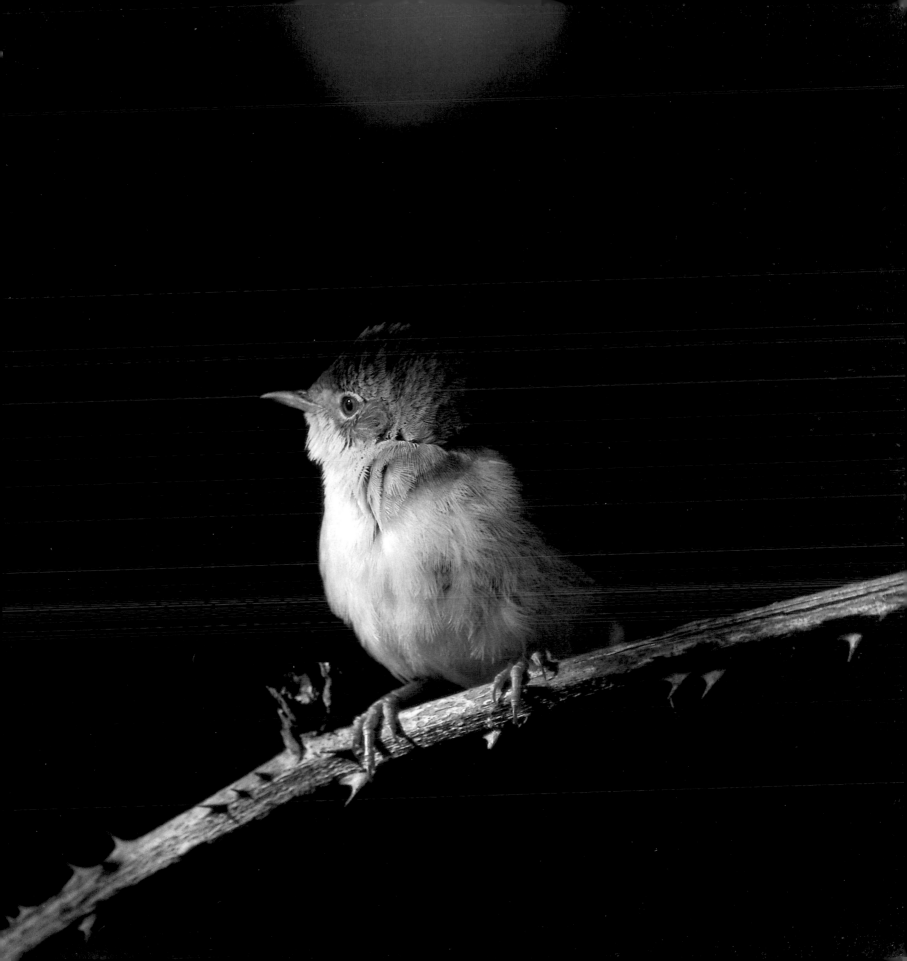

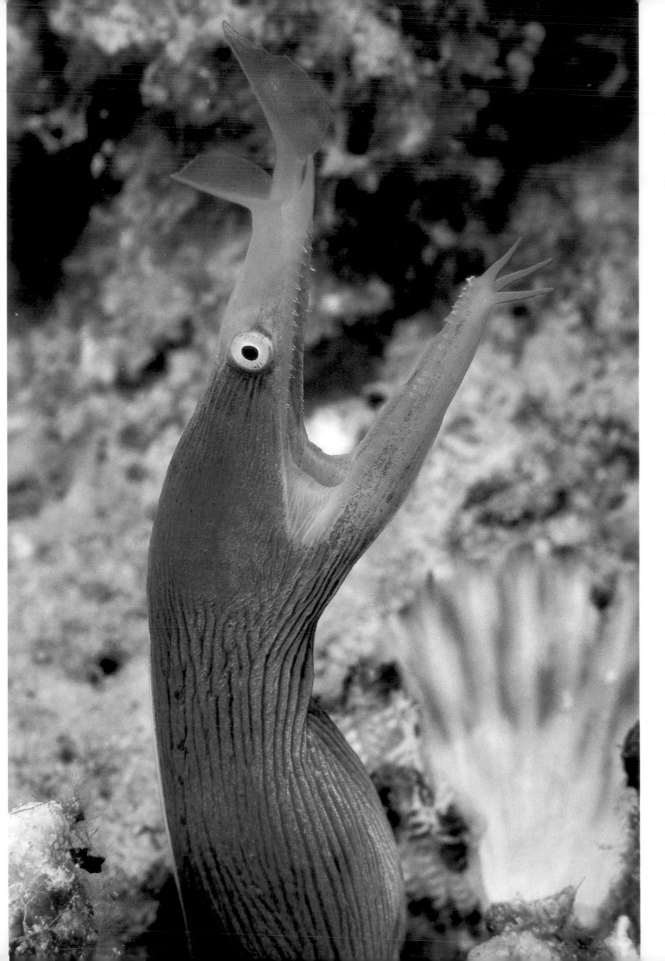

**Keenan Brown**
*USA*
**15-17 YEARS OLD**

### BLUE RIBBON EEL

Ribbon eels, members of the moray-eel family, are one of the most colourful eels. We found this male blue ribbon eel while diving on the island of Wakaya in Fiji. Initially, it was quite shy. It would reverse right back into its hole in the rock and emerge again after a while, its head constantly bobbing up and down.

Nikon F4 with 105mm micro Nikkor lens; 1/250 sec at f16; Fujichrome Velvia; Subal housing; twin substrobes.

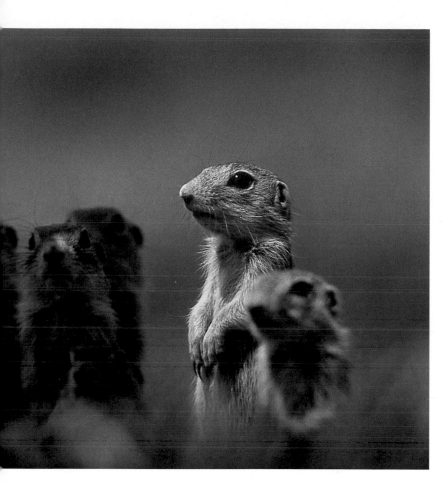

## Bence Máté
*Hungary*
HIGHLY COMMENDED
15-17 YEARS OLD

### SOUSLIKS
I encountered these sousliks at a riding school in Hungary. Each time I tried to photograph them, they would catch sight of a horse and bolt from view with shrill whistles. I eventually managed to keep the horses fenced in, and just as I took this photograph, a sunbeam lit up the tallest individual. Sousliks are burrowing rodents, closely related to squirrels, and are active in the daytime, when they forage for grass seeds.

**Chinon CG5 with Pentacon 500mm lens; 1/250 sec at f5.6; Fujichrome Sensia.**

## Iwan Fletcher
*UK*
HIGHLY COMMENDED
15-17 YEARS OLD

### REDSHANK SLEEPING
Foryd Bay, near my home in North Wales, is an important wintering ground for many migrant waders. I've been visiting the tidal pools there for many years, setting up my camouflaged hide early in the morning. Sometimes, if the pools have frozen over, the birds can't feed until the water has melted. On this occasion, a redshank had been feeding for several hours before the rising water level forced it to retreat on to the mud. I took this picture while it was resting in the warm winter sun.

**Nikon F90X with Sigma 500mm lens; 1/80 sec at f6.3; Fujichrome Velvia rated at 100; tripod and hide.**

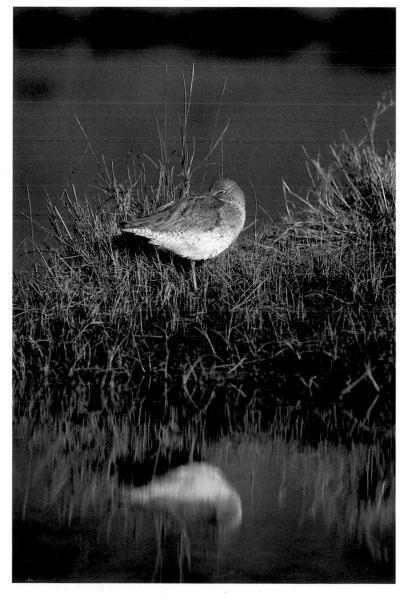

# Index
## of Photographers

The numbers before the photographers' names indicate the pages on which their work can be found.
All contact numbers are listed with international dialling codes from the UK – these should be replaced when dialling from other countries.